Chinese Painting Techniques

Chinese

Painting Techniques

by ALISON STILWELL CAMERON

Rutland Vermont: CHARLES E. TUTTLE COMPANY: *Tokyo Japan*

Representatives

For Continental Europe:
Boxerbooks, Inc., *Zurich*

For the British Isles:
Prentice-Hall International, Inc., *London*

For Australasia:
Paul Flesch & Co., Pty. Ltd., *Melbourne*

For Canada:
Hurtig Publishers, *Edmonton*

Published by the Charles E. Tuttle Company, Inc.
of Rutland, Vermont & Tokyo, Japan
with editorial offices at
Suido 1-chome, 2–6, Bunkyo-ku, Tokyo

Copyright in Japan, 1968
by Charles E. Tuttle Co., Inc.

Library of Congress Catalog Card No. 67-15140

International Standard Book No. 0-8048-0103-7

First printing, 1968
Fourth printing, 1974

Book design & typography: Florence Sakade
Layout of plates: Shigeo Katakura
PRINTED IN JAPAN

The talents of Prince P'u Ju *were many:*
poet, calligrapher, artist, teacher, and friend.

To his memory
this book is most gratefully and respectfully dedicated.

Table of Contents

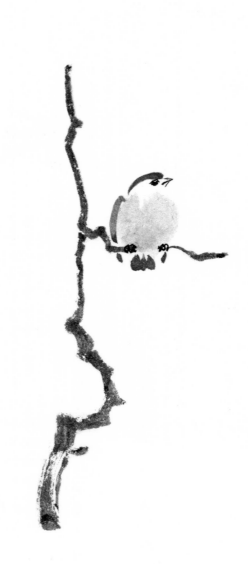

Preface

BY JAMES CAHILL

IT SEEMS strange, when one stops to think about it, that the Chinese themselves never produced a book quite like this one. The closest counterpart to it in the Chinese literature of art, the *Chieh-tzu Yüan Hua-chuan* or *The Mustard-Seed Garden Manual of Painting,* is far more theoretical in tone, occupied with categorizing motifs and techniques, defining schools and traditions. In place of down-to-earth advice for beginners, it serves up an endless fare of aphoristic "principles" culled from ancient writings. To be sure, the first chapter contains some general instructions on brushwork, the selection of paper and pigments, and the like, but anyone who sets out to become a Chinese painter with this alone for his guide will soon discover the book's limitations.

Confucius is partly to blame. He once praised a disciple who "had but to hear one part in ten, in order to understand the whole ten," and good Confucianists ever since have avoided spelling out anything in too great detail. Then there was the understandable reluctance of professional painters to give away their trade secrets to anyone who could afford the price of a book. The great majority of the interesting Chinese artists during the last six centuries, however, were amateurs—very dedicated amateurs, many

of them, but people who didn't have to make their living by painting and who therefore *had* no trade secrets—and one might expect that one or another of them would have written a "how-to-do-it" book. Actually, one of them did, namely the great 17th-century landscapist Kung Hsien, but his album of sketches and instructions, which was not printed until modern times, was obviously intended as a memory aid for his students and is not for the beginner.

The real reason why this book has no true Chinese predecessor is simple: there was never a pressing need for one. A painting teacher was always available. Some member of any large gentry family—the father, an uncle, the grandfather—was likely to be an amateur artist with enough command of painting technique to teach it to the young. If not, a teacher could be found outside, just as a piano teacher can be found in almost any American city or town. The aspiring painter, who already had some facility with the brush through practice in calligraphy, could thus learn at least the rudiments of the art without going far from home. For the American, it is not so easy; he is seldom going to find an obliging Chinese artist nearby. For him, Mrs. Cameron's book will be the next best thing. And a very good thing it is. Anyone with a little talent

who follows her clear and expert directions should be painting quite acceptable pictures in a surprisingly short time.

This is not to say that their paintings necessarily will, in the early stages of study, be original and creative works of art. They may or may not be, depending on the imagination and ability of the individual. What they *will* be is the kind of pleasing and satisfying pictures that thousands of amateurs have been producing in China for centuries. One great advantage of Chinese painting techniques is that they can be, and have been, codified—reduced to formulas that the beginner can learn and practice with a comfortable sense of having behind him the cumulative experience of countless generations of Chinese artists. The Chinese arrived long ago at a kind of collective repertory of very good ways to paint rocks and trees and bamboo; not the only ways of course, but no one is encouraged to stick with them forever, although they at least start one off in the right direction. They are to the beginning painter what five-finger exercises are to the pianist: you don't perform them in concert, but they enable you to reach fairly soon the point where you can perform well enough to give pleasure to yourself and your friends.

Alison Stilwell Cameron is an inspiring example of the rewards that a thorough mastery of the Chinese traditional techniques can bring if applied to a sufficient artistic talent. Her paintings in this book will be the delight and despair of those who use it and who find that their trees and rocks never look quite the same as hers. Leaving aside the harsh (for most of us) truth that some people seem to be endowed by nature with more aptitude for painting than others, we may console ourselves by reflecting that very few Occidentals have had the extraordinary privilege of growing up in China and having for a painting teacher one of the most famous modern Chinese artists, who was also a prince of the imperial family. The daughter of Gen. Joseph W. Stilwell, Mrs. Cameron was born in Peking and lived there during her father's years of distinguished service as military attaché at the American Embassy. When she reached the age at which she might have returned to the United States to enter college, she chose instead to stay in Peking and to continue studying painting. Her success as a painter since then has proved that it was a wise decision. We can be glad she made it and grateful to her for so generously sharing with us what she learned.

 Acknowledgments

IN ACKNOWLEDGING the fact that a book is never the product of one person's thoughts and capabilities, I would like to give credit where it is due, first to my parents for the advantages to which I was exposed and the encouragement they always gave me; to my husband and children for their understanding; to my teachers and students (who in a sense were my teachers too).

Had it not been for Helen Vail the book would probably never have had a beginning, so to her my thanks for so much patience. With pencil poised above a stenographic notebook and her great eyes pinned on mine, the halting sentences were dragged from me for the first draft. To Alzora Rutter I can never express my gratitude for the typing of several more drafts and the endless hours of editing and suggestions which led to many improvements in the manuscript. My particular thanks go to Dr. Eugene Ching of the Department of East Asian Languages at Ohio State University for his advice concerning the lesson on characters. His vast knowledge assured the accuracy of the text and of the phrases which I wanted to include.

To James Cahill, former Curator of Chinese Art at the Freer Gallery in Washington, D.C., I owe the most humble thanks for giving of his valuable time and talents in writing the preface to this book. To his generosity of expression I can only answer the Chinese way: "K'e t'ou, k'e t'ou!"

I wish to express my appreciation also for permission to quote from three of my favorite books: *The Chinese on the Art of Painting* by Osvald Sirén; *Chinese Calligraphy* by Chiang Yee, published by Methuen and Co., Ltd.; and *The Tao of Painting: A Study of the Ritual Disposition of Chinese Painting* (translation of *The Mustard-Seed Garden*) by Mai-mai Sze, Bollingen Series, XLIX, Pantheon Books.

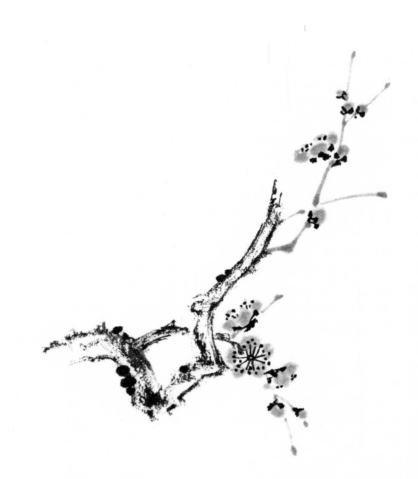

Introduction

As a daughter of the Army and later as an Air Force wife, it has been my good fortune to have had a life of travel, much of it centered in the Orient and the Pacific. In 1955 our three children and I accompanied my husband to the island of Guam for a tour of duty. Although I had been practicing my vocation of Chinese painting for many years, it was in Guam that I began to teach for the first time. It started rather casually, because of the interest of a few friends, and the classes were informal at first but gradually took on a more serious form. Because of the questions of my students, I began to realize that a textbook of some sort would be useful. Also, because we moved from Guam to Hawaii, from there to Ohio, and later on to Ecuador, I left many students in my wake, wailing for some kind of practical instruction to keep them working after "Teacher" left.

Many excellent books have been written on the subject of Chinese painting. There are books on its history, books on its philosophy, translations of Chinese textbooks, and books on "Oriental brush painting." But I could not find explicit directions of the kind my pupils wanted. For our purpose, all these books were either too serious or too sketchy and did not give the stroke-by-stroke instruction needed by those who have had no art training of any kind. My belief that there is a need to bridge the chasm between the profound wisdom of the philosopher-critics on the one hand and the sometimes unrealistic Occidental conception of Chinese painting on the other has led to the writing of this book.

You may be wondering how any Caucasian could presume to teach Chinese painting or write a book about it. The fact that I was born in Peking and spent well over half of the first two decades of my life in China has given me a strong feeling of kinship with the people and culture of that country. Looking back now over a distance of many thousands of miles and twenty-some years, I think my memories of the years we spent in the lovely old city of Peking have been sharpened rather than dulled by the passage of time. Perhaps it is because of a longing to return to the old days, in what now seems like never-never land.

My family was stationed in China three times. Our first tour of duty in Peking was from 1920 to 1923, when my father was among the first group of military language students sent to China from this country. I was born in the then-new Rockefeller Hospital, known as the Peking Union Medical College. I am ridiculously proud of the fact that

13

I was the first baby born in this hospital, but my family is fond of reminding me that this is debatable—a baby camel was born in another wing shortly before my debut. The mother camel was there to give serum for vaccine, but she surprised the staff by producing a baby as well. My claim still stands, however, that I was the first human baby born there.

My first language was Chinese, the Mandarin dialect spoken in Peking; no one spoke English to me until we were aboard the Army transport returning to the States. People thought it very amusing that a little yellow-haired girl could babble only Chinese, forgetting that one is very sensitive at the age of three. I firmly closed my mouth and refused to speak at all until I had learned English.

We were in the States for three years and then sent back to China for three years in Tients'in. But our third tour of duty in China was the best of all when Dad was appointed military attaché to China and Siam for four years, from 1935 to 1939. I was old enough then to really appreciate our good fortune in being able to live in that country, and particularly in the fascinating city that was Peking. This time we lived in a beautiful old Chinese house which had been built as a palace. Two hundred and fifty years before, the viceroy of Canton had ordered it built for his use when in Peking, but on his arrival in the city he was horrified to learn that it was located on Magpie Lane. His name was Pai Ling, which translates to mean "lark," and since magpies fight larks, this was a bad omen! He disposed of the property immediately and returned to South China.

Old Chinese houses built by the well-to-do consisted of many pavilions placed around series of courtyards, with the protection of high walls around the perimeter of the property. The main structures always faced the south because good influences come from that direction; lesser pavilions faced east and west; and very few (if any) were allowed to face north, the direction of evil influences. There was generally a "devil screen" placed just inside the main entrance which also faced south; this was to stop any devils which might have slipped around to enter there . . . somewhat unlikely, but still possible.

Our house was built of gray stone with roofs of blue-gray tile. The wooden pillars, doors, and window lattices were a soft shade of faded red. The courtyards were filled with lovely old trees—lilacs, plum, Chinese date, willows, and many flowers in season. Once inside the lacquer-red main gates, we were in a private world, peaceful and quiet, with only the diluted street sounds drifting over the walls and roofs. There were fifteen pavilions and six main courtyards connected by passageways and gates in our section of the palace alone. We lived in the central portion; Dr. John Ferguson, our American landlord, and his family occupied the eastern section, while a Russian family rented the western portion.

In the main pavilion of our central section was a large entrance hall flanked by the living room on the east and the dining room on the west. My younger brother Ben and I had our bedrooms separated by a large living room and bath, in the east pavilion. The west pavilion, with the same floor plan, was occupied by my two sisters, Nancy

and Doot. In the corner between the main and east pavilions was a suite consisting of a bedroom, dressing room, and bath, used by our parents. In the opposite corner was located the kitchen, pantry, and storeroom pavilion, with its own small courtyard. Lying behind all this to the north was another series of connecting courtyards, each with its own pavilion; these were used as guest quarters. There was a moon gate here that we particularly loved, and I remember a large circular wooden Chinese bathtub in one of the bathrooms. The plumbing in the house had been brought up to date by Dr. Ferguson; he had also installed a coal-burning furnace. During the years of the Japanese occupation of Peking we were unable to obtain coal, so we used small Chinese porcelain stoves in each room in winter. The resourceful Chinese made from coal dust "coal balls" which we could buy to burn in our small stoves, but the fumes given off sometimes had us waking up sick and dizzy in the morning.

We were encouraged by our parents to take advantage of living in a foreign country and to appreciate, even at an early age, the many and varied forms of Chinese culture. My sister Doot, a violinist, became interested in Chinese musical instruments and learned to play the *erh hu* (the Chinese version of the viola) and several others in her collection of twelve different Chinese instruments. Nancy excelled in the very difficult study of Chinese language and history. My only show of talent so far had been an interest in art; I had one year of instruction in landscape painting in oils in Coronado with Ella Ingle and one year with Arthur Hill Gilbert in Monterey. For a year after our arrival in Peking I spent much time painting scenes of the city in oils, with results which could only be called indifferent.

One day my parents commissioned a Chinese artist to paint a mural on one wall of our living room, which was papered in plain dark gray. The little old gentleman with a small white beard spent about ten days on the project, while I watched in fascination. It became clear that I had found my niche at last, Chinese brushwork. And so the search for a teacher began. Dr. Ferguson, an authority on Chinese art, told us that the finest teacher in Peking would be Prince P'u Ju, the first cousin to the last Emperor. He was doubtful about the Prince's reaction to a request to take a foreign pupil, but said he would inquire. Before long we received an invitation to tea at the home of Prince P'u and his family.

It was indeed a family affair, as all the Stilwells and all the Fergusons were invited, and we were greeted by all the P'us. As they spoke no English, the conversation was entirely in Chinese. The tea itself was typically Chinese—it was more than a tea; it was a feast. Among other delicacies, I remember having wisteria cakes, which are something like Napoleons but the jamlike filling was made of fragrant wisteria blossoms from the family's own vines. After tea, which was served in the courtyard, we wandered about admiring the famous old gardens. One highlight was a small *t'ing tze,* an outdoor pavilion with a floor carved in the shape of a Chinese character. Through the indentations in the carving flowed a stream which dropped from the pavilion to a rocky garden. We were also shown the

spot where Prince P'u, as a child, had shot an arrow from horseback into one of the garden walls; the arrow was still hanging there.

No mention of lessons was made by either family. After a few days Dr. Ferguson received word that the Prince had accepted me as a pupil—I was to go to his home for a lesson once a week. Monetary arrangements were made in the Chinese way through our go-between, Dr. Ferguson, as insurance against loss of "face" on either side. Payment for the lessons was hand carried by one of our houseboys every month, although of course no bill was ever presented.

So my lessons in the classical tradition of Chinese painting began. Each one was conducted in much the same way. I was driven to Prince P'u's home in our car; after passing the gateman at the outer entrance, we drove along a winding road inside the walls. At the front door the number-one boy ushered me into a front hall where I was asked to sit down. In a little while he returned, took me to the studio where Prince P'u was waiting, and we bowed to each other in greeting. Prince P'u then asked about the health of my parents, and I asked about the health of his mother. He inquired about my sisters and brothers, and I about his wife, daughters, and sons. He wondered how my grandparents in America were doing, and I hoped Prince P'u Chin, his brother who is also a well-known artist, was well. After these formalities were concluded, we sat down and his wife and daughters joined us. Tea was served while we chatted in a leisurely and informal manner. After tea the family departed and the lesson began.

A Chinese artist's studio is usually a clean, uncluttered, peaceful place in which to work. This is essential, as the artist's mind must also be uncluttered, ready for the conception of the idea. The desk in Prince P'u's studio was large and held only the necessary equipment: his inkstones, brushes and holders, color dishes, and water bowls. In one of these bowls there was always a fresh flower floating. There was some disorder to be sure, but it consisted mainly of rolls of paper or finished paintings and piles of books, brocade bound. At fifteen, I had discovered a new world.

Prince P'u Ju sat on one side of his desk and I sat opposite him; therefore my view of his work was upside-down. He painted whatever he wished me to learn, and, as he painted, explained and discussed the strokes and composition. When the lesson was over, I took his painting home with me, copied it, and brought it back the next week with my own, which he then criticized. By copying, the Chinese student assimilates the traditional methods, learns technique, composition, the use of color, and finally that almost indefinable element known to the Chinese as *ch'i yün,* or spirit-vitality.

Most Chinese art students are required to study calligraphy, the writing of Chinese characters, for many years before they are allowed to begin the study of painting. In my case, my teacher took into consideration the fact that we had only three more years before we would return to the States and, I suspect, the fact that I was a foreigner and therefore in a hurry. He kindly allowed me to continue my studies of calligraphy along with the painting lessons. I learned to write many characters but was required to concentrate on the three characters of my own name,

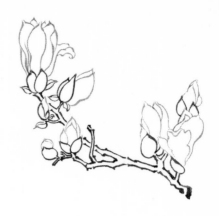

Shih Wen-sen (pronounced shehr one sun). Prince P'u wrote the characters for me in the formal way and also in the loose, easy-flowing, "running" style. I copied these over hundreds of times. Later, when he gave me my artist's name, I spent much time writing those characters also.

Our family name was given us by Kuan *hsien sheng,* our tutor. Taking the sound of the name of Stilwell and transposing that sound into the Mandarin dialect, he gave Dad the name Shih Ti-wei, which translates to mean "maker of history." This was back in 1920! We children therefore had the surname Shih or "history." Our generation was given the middle name Wen, meaning "literary." Then by taking the sound of our Christian or given names, he was able to decide on our third names. "Alison" became "sen," which means "forest." Thus my Chinese name, Shih Wen-sen, means "History Literary Forest," forecasting at my birth someone who would be interested in history and literary pursuits and would love the forests.

When it came time for me to have my artist's name, Prince P'u gave it a lot of thought. This was an honor bestowed only when the teacher felt the student was qualified to receive it. Finally one day he told me he had it; I was to be Sheng Hua, "Birth of a Flower." Here is the story, based on a poem by Li Po, which he told me:

Once there was an American girl who wanted very much to paint as Chinese artists do. She worked very hard for a long time. One day she fell asleep over her work, dreaming that she was again at her desk painting, and then suddenly she saw that the tip of her brush was a flower which burst into bloom. On awakening she found that at last she could paint in the Chinese way.

A year after my studies with Prince P'u began, we received the sad news that his mother had passed away. He immediately went into mourning, which meant wearing white clothing, shoes, and hat. To further mourn his loss, he did not cut his hair or shave for the first few months of the period which lasted a full year. (If his family, the Ch'ings of the last dynasty, had still been in power, the mourning would have continued for three years.) He could not teach while in mourning. He did no painting except for religious pictures executed in black or red ink and no writing except for religious poems composed to revere his mother's memory, using only these two colors of ink.

Even one year of lessons lost seemed too much. After the funeral, which we all attended, I was allowed to visit him but only for a social call. His natural air of formal dignity was put aside on these occasions and his kindness and sense of humor always put me at ease. I was asked to bring any paintings I had done for him to see, and he talked to me about them and gave me criticism. After the year passed, regular lessons were resumed.

During the period of mourning, with Prince P'u's approval my family found another teacher for me. This artist was Yü Fei-an, who specialized in painting flowers and birds. His technique was very different from that of P'u Ju, but his teaching method was the same. He painted; I watched. The two teachers did not conflict since, although he was also extremely proficient at depicting birds, flowers, and insects, Prince P'u's particular specialties were landscape and figure painting.

At the time I was studying insect painting, my brother

Ben became interested in cricket fighting, a popular sport in China. Crickets were sold in the market places, fed and cared for as pets, and pitted against each other in a sort of wrestling match. Ben's interest in these small creatures gave me the idea for a children's story which I later wrote and illustrated.

Grasshoppers also were sold at the market place, and one day Ben brought home a very large green one as a pet which, with ten-year-old relish, he named Gangrene. This was a most unusual grasshopper. He never hopped but merely strolled in a rather dignified fashion when let loose, reminding us of an old Chinese gentleman. Gangrene became so tame that he was let out of his cage at frequent intervals and sometimes was lost. On these occasions we went through the house from room to room, calling to him in a high "Tr-r-r, tr-r-r." He always answered this call with one of his own and returned to the fold. Several times he was located deep in a closet or in the toe of someone's shoe, with the result that after this we were careful to check thoroughly for grasshoppers before putting on our shoes.

Ben liked to bring Gangrene in at lunch or dinner time and put him on the plant or bouquet currently being used as the centerpiece on our dining table. There he would swing from leaf to leaf, or crawl up and down the stems. Sometimes he came down from his plant and walked slowly over to see what was on our plates. If we were having a green vegetable, he could be induced to have a friendly bite or two, and then he returned to show off some more in his small jungle gym. Once while I was painting at my desk, Ben placed the grasshopper on some of my brushes which were standing upright in their *pi t'ung,* or jar. He began to swing and climb around on them as if they were stems of a plant. Unable to resist, I sketched him in various positions and later did his portrait on a spray of narcissus. Yü Fei-an was particularly pleased with this painting for technical reasons, and I was always glad later to have immortalized Gangrene, who lived with us for about six months before dying of old age. He was given an honorable funeral in a coffin usually reserved for cricket champions and was buried under the great central stone in our main courtyard.

During these years Dad was often away in South China on military business. In the course of his travels he saw a great deal of the country and was very much impressed by its beauty. Being something of an artist himself, he used to make sketches of what he saw and bring them back to me for inspiration. Once in awhile one would come in the mail with a note in the corner: "Al, do this one." For the first time I realized that the tall peaks and deep valleys in Chinese paintings, which had seemed the product of someone's wild imagination, actually existed. They really did build monasteries on the tiptop of what seemed insurmountable crags; mountain ranges really did flow along in unbelievable undulations; the mists really did rise from the ravines in swirling clouds! There was one area, in fact, where mountains jutted up like tall thin fingers from the flat valley floor, continuing in a range of a hundred miles or more.

During the course of my studies with Prince P'u Ju,

he talked of a philosopher art critic who lived in the 5th century A.D., Hsieh Ho. This gentleman authored the "Six Canons" of Chinese painting. They were to serve as a guide for the next fifteen centuries, not only for the student but also for the critical admirer of Chinese painting. No book on the subject would be complete without them, so I will list his six principles here:

1. *Ch'i yün*. Most important of the six, this term has the meaning of spirit. Hsieh Ho says the spirit-vitality or life-breath of a painting is the intangible something born in the artist's heart and is the most difficult of all the principles to achieve.

2. *Bone structure*. The brush strokes used in Chinese painting are known as the bone structure or bony framework of the painting. On their excellence, or lack of it, a painting stands or falls. Strong brushwork will produce a strong painting; weak brushwork results in a weak painting. The strokes used must be variously light and dark, wet and dry, thick and thin; otherwise the finished work will not have character. The writing of Chinese characters, or calligraphy, is closely allied to their painting, and brush mastery is essential to both arts.

3. *Likeness*. This principle governs the artist's striving to reproduce the forms of nature, not necessarily in a completely realistic manner but as he sees them.

4. *Coloring*. The Chinese approach to coloring is different in some ways from the Occidental. First of all they consider black ink a "color." It is capable of such a range of shading that a monochrome painted by a fine artist can give the impression that many colors were used. The Chi-

nese have a masterful hand with color also, and Hsieh Ho's Fourth Canon covers the many ways in which it may be applied. Varying with the styles that were conceived and flowered through the centuries, color was used sometimes delicately, sometimes brightly, but always conforming to the subject.

5. *Composition*. To the Chinese eye, composition is a matter of balance, but not as Westerners see it, in terms of balancing the objects in a painting against each other. The Chinese artist weighs his subject against the *spaces* in his painting; thus the spaces become part of the composition and are significant in themselves.

6. *Copying classical models*. This is the last principle and refers to the traditional way of studying, by copying from the ancients. This method is followed only through the student years. There comes a time when the student is ready to compose his own paintings and perhaps even find his own style, but none of this is possible without first laying a firm foundation by copying.

As Prince P'u painted, he talked, explaining each step in the creation of the painting. When copying his work, I tried to remember all he had said, learning, I think, by absorption! He advised me to acquire a set of textbooks known as *The Mustard-Seed Garden,* a manual written in the 17th century, which has been the guide for countless Chinese art students since that time. It consists of prints from paintings by old masters, many examples of classic works, and treatises on them written by several critics.

My teacher also told me of the many schools of painting

which developed over the centuries in China, dating from the Han dynasty and beginning with stone rubbings and wall murals. The history of Chinese painting pre-dates 200 B.C., but that is the time of the earliest surviving relics. Down through the centuries China has produced a great number of famous artists who developed new schools and styles. It is a pity, and certainly our loss, that they are not as well known in this country as Michelangelo, Reubens, Van Gogh, and others, for they have brought forth as many diversified styles as these Western masters.

There was Ku K'ai-chih, who lived in the 4th century; Han Kan of the T'ang dynasty, famous for his powerful paintings of horses; Wu Tao-tze, born about A.D. 680 and said to be the only artist to master all of Hsieh Ho's Six Canons. There were Kuo Hsi, Li Ch'eng, and Fan K'uan of the Sung dynasty; and in the same period, Mi Fei, whose style was so new and different that a certain painting stroke became known as the "Mi" dot. More illustrious names must include those of Ma Yüan and Hsia Kuei; Mu Ch'i, whose paintings, done in about A.D. 1200, look modern enough to have been executed yesterday; and Liang K'ai, famous for quick, staccato brushwork. How different was his work from that of his contemporary Ma Yüan, which was calm and contemplative. The Yüan dynasty (1260–1368) brought us Ch'ien Hsuan, Kao K'e-kung, and Ni Tsan, the latter well known for his simplicity, rigid brushwork, and economy of ink. There was Lü Chi in the Ming dynasty, whose work greatly influenced the Japanese master, Sesshu; also, Hsü Wei and Tung Ch'i-ch'ang. The Ch'ing dynasty gave us three painters who revolted against the scholarly attitudes of the Mings: Tao Ch'i, Chu Ta (better known as Pa-ta-shan-jen), and K'un Ts'an. Artists of our own day whose fame has spread all over China include Ch'i Pai-shih, who painted right up until his death a few years ago at the age of 96; Chang Ta-ch'ien; and my own teacher, P'u Ju (also known as P'u Hsin-yü). The Chinese have a saying about these last two: "Nan, Chang; Pei, P'u" which translates as "In the South, Chang; in the North, P'u."

All Chinese painting falls into two main categories known as *ku fa* and *mo ku*. In the *ku fa* (pronounced goo fah) style, meaning literally "bone manner," the painting is carefully delineated by outlining in varying shades of the black ink. Color is laid on in a series of washes, but only after the outline is complete. *Mo ku* (pronounced maw goo) means "boneless." There is no outline in this style; brush strokes are made in either ink or color, but each stroke produces an object or a part of one. For example: a leaf may be brushed in with one stroke or two; a petal, one stroke; a flower stem or a bird's wing, one stroke. Accents, such as veins in a leaf or stamens on a flower, are added afterward. *Pai miao* (pronounced bye meow) is a third term, used when outlining without the addition of color. Often *ku fa* and *mo ku* are combined in one painting. For example, a bird may be painted in the *mo ku* style, while the branch on which it is perched may be drawn in outline, *ku fa* style.

One final thought: painting to the Chinese is not merely a flat representation of an object but a means of symbolic expression. They speak of pine trees as being "young dragons coiled in deep gorges." When a group of trees is painted,

one large tree is referred to as the "host," while the smaller trees are "guests." Similarly with rocks, when a large one is surrounded by smaller ones, they are spoken of as "father and children."

The Chinese artist does not paint his subject while observing it; he may walk in the woods, looking at the trees and mountains, and then return to his studio to paint what his mind's eye remembers. He sees with his spirit or, as the Chinese say, his "heart-mind."

The symbolism embodied in the Yang and Yin (male and female principles) and in the religion-philosophy known as Tao or the "Way" are intertwined with Chinese painting to such a degree that they must be considered as one. In my own studies I have long searched for my Way. I am still searching, but in writing this book many new roads opened. The questions of my pupils helped me immeasurably to clarify my thoughts, and to them all I owe a fond debt of gratitude. I hope this book will help them and you, in some small measure, to find the Way.

Materials & Equipment

THE CHINESE paint on a flat, horizontal surface such as a table. You should work on a large table or desk at a comfortable height and sit on a straight chair. Cover the table with a piece of smooth white plastic or oilcloth. It is easy to wash the ink off such a surface, and it makes a good background for your work. The ink may not come out of fabrics unless washed immediately, so wear a smock or apron.

You may wish to buy supplies in a boxed set which usually includes the following items: an inkstone, a stick of ink, a water well, two or three brushes, a chop, and chop ink, all packed in one convenient carrying case. These pieces may also be bought separately but, except in the case of the brushes, the sets are usually quite adequate for the beginner. The inkstone is simply a slab of stone (sometimes made of a composition) polished to a smooth surface, on which the ink stick is ground. The ink stick is made by a process in which pine soot and gum are combined in a mold and allowed to harden into the stick form. A water well is a small porcelain block, pierced by two tiny holes. This is immersed in water until it is full, and then by holding a finger over one hole, water may be released drop by drop onto the ink stone as the finger is lifted. A water bowl

and spoon may be used instead to place the water on the stone.

Brushes are made in all possible sizes and qualities; therefore I would like to emphasize that it is better to have quality than quantity, if you must choose. Most brushes available in this country are from Japan but are made in the same way as the Chinese brush. Generally the handle is made of bamboo, and the hairs are of wolf, deer, goat, sable, or rabbit. Different types of hairs are required for different kinds of work. The chart in Fig. 1, illustrating the various brushes you should have, may be used to compare the sizes of your brushes to the sizes you will need. They need not be exactly the same size, but they should be close. Brushes 1 through 6 are sable or wolf hair, and brushes 7 through 9 are rabbit or goat hair. At first you will use brushes No. 1, 2, 4, 6, and 7, but later you will want to add No. 3, 5, 8, and 9. A recommended supply of brushes for the beginner is three of No. 1 or 2, two of No. 7, a minimum of four (six would be better) of No. 9, and one each of the others. The numbers used in the chart are only for reference in this book. Fig. 2 illustrates the various parts of the brush. Do not try to use the Western type of water-color brush for this kind of painting. The hairs are

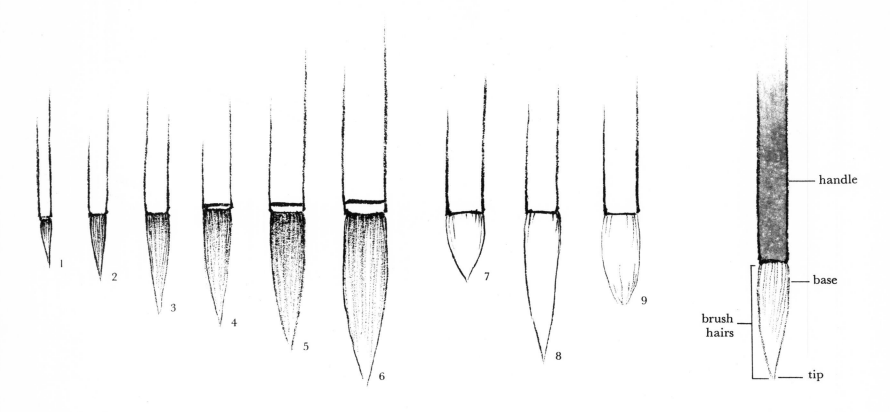

1. Various brushes.

2. Parts of the brush.

not cut in the same way (to a fine point), and it cannot produce the proper strokes.

Accessories (Fig. 3) which are not really necessary but nice to have are: a compartmented water bowl and spoon, a brush rest, weights, and a jar to hold brushes when not in use. For mixing ink washes and colors you should have a few small shallow bowls or saucers. These may be of glass or china (preferably white) and approximately three inches in diameter and one-half or one inch deep. At a later date you will undoubtedly want colors. The most convenient I have found are a Japanese product which comes ready to use in small white porcelain bowls. They may be purchased separately or by the set.

It is possible to find paper in many qualities, of two distinct types: absorbent and non-absorbent. Both types are usually made from the pulp of rice or bamboo fibers, but nowadays some is manufactured from cotton fibers. Each variety and quality of paper has its own particular use, and by experimenting a little you will find the types which suit you best. For practice work, however, we find that common newsprint (the paper used for printing newspapers) is by far the most useful. It is of just the right absorbency and cheap enough to be bought in large quantities. Any paper company will sell it to you by the pound. Have it cut to size, 12″×18″. You will find this much less expensive than the tablet form found in most stationery shops.

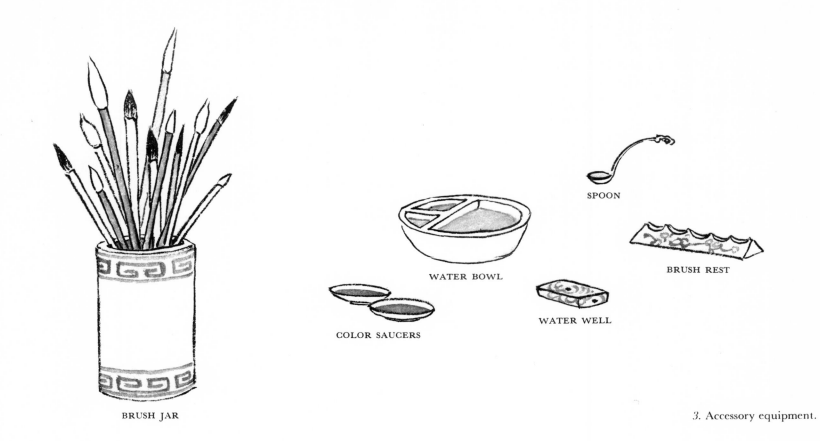

BRUSH JAR SPOON WATER BOWL BRUSH REST COLOR SAUCERS WATER WELL

3. Accessory equipment.

For tracing purposes you will need a supply of architect's tracing paper or the thinnest onion-skin typing paper you can find.

Silk is a wonderful surface on which to use the Chinese medium, but you must have the kind made specifically for this purpose. It is very similar to that used for silk-screen printing and is available in Hong Kong and Japan.

To sign a painting with a seal or chop is a great satisfaction. They are sold as blank sticks to be carved with one's own Chinese name or character. Seal ink, which is vermilion in color and very oily, is packaged in an airtight container. The seal is first pressed into the red ink and then stamped on the finished painting.

The seriousness of your purpose will dictate what supplies you wish to have, but please heed this advice: try to get the *best* when you purchase any of these tools. It will pay you well in the long run, whether you are trying this art form for serious study, to help you appreciate Chinese or Japanese painting in general, or just for the fun of it. My experience with pupils has been that they surprise themselves with the results they are able to achieve. Also, this type of brushwork may be used in many other ways such as decorating ceramics, making patterns for silk-screen or block printing, making greeting cards, and so forth.

The tools and supplies you will need are made in such variety that you may have the simplest or the most elegant,

according to your own taste. But you may question where they can be found, especially if you live far from a large city. Aside from the sources listed at the back of this book, there are these possibilities: book stores, college supply shops, and gift shops (especially those in museums or galleries). However, if you are fortunate enough to be near one of the larger cities with a fair-sized Oriental population, your problem is solved, as every Chinatown is sure to have plenty of these materials. There are also several magazines, devoted to art and the artist, which carry advertisements for supplies of this sort. If you are unable to find these supplies in your vicinity, they may be ordered by mail.

Ink, Inkstone, & Brush

THE TABLE in Fig. 4 is ready with its plastic covering in place. The inkstone and ink are at one side, and the water bowl is filled. The brushes, selected for use, are wearing their little plastic caps. A fresh sheet of newsprint lies in front of you, but you are not quite ready to begin.

First you must learn how to grind the ink and how to handle the brushes. The amount of care and attention you give to this part of the process will be rewarded with the resulting condition of your tools; lots of care equals long life.

If your stone arrived in a cardboard box, first take it out of the box and lay it on the table. With the spoon or water well, place a small amount of water on the inkstone—about one-quarter to one-half teaspoonful is sufficient. Now grasp the ink stick between the thumb and first two fingers, holding it upright. Rest your elbow on the table and raise the wrist, resting the end of the stick lightly on the stone (Fig. 5). Now press downward rather heavily and let your wrist move the stick in a circular, clockwise motion through the water. Always get into a comfortable position and plan to grind for approximately three to five minutes. Two ways to check on whether you have ground enough are: the ink will begin to look thick and bubbly,

or a dry path will follow the ink stick after a short time interval. As you grind, the ink becomes progressively thicker and blacker. Most ink sticks are covered with a protective coating of shellac when new, and this must be ground off first. So if the ink does not seem black enough right away, do not be discouraged. Have patience and grind some more. The Chinese artist considers this a time for contemplation, and he is never in a hurry.

If the stone becomes too dry, add a drop or two of water. If the stone is too wet, use the ink stick to scrape the excess water down into the depression or well in the inkstone (Fig. 6). The ink left on the stone should be washed off with clear water after each painting session. If it is forgotten and a crust forms, this can be removed by soaking the stone in water for a short while or by scrubbing it with a soft brush. Never use an abrasive cleanser! Never leave the ink stick standing or lying in the ink mixture, as it will stick to the stone and possibly break when pulled off. Lay the stick across the corner of the inkstone so the wet end is exposed to the air (Fig. 7).

Care of brushes is very important. The tips of brushes are encased in protective little plastic dunce caps which should be thrown away when first removed so that you

27

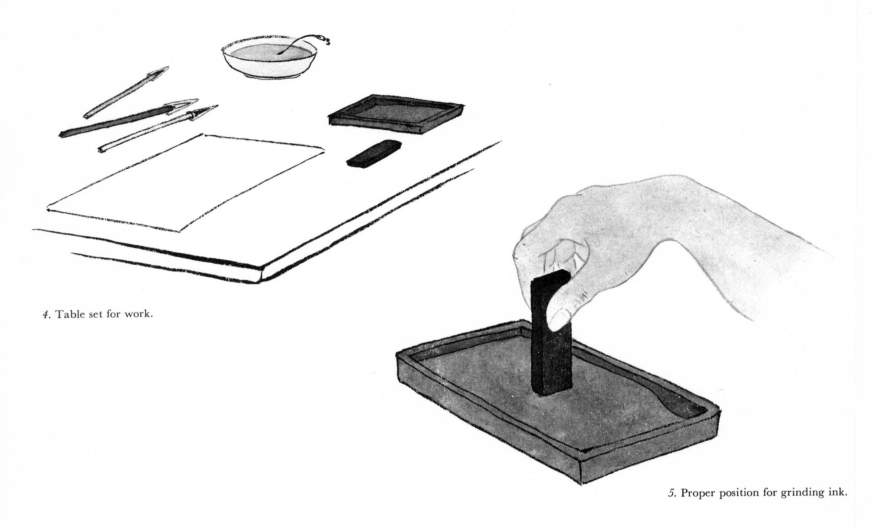

4. Table set for work.

5. Proper position for grinding ink.

will not be tempted to put them back on. Replacing these caps after a brush has been used may possibly break the hairs or create a humid atmosphere which invites the growth of mold. You will find that the brush feels stiff, for the hairs are held together with a kind of glue or starch to protect them until the brush is first used. To "open" the brush and loosen the glue, hold the brush so that only two-thirds of the brush hairs are immersed in a bowl of very hot water (Fig. 8), slowly turning and pressing the hairs against the side of the bowl. (A new brush will sometimes lose a few hairs, so just pull any wayward ones out.) Never immerse the hairs in hot water as far up as the point where they are attached to the bamboo handle, as the entire tip may eventually fall out. Now give the whole brush a jarring shake down toward the water bowl to remove the excess water. The whole brush may be put in water now, as long as the water is *cool*. If you are pausing in your work for a few moments or when you are through working, be sure to rinse all the ink out of your brushes. Swish them through a bowl of clear water, hold them under a running faucet, or if necessary, use a little pure soap. Once a new brush has been softened, all that is needed thereafter is a quick dip in the water bowl and a good shake and it is ready for use.

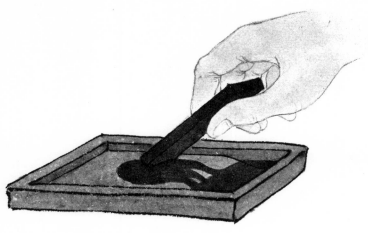

6. Scraping excess water into the well.

7. Position of the ink stick when not in use.

8. Dipping the brush in hot water.

Another way to prolong the life of your brushes is to learn the proper technique for picking up ink on the brush. With the tip pointing to the left, hold the handle between the thumb and all four fingers (Fig. 9), rolling the brush up and down over your fingers (Fig. 10*a, b*). Now make short swooping motions across the stone, pulling through the ink and to the right, *away* from the tip of the brush. There is a rhythm to this motion: pull through while rolling up, return to the inkstone, pull through while rolling down. Try saying it to yourself as you go through the motion, since it helps to establish the rhythm. Never dab or scrub at the inkstone to pick up ink! The pulling and rolling method straightens out the hairs of the brush, and this is essential for making good brush strokes. Try rolling the brush in one direction only and you will see how the hairs spiral and the tip splits. After you become adept at using this motion to load your brush with ink, try to speed it up, brushing across your stone in shorter, faster strokes. Roll the brush across a piece of newsprint in this same back and forth motion to remove excess ink before starting to paint. Newsprint will not harm the hairs as wiping the brush with a piece of cloth or absorbent tissue will. When you are finished working and have rinsed your brushes, shake them hard and roll them across a sheet of newsprint before putting them away.

To hold the brush correctly for painting, you must now change your grip. Grasp the handle between the forefinger and middle finger on one side and the thumb and third (or ring) finger on the other. In other words, it is clasped between the thumb and one finger in front and two fingers in back (Fig. 11). The fourth or little finger simply supports the third finger and should never touch the table surface. This last word of caution will be hard to remember for those who have had training in other art work, as the fourth finger is used to support the hand in many schools of painting. In Chinese painting, however, the forearm and wrist act as supports for most strokes. So watch that little finger! After some practice you will find that this grip, which may seem strange and difficult at first, gives great control over the brush. You will produce

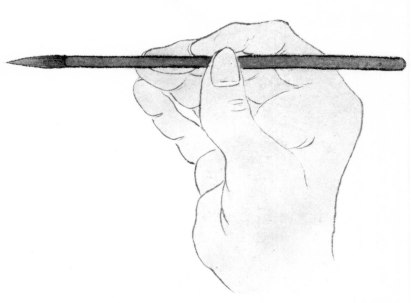

9. Grasping the brush handle.

better strokes if you stick with it; in fact, authentic Chinese brush strokes cannot be executed without using it.

With your forearm and base of the wrist resting on the table, hold the brush so the handle points out and away from you, at about a 45-degree angle from the table surface. Now pull the brush back to a vertical position (Fig. 12). If the tip just clears the table, you are holding the handle at the proper spot. If it is a half inch or more above the table, your hand is too close to the hairs. If the brush will not stand vertically without bumping into the table top, you are holding it too far up on the handle. Be sure your arm and wrist do not roll over to the right or left but remain flat on the table.

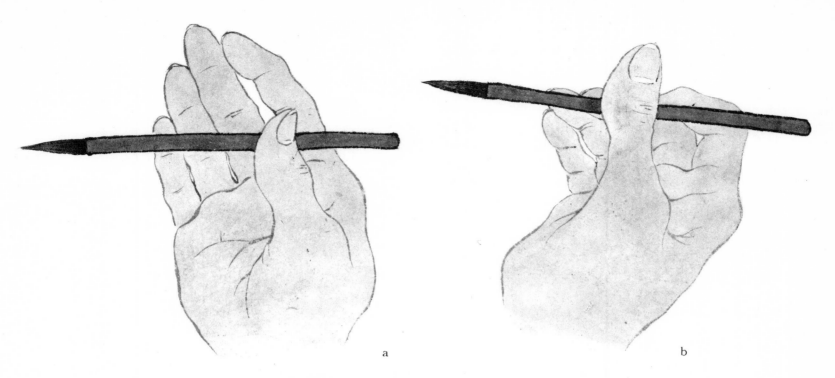

a b

10. Rolling the brush handle up and down the fingers.

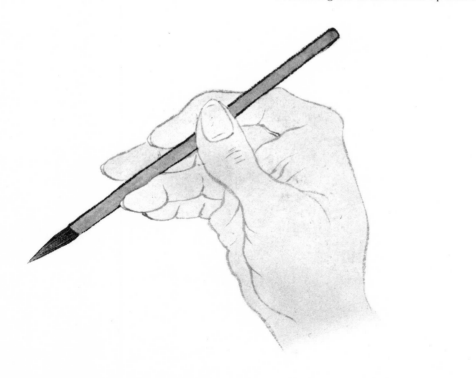

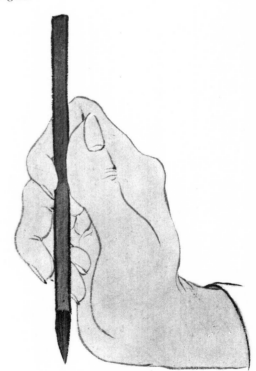

11. Painting grip. *12.* Starting position.

Now play with the brush a little to get used to manipulating it. Roll it through the freshly ground ink and then switch back to the proper grip for making strokes. The brush should be held at the vertical position before starting any stroke, as well as after completing various strokes. You may think of it as returning to "home base," or to use a ballet dancer's term, "first position." Doodle a bit on the paper. Don't be afraid—it's fun! Try this with all your brushes. Does the grip tire you? Put the brush down, flex your fingers, and shake your arm. Everyone is tense at the beginning, and the position is naturally more tiring at first. Now try it again. When you feel at home with the brush, it is time to start your first lesson.

Painting Strokes

<div style="text-align:right">3</div>

Lesson 1 : Basic Strokes

We have four terms to describe the quality of strokes: Bone, Flesh, Muscle, and Blood. For we look at strokes and characters from an animistic point of view. . . . Thus every type of stroke should have a bone within it, formed by the strength of the writer. We criticize calligraphy according to whether it has strength—"bone"—or not. That is why the handling of the brush is of such importance. . . . The flesh of the stroke depends upon the thickness of the brush-hair and the pressure or lightness of the writer's touch. It also depends upon the amount of water in the ink. The flesh will be loose if there is much water, and arid if there is too little; it will be fat if the ink is very thick, lean if the ink is very thin. The nature of "muscle" in a stroke can be left to the imagination; when the stroke is bony and has the right amount of flesh, muscle is sure to be there. In well-written characters there seem to be muscles joining one stroke to another, and even one character to another. The "blood" of a stroke depends entirely upon the amount of water with which the ink is mixed—the color. Thus it can be seen that the principle of "life" is borne out even in the technical detail of Chinese calligraphy.

—CHIANG YEE, *Chinese Calligraphy*

There are many fascinating names given by the Chinese to brush strokes as they are used in painting. The following (Fig. 13) is only a partial listing: *p'i ma ts'un,* or brush strokes like spread-out hemp fibers; *ta fu p'i ts'un,* like big axe cuts; and *ma ya ts'un,* like horses' teeth. There are also descriptive terms for the dotting strokes: dotting like pepper; Mi dots, or dotting like eggplant; dotting like plum blossom; and dotting like water grass.

Before you start, it is a good idea to follow the method used by good cooks when consulting a cookbook. First read the instructions; second, gather the necessary equipment together; and third, go back and read the instructions again. Keep your inkstone on your right-hand side, placed so the well is at the left. (If you are left handed, transpose these and any similar instructions to the opposite side.) This position gives you the entire length of the stone for rolling the brush and picking up ink. Remember also to have a piece of newsprint handy for testing the ink shading as well as rolling the brush.

My students begin by learning a few simple brush strokes, of which the most basic is that forming the character *i* (pronounced ee), which means the number "one." It closely resembles a bone, and the Chinese speak of these strokes as the bone structure of painting; therefore my own name for it is the bone stroke (Fig. 14). As you proceed

SPREAD-OUT HEMP FIBERS

AXE CUTS

HORSES' TEETH

PEPPER DOTS

MI DOTS

PLUM-BLOSSOM DOTS

WATER GRASS

13. Various brush strokes.

with your lessons, you will see that the bone stroke is the basis of all Chinese painting.

To form the bone stroke properly, it should first be broken into two parts. Each portion is a stroke in its own right, but the brush is handled in a slightly different way when one of the two parts is painted alone.

The first, which I call a hook stroke (Fig. 15) for obvious reasons, is painted in the following manner. Be sure that your arm is resting comfortably on the table, and use brush No. 1 or No. 2. Angle the handle of the brush out and away from you, directing the tip of the brush toward the upper left corner of the paper. Press the brush to the paper, drag from left to upper right, gradually lifting it like an airplane taking off. Check your work with the stroke in Fig. 15.

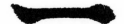

14. Bone stroke.

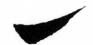

15. Hook stroke.

Prince P'u always marked my work with a circle if it was correct or good, and an *x* if it was incorrect or poorly done. I will use the *x* for incorrect or negative examples throughout the book, but I will omit any mark on examples which have been done correctly. Fig. 16 shows some common mistakes made by students in making the hook stroke. In *(a)*, the brush was pulled to the lower right before beginning the upward stroke. To overcome this tendency, push into the tip of the brush. In *(b)*, too much pressure was applied without enough pull to the upper right. The angle of the brush was wrong too, because the tip should have pointed to the upper left. In *(c)*, the base of the brush was lifted after it was laid on the paper. Try to make a conscious effort to keep the brush down, gradually lifting it only after the pull to the upper right is started.

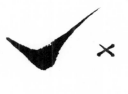

a

b

c

16. Common mistakes made in painting the hook stroke.

The outline of the shape of the hook stroke is illustrated in Fig. 17, so you may practice it by tracing. The arrows indicate the path of the brush. Lay a piece of tracing paper over the outline and try to fill it in with one stroke, but do not let the ink go outside the outline. Move the tracing paper and try it again. And several times again! Note that the top of the stroke curves slightly, while the lower side is angular. If your stroke still does not look like the example, check to see if the following questions can solve the problem.

Is your grip on the brush correct? Look again!

Are you slanting the handle out at an angle of approximately 45 degrees?

Is the tip pointing in the direction of the upper left corner?

Are the hairs aligned? Roll and pull after each stroke or two.

Did you read the directions thoroughly?

Are you using the right size brush?

Now try the same stroke freehand on newsprint. The size of these strokes does not matter at all at this stage, but the shape is of the utmost importance. If you have a lot of trouble with it, try another size brush, making your strokes larger or smaller than the size you have been practicing. It is a good idea to put the date on each piece of practice work, because you will be able to look back later on to see how you have progressed. This can be very encouraging.

Be deliberate about painting these strokes, pausing between each one. There is no hurry. Try to get into a rhythm, saying to yourself, "Press, drag, lift." Do not draw with your brush as if it were a pencil; make it do the work. It is like a fine instrument and will perform beautifully when manipulated correctly. When you are sure you are doing this stroke properly, try to increase your speed, which may make the execution of the stroke easier for you.

Then go on to the second half of the bone stroke, the teardrop (Fig. 18). Start this stroke holding the brush handle vertically with the tip barely touching the paper. Then press down quickly in a curving movement in the direction of the lower right-hand corner of the paper. Pause here and rotate the base of the brush hairs in a clockwise motion until it has formed a rounded foundation, as this should be a short, plump stroke. Sometimes the use of a shorter, fuller brush will help you perfect it. Try brush No. 7. Practice first by tracing over each outline in Fig. 19 in one stroke. Practice the larger one first, and then try the smaller, changing brush if necessary. Remember to press down quickly. The arrows again indicate the direction the brush should follow. After you have practiced tracing, try it freehand on newsprint.

Fig. 20 illustrates some of the mistakes commonly made in painting the teardrop. In *(a)* the stroke is too elongated because the brush handle was not kept vertical. The "quotation mark" in *(b)* was caused by not pressing down quickly enough. The stroke in *(c)* was started from the right instead of the left, resulting in an "S" curve.

Form the teardrop fifty times or more. Then check the following:

Is your grip on the brush correct?

Are you keeping the handle vertical?

Are the hairs aligned properly?

Are you keeping the base of the brush down while rotating?

Are you using the right size brush?

Did you read the instructions again?

With this stroke, say to yourself, "Down! Pause . . . rotate, lift." Remember the direction of the stroke curves from upper left to lower right.

It may help you to remember a few other points. Do not work on a pile of newsprint or other paper; your arm should be moving freely over a perfectly flat surface. You should not paint on both sides of a piece of paper. The ink brushed onto the first side will cause the paper to ripple, and trying to make good strokes on rippled paper is next to impossible.

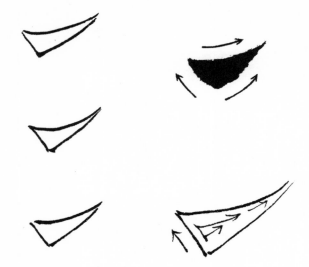

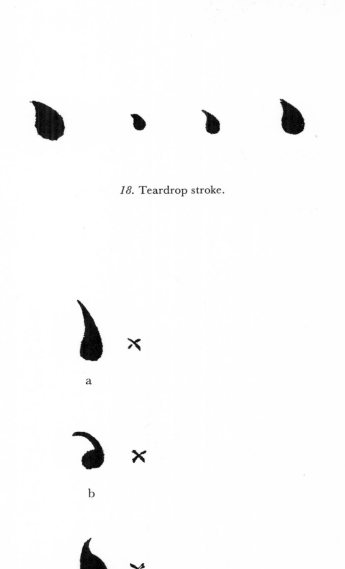

18. Teardrop stroke.

17. Outlines and path of the brush for the hook stroke.

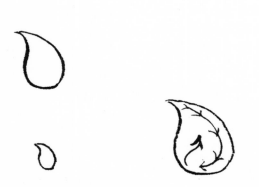

a

b

c

19. Outlines and path of the brush for the teardrop stroke.

20. Common mistakes made in painting the teardrop stroke.

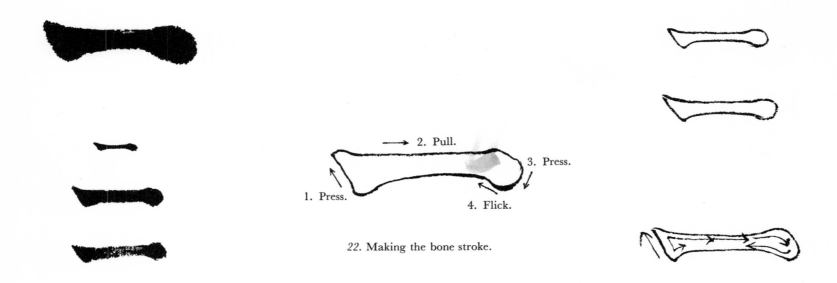

21. Bone stroke: large, small,
medium, and with dry brush.

22. Making the bone stroke.

1. Press. 2. Pull. 3. Press. 4. Flick.

23. Outlines and path of the brush
for the bone stroke.

Practice the teardrop until you feel it is coming easily and the shape is like the example. Then it will be time to put the hook and teardrop strokes back together again to make the bone stroke (Fig. 21). Use brush No. 1 or No. 2. Start with the hook and end with the teardrop, but with this very important difference: the stroke is continuous and is lengthened until it is almost a straight line with points of pressure at each end. Press the brush on the paper with the tip pointed toward the upper left. Lift *gradually* as the brush is pulled to the right, and then gradually press down and pause at the end of the stroke. Stop, press, then flick the tip back to the left *into* the stroke you have just made. The tip of your brush should now be back where you began, pointing to the upper left. Try repeating to yourself the four-beat rhythm: "Press, pull, press, flick." One, two, three, four. "Press, pull, press, flick" (Fig. 22).

Trace over the outline of this stroke following the arrows (Fig. 23), as you did for the previous two, and then try it freehand on newsprint. Some of the common mistakes made

in the bone stroke are shown in Fig. 24. In *(a)* and *(b),* the student was still painting hook strokes and teardrop strokes instead of thinking of the bone stroke as an entirely different stroke. There is too much of an "S" curve in *(c).* Stroke *(d)* was done with too much pressure and too much lift, and then it was pulled down too far on the right. Don't pull down, but just press. Stroke *(e)* is better because it is straighter, but the horizontal stroke should be suspended midway between the two pressure points rather than above them.

Again, check for these possible mistakes if your stroke is not like the example:

Are you holding the brush correctly?

Are the hairs aligned?

Is the handle properly slanted, as for the start of the hook stroke?

Are you lifting and pressing down gradually?

Are you pressing enough at the beginning and end of the stroke?

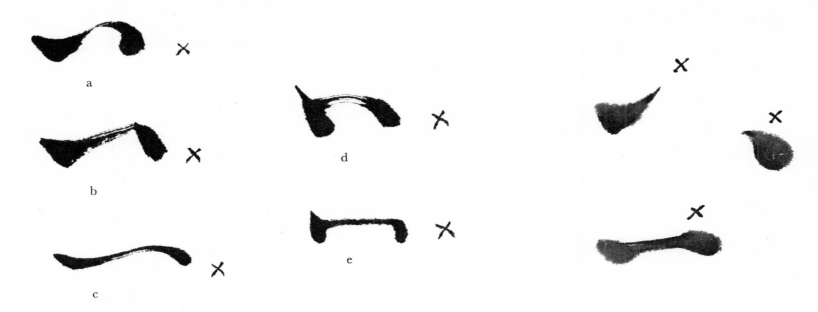

24. Common mistakes made in painting the bone stroke.

25. Stroke which has been gone over.

Did you re-read the instructions and look over the illustrations again?

These three basic strokes may seem very difficult at first, and you may become quite discouraged. Beginners often produce bone strokes that resemble auto horns, "S" curves, or the letter "H." Do not be surprised if you do the same. Remember that practice will eventually bring these strokes under control, and after you have cleared this first hurdle, the rest will seem easy and much more interesting. You must be able to do these strokes fairly well before going on to the next lesson, just as you had to practice penmanship of individual letters before learning to write words.

Never, never "fill in" with little daubs to perfect the shape of any stroke. Sometimes the cause of a poor stroke may be a faulty brush with splitting hairs, so look at your orush, and if this is the culprit, simply change it with another brush.

Neither should brush strokes ever be retraced. It is always obvious, especially in this medium, when a stroke has been gone over in an effort to improve it (Fig. 25). Better to leave a stroke as it is, even when you are not satisfied with it. After a stroke is once mastered, it should be practiced more rapidly. An apparently casual or careless effect, as achieved by many of China's greatest artists, is the goal to strive for, but remember this can only be yours after the essentials are grasped and the strokes perfected. Borrow a little philosophic patience from the Chinese and you will be rewarded with success. No matter how far you progress, however, you will find it a help from time to time to go back and review the instructions for these basic strokes.

When starting any practice session, it is helpful to have a warm-up period first. This chapter concentrates on the three basic strokes, but even when you have started on the succeeding lessons, warm up by tracing characters for fifteen or thirty minutes before starting with a brand new lesson.

Lesson 2 : Characters

Speech and writing are two organs of the same human impulse
—the conveyance of thought: the one operating through hear-
ing, the other through sight; the one by sound from mouth to
ear, the other by form or image from hand to eye. But each can
do something besides convey thought. Spoken words can be
arranged to discharge aesthetic "musical" significances, as in
much Western poetry. Written words can be formed to liberate
visual beauties; and this is possible with Chinese characters in
a greater degree, it is safe to say, than with the script of any
other language, because *art,* not science or religion, was the
prime end of those responsible for their development. A good
Chinese character *is* an artistic thought.

—CHIANG YEE, *Chinese Calligraphy*

The Chinese student of painting must learn calligraphy,
or the writing of characters, before he learns to paint.
The brush strokes used in calligraphy are the basis of all
painting strokes, and to the Chinese, calligraphy is the
higher form of these two arts. A beautiful example of writ-
ing is enjoyed for its composition, spirit, and masterful
brushwork, just as a painting is admired for the same quali-
ties. The two arts are so closely allied that the most fitting
description of them was expressed by a Chinese: "Writing
is mind-painting."

Just as the Chinese art student learns by copying, so he
learns to write by the same method. My students spend
the first half hour of each lesson writing characters. This
not only improves the basic brush-stroke technique but
also helps to limber up the hand and fingers for the painting
which follows. Your hand may be shaky at first, and prac-
ticing characters will help to steady it.

There is no alphabet in the Chinese language. Each
word is written as a separate character. Originally, thou-
sands of years ago, each character was a small picture, but
these have gradually changed in shape and form until
today they are known as ideograms or pictographs. Fig.
26 illustrates a few examples of the changes from early
pictographs (left) to present-day characters (right). "Sun"
and "tree" are combined to make the word "east," with
the sun shown coming up behind a tree.

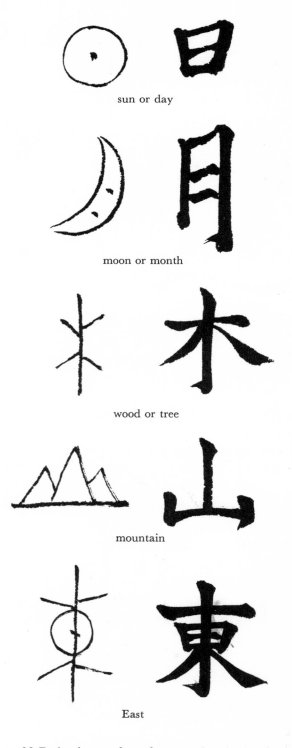

sun or day

moon or month

wood or tree

mountain

East

26. Early pictographs and present-day characters.

The characters written on the following pages include all the brush strokes you will need to master. By tracing these and any other good examples you may find, you will improve your own technique. Lay a piece of tracing paper over the pages of characters and trace them slowly and carefully. Press down on the brush where the stroke is thick and lift where it is thin. The numbers indicate the sequence of the strokes, and the arrow, the direction to follow. Use brush No. 1 or No. 2.

There are thousands of characters in the language. For the simplest, most basic usage, the mastery of about 1,000 characters is necessary; to read a newspaper one must know at least 2,000; there are 6,000 or so used by Chinese typesetters. A look at lists of dictionaries indicates the vast range of characters which were in use at a given time. In 1716, the Emperor K'ang Hsi's dictionary with supplement lists 49,030 characters! In 1915, the Commerical Press listed 12,000 characters, and in 1949, it listed 9,883. A dedicated scholar might recognize 15,000 or more.

The student must memorize each character, but he is often given a clue to its meaning by the use of radicals or clue words; for instance the character for the word "table" contains the radical "wood." The characters included in this book are fairly simple ones which are in everyday use, and there are also some phrases which you may find useful. When you reach a point in your lessons where you feel capable of painting bamboo or pine trees on a greeting card, it will add to your enjoyment if you know how to write the characters which say "Happy Birthday" or perhaps "Bon Voyage."

The Chinese begin writing at the top of a page on the right-hand side and proceed vertically in a straight line to the bottom. The next line begins at the top, just left of the first, and so on. Their books open from the side we consider the back, but from their viewpoint (and you should remember they have a few thousand years' head start on us!) we are the ones who seem to be in reverse. Interestingly, in 1956, in spite of their apparent disdain for anything of Western origin, the Communist government in China adopted the left to right, horizontal method of writing.

Over many centuries, although the written words remained much the same, because of lack of communication or transportation the way in which they were pronounced differed widely from province to province. Thus many dialects are spoken in China, although Mandarin is recognized as the official language and most well-educated Chinese and all those in diplomatic service speak Mandarin as well as their own native dialect.

There are four tones in the Mandarin dialect, and using the wrong intonation for a word can give it an entirely different meaning! The first tone is a level one; the second tone has a rising inflection; the third tone dips and then rises again; and the fourth tone drops abruptly downward, as in the following, using the word "ma":

Ma^1 (level) means "mother"
Ma^2 (rising) means "hemp"
Ma^3 (falling and rising) means "horse"
Ma^4 (falling) means "to scold"

There are other meanings for these tones used with this word, but I have selected only one example for each. The numeral for the tone will appear beside each character in Fig. 27, along with the phonetic pronunciation of the Chinese word itself and the English translation.

When you have learned to paint well enough to sign your work, you will probably want to sign your name in Chinese characters. Names with European origins can be transposed into their Chinese counterparts by using the sound of the name, or sometimes its actual meaning, as in the case of White, Black, etc. In China the surname is used first, followed by the given names.

The *san chüeh*, Three Absolutes, or Three Impossibles, are known as: 1) calligraphy, 2) poetry, which is often written on paintings as well as alone, and 3) painting. It was a very rare thing indeed for any artist to achieve renown in all three arts, so content yourself at first with writing only your name on your paintings. Practice this until it is truly perfect, as it is possible to ruin an otherwise fine painting by signing it with badly written characters.

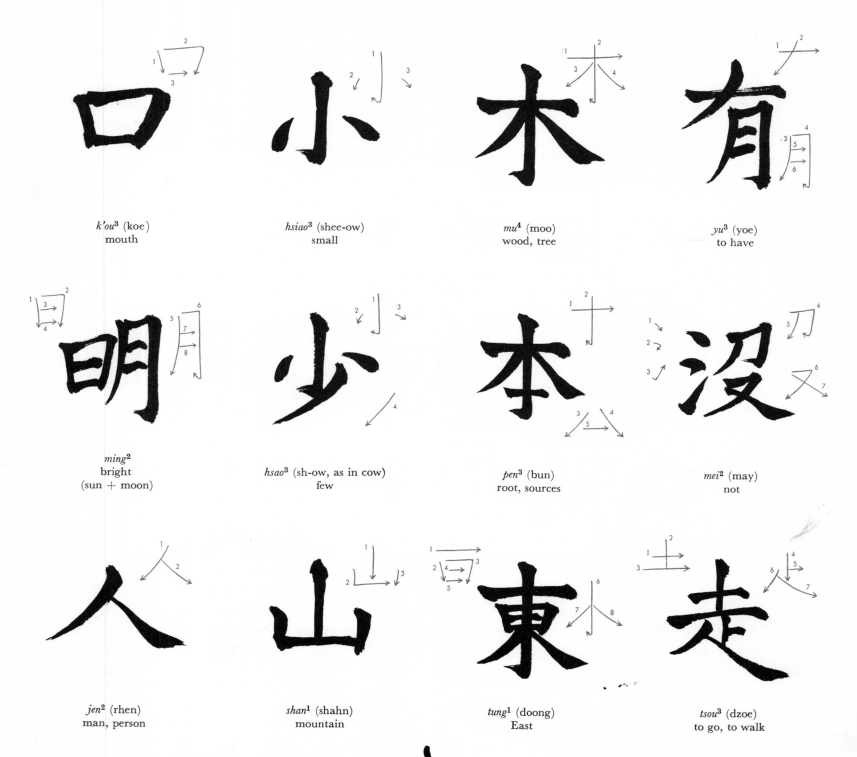

k'ou[3] (koe)
mouth

hsiao[3] (shee-ow)
small

mu[4] (moo)
wood, tree

yu[3] (yoe)
to have

ming[2]
bright
(sun + moon)

hsao[3] (sh-ow, as in cow)
few

pen[3] (bun)
root, sources

mei[2] (may)
not

jen[2] (rhen)
man, person

shan[1] (shahn)
mountain

tung[1] (doong)
East

tsou[3] (dzoe)
to go, to walk

27. Some Chinese characters, their stroke orders, meaning, and pronunciation aids.

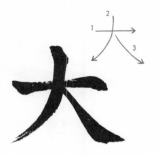 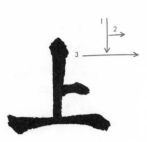 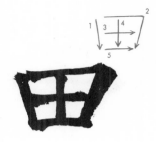 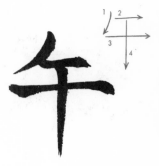

大　　　　　上　　　　　田　　　　　午

*ta*⁴ (dah)
big, large

*shang*⁴ (shahng)
above

*t'ien*¹ (tee-ehn)
field, land

*wu*³ (woo)
noon

天　　　　　下　　　　　力　　　　　問

*t'ien*¹ (tee-ehn)
heaven, day

*hsia*⁴ (shee-ah)
below

*li*⁴ (lee)
strength, force

*wen*³ (one)
to ask

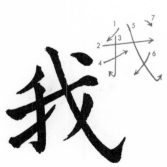 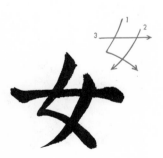 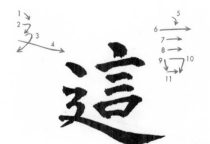 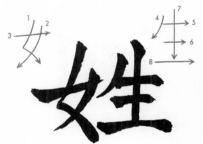

我　　　　　女　　　　　這　　　　　姓

*wo*³ (woh)
I, me

*nü*³ (as in French *u*)
female, woman

*che*⁴ (juh)
this

*hsing*⁴ (shing)
surname

你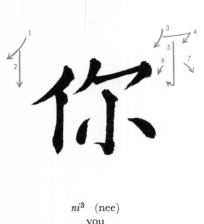

子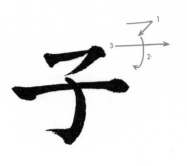

是

貴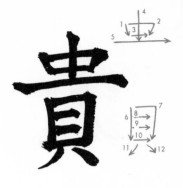

*ni*³ (nee)
you

*tze*³ (dzuh)
child

*shih*⁴ (sherh)
is, are

*kuei*⁴ (gway)
honorable

他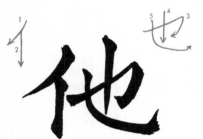

好

那

敝

*t'a*¹ (tah)
he, she, it

*hao*³ (how)
good, well
(woman + child)

*na*⁴ (nah)
that

*pi*⁴ (bee)
humble

門

男

請

太

*men*² (mun)
door, gate

*nan*² (nahn)
male, man
(field + strength)

*ch'ing*³
please

*t'ai*⁴ (tie)
too, very

 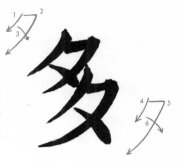

*men*² (mun)
plural form for pronouns

*hai*² (hie)
child, youth

*hsieh*⁴ (shee-eh)
to thank

*to*¹ (daw)
many, much

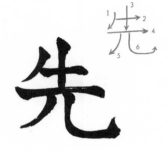 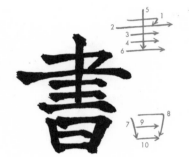 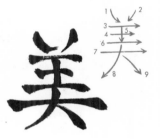

*hsien*¹ (shee-ehn)
first, before

*shu*⁴ (shoo)
book

*mei*³ (may)
beautiful, excellent

*tso*⁴ (dzaw)
to sit

*sheng*¹ (shung)
birth, to produce

*hua*⁴ (hwah)
picture, to draw

*chung*¹ (joong)
central, middle

*ch'e*¹ (chuh)
a cart

 學

hsüeh[2](shew-eh)
to study, to learn

 筆

pi[3] (bee)
brush, pencil

 國

kuo[2] (gwaw)
country, nation

 水

shui[3] (shway)
water

 文

wen[2] (one)
literary, elegant

 會

hui[4] (hway)
to be able

 羊

yang[2] (yahng)
sheep, goat

 火

huo[3] (hwaw)
fire

 士

shih[4] (sherh)
scholar, gentleman

 看

k'an[4] (kahn)
to see

 洋

yang[2] (yahng)
foreign

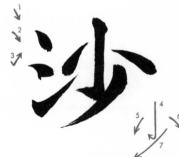 沙

sha[1] (shah)
sand

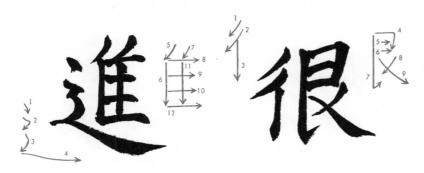 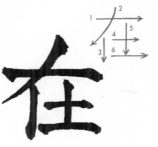 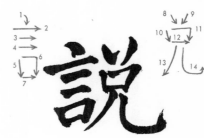

*chin*⁴ (jin) to enter	*hen*³ (hun) very	*tsai*⁴ (dzye) at, in	*shuo*¹ (shaw) to speak, to talk

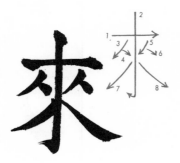 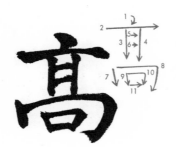 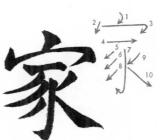 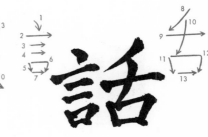

*lai*² (lie) to come	*kao*¹ (gow) tall, eminent	*chia*¹ (gee-ah) family, home (roof over pig)	*hua*⁴ (hwah) speech, language

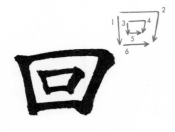 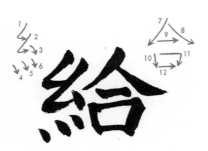 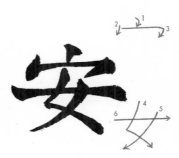 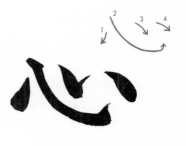

*hui*² (hway) to return	*kei*³ (gay) to give	*an*¹ (ahn) peace, quiet (roof over one woman)	*hsin*¹ (shin) heart

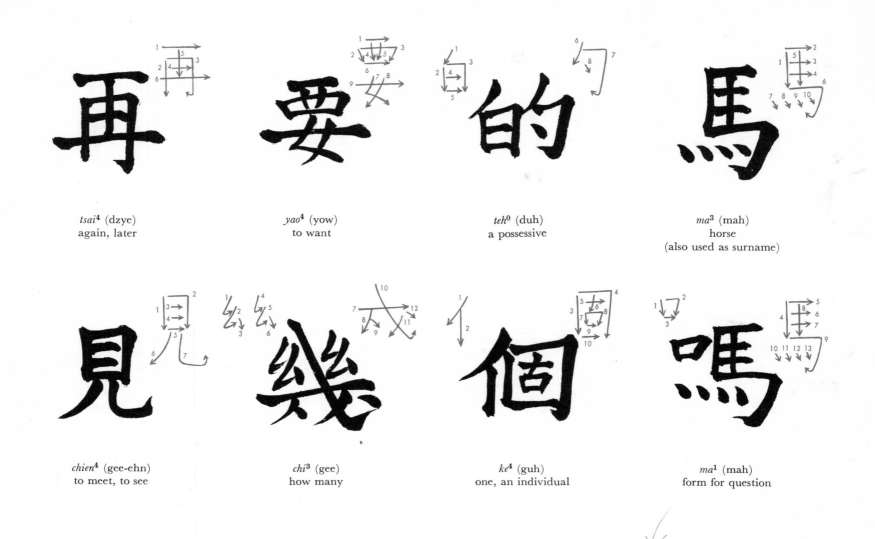

*tsai*⁴ (dzye)
again, later

*yao*⁴ (yow)
to want

*teh*⁰ (duh)
a possessive

*ma*³ (mah)
horse
(also used as surname)

*chien*⁴ (gee-ehn)
to meet, to see

*chi*³ (gee)
how many

*ke*⁴ (guh)
one, an individual

*ma*¹ (mah)
form for question

The writing of characters may vary just as our hand-writing differs, and the use of brush and ink lends itself to many variations, strong or subtle. A student must first learn how to write each word in the *k'ai shu* or "regular" style, which might be likened to our way of printing. Later he may try the *hsing shu* or "running" style, *ts'ao shu* or "grass" style, and eventually develop his skill to such a degree that he forms a recognizable style of his own. The Chinese characters and names, with translations, for the various strokes used in writing are shown in Fig. 28.

For the written language there is a definite order in which to make the strokes in each character; follow a general rule of starting at the upper left and finishing at the lower right.

Characters may be simple or complicated; the more complex ones can be broken down into two or more components (Fig. 29). Principles governing the order in which the components should be written are: *(a)* top components before lower ones; *(b)* left components before right ones. The order of writing within each component is: *(c)* top strokes before lower ones; *(d)* left strokes before right ones; *(e)* horizontal stroke before others crossing it; *(f)* central vertical stroke before other noticeable symmetrical strokes; *(g)* slanting stroke to left before one to right.

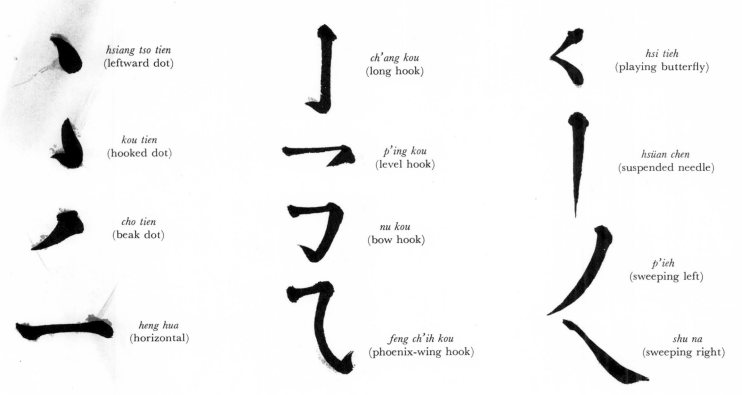

hsiang tso tien
(leftward dot)

ch'ang kou
(long hook)

hsi tieh
(playing butterfly)

kou tien
(hooked dot)

p'ing kou
(level hook)

hsüan chen
(suspended needle)

cho tien
(beak dot)

nu kou
(bow hook)

p'ieh
(sweeping left)

heng hua
(horizontal)

feng ch'ih kou
(phoenix-wing hook)

shu na
(sweeping right)

28. Strokes used in writing.

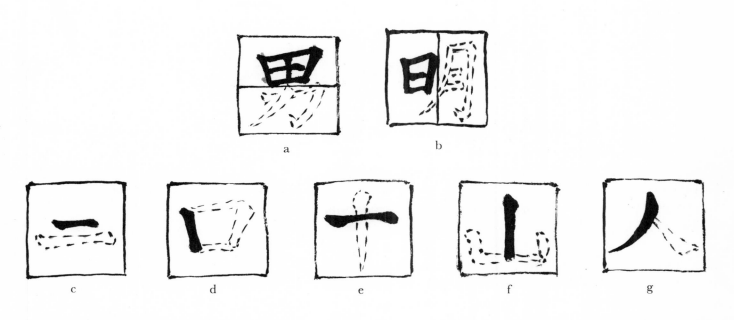

a b

c d e f g

29. Order of writing various components.

The necessary characters for writing the date are given in Fig. 30. If you were to date your painting August 5, 1967, for instance, it would look like the left-hand column of the figure.

In Fig. 31 are some simple sentences constructed from the characters illustrated in Fig. 27. You may trace these too, starting at the right side and working down in Chinese fashion. In Fig. 32 are six congratulatory and holiday phrases to use on greeting cards. The large characters are for practice work, but their smaller counterparts are apt to fit better on a card, so use this size when you feel qualified.

一 one

千 thousand

九 nine

百 hundred

六 six

十 ten (sixty)

七 seven(th)

年 year

、 comma

八 eight(h)

月 month

、 comma

五 five (fifth)

日 day

period

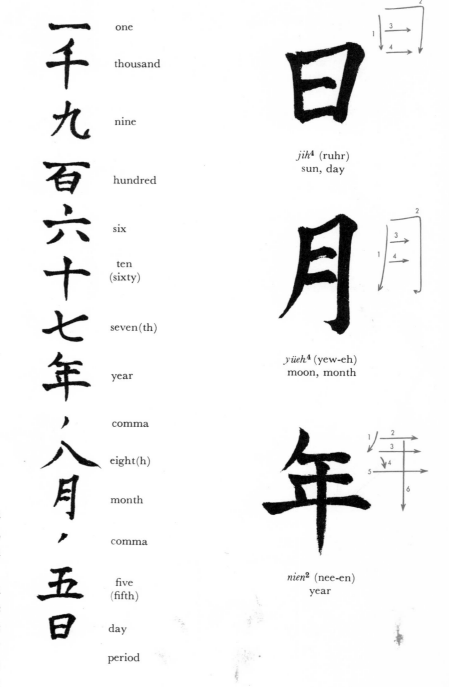

jih[4] (ruhr)
sun, day

yüeh[4] (yew-eh)
moon, month

nien[2] (nee-en)
year

30. Characters for writing dates.

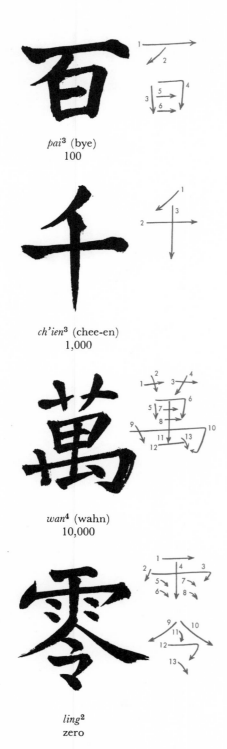

*pai*³ (bye)
100

*ch'ien*³ (chee-en)
1,000

*wan*⁴ (wahn)
10,000

*ling*² zero

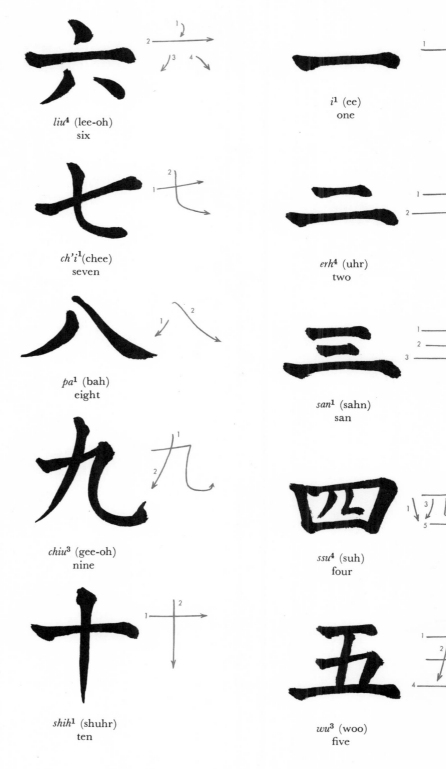

*liu*⁴ (lee-oh)
six

*ch'i*¹(chee)
seven

*pa*¹ (bah)
eight

*chiu*³ (gee-oh)
nine

*shih*¹ (shuhr)
ten

*i*¹ (ee)
one

*erh*⁴ (uhr)
two

*san*¹ (sahn)
san

*ssu*⁴ (suh)
four

*wu*³ (woo)
five

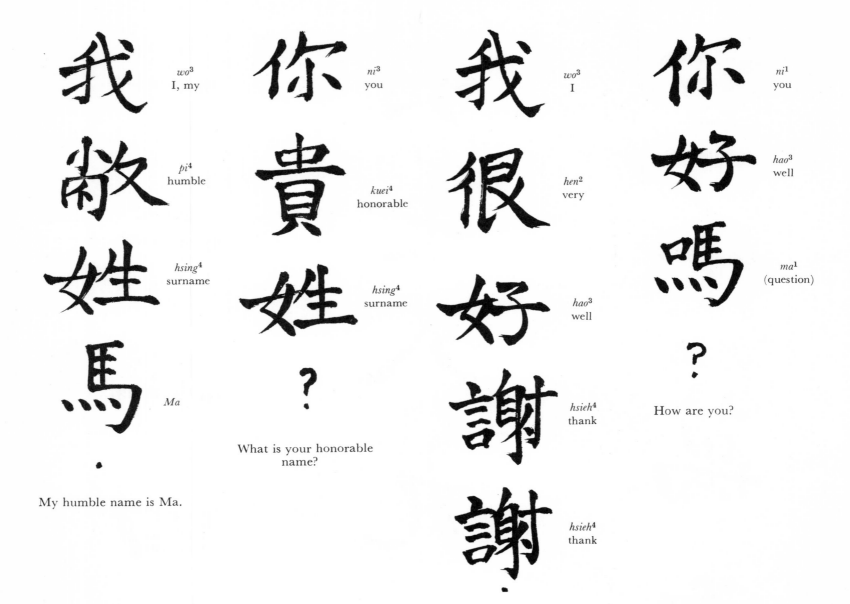

我 *wo³* I, my
敬 *pi⁴* humble
姓 *hsing⁴* surname
馬 *Ma*
。

My humble name is Ma.

你 *ni³* you
貴 *kuei⁴* honorable
姓 *hsing⁴* surname
？

What is your honorable name?

我 *wo³* I
很 *hen²* very
好 *hao³* well
謝 *hsieh⁴* thank
謝 *hsieh⁴* thank
。

I'm very well, thanks.

你 *ni¹* you
好 *hao³* well
嗎 *ma¹* (question)
？

How are you?

31. Some simple sentences in Chinese.

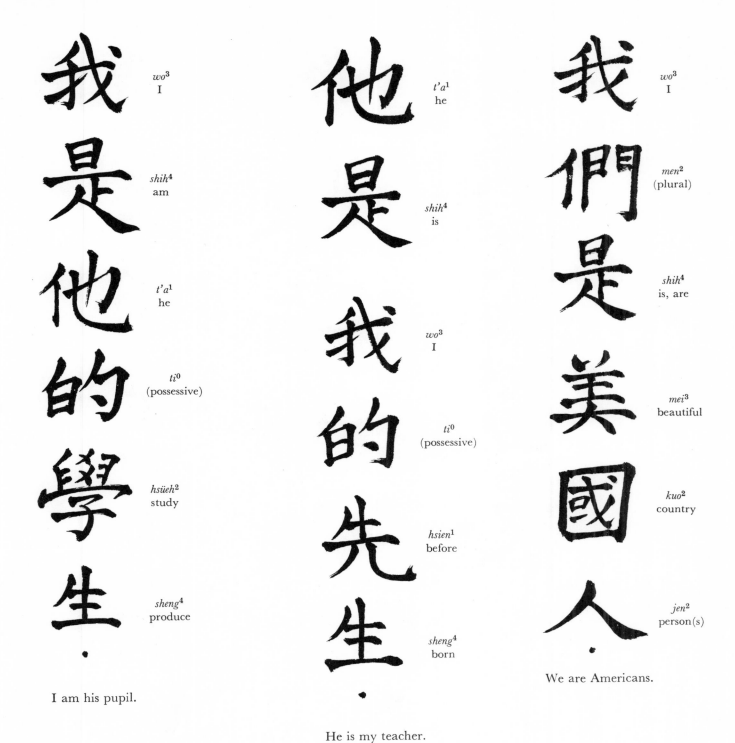

我 *wo³* I
是 *shih⁴* am
他 *t'a¹* he
的 *ti⁰* (possessive)
學 *hsüeh²* study
生 *sheng⁴* produce

I am his pupil.

他 *t'a¹* he
是 *shih⁴* is
我 *wo³* I
的 *ti⁰* (possessive)
先 *hsien¹* before
生 *sheng⁴* born

He is my teacher.

我 *wo³* I
們 *men²* (plural)
是 *shih⁴* is, are
美 *mei³* beautiful
國 *kuo²* country
人 *jen²* person(s)

We are Americans.

請 *ch'ing*[3] please
進 *chin*[4] enter
來 *lai*[2] come
馬 *ma*[3] Ma
太 *t'ai*[4] very
太 *t'ai*[4] very

請進來，馬太太。

Please come in, Mrs. Ma.

你 *ni*[3] you
們 *men*[2] (plural)
坐 *tso*[4] sit
一 *i*[1] one
坐 *tso*[4] sit

你們坐一坐。

Won't all of you sit down for awhile?

明 *ming*[2] bright
天 *t'ien*[1] day
我 *wo*[3] I
們 *men*[2] (plural)
回 *hui*[2] return
來 *lai*[2] come

明天我們回來。

Tomorrow we will return.

再 *tsai*[4] again
見 *chien*[4] meet

再見。

Goodbye.

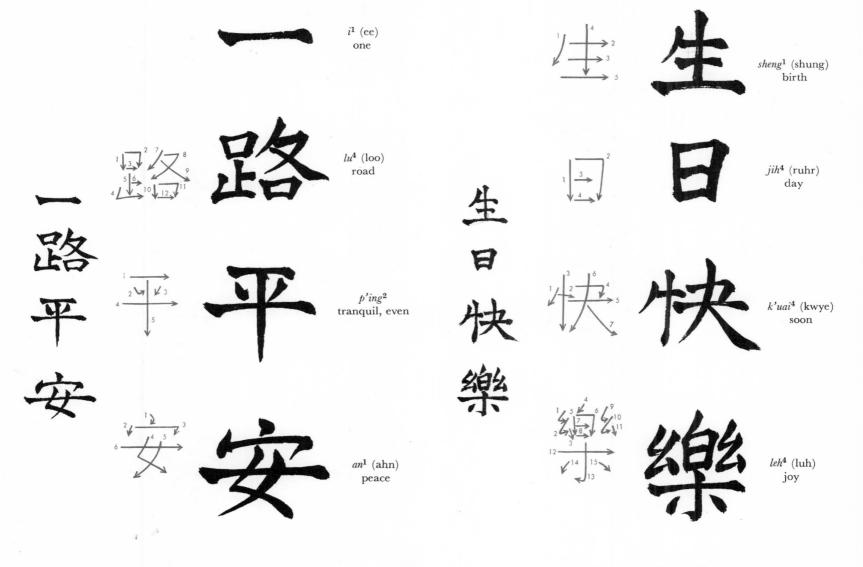

i[1] (ee)
one

lu[4] (loo)
road

p'ing[2]
tranquil, even

an[1] (ahn)
peace

sheng[1] (shung)
birth

jih[4] (ruhr)
day

k'uai[4] (kwye)
soon

leh[4] (luh)
joy

BON VOYAGE

HAPPY BIRTHDAY

32. Congratulatory and holiday phrases in Chinese.

恭喜

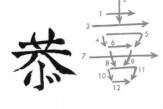
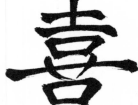

恭
喜

kung[1] (goong)
respectful

hsi[3] (shee)
happiness

<small>CONGRATULATIONS</small>

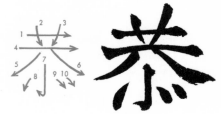

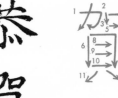
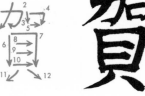

恭
賀
聖
誕

kung[1] (goong)
respectful

ho[2] (huh)
to congratulate

sheng[1] (shung)
sacred, holy

tan[4] (dahn)
birthday

<small>MERRY CHRISTMAS</small>

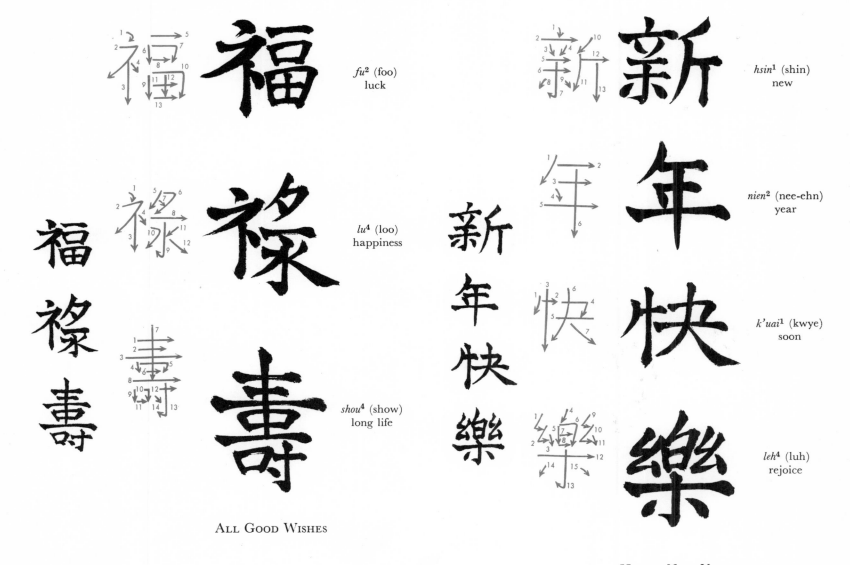

fu[2] (foo)
luck

lu[4] (loo)
happiness

shou[4] (show)
long life

ALL GOOD WISHES

hsin[1] (shin)
new

nien[2] (nee-ehn)
year

k'uai[1] (kwye)
soon

leh[4] (luh)
rejoice

HAPPY NEW YEAR

4

The Three Friends

THE BAMBOO, the pine, and the plum have long been known as the "Three Friends" to the Chinese, because of their faculty of remaining green even in the coldest weather. In this section we shall take each of the friends separately, explore the mysteries of the way they are painted, and in the end put them back together in one composition.

Lesson 1 : Bamboo, *Mo Ku* Style

Bamboos . . . were . . . interpreted in a symbolic sense; their energetic growth, their power to remain fresh and green even in the cold season, their habit of yielding and bending before the storm without ever breaking, represented to the Chinese qualities which were traditionally associated with the character of the gentleman-scholar. Su Shih . . . painted these elegant and noble plants with a definite emphasis on their symbolic meaning; he saw in the different kinds of bamboos reflections of various conditions of human life and character; he loved them just as much as the poor painter in whose mouth he puts the words, "I could live without meat, but not without bamboos."

—OSVALD SIRÉN, *The Chinese on the Art of Painting*

The stroke used in painting each section of a bamboo stalk is simply a variation of the bone stroke. Try a large straight section first. Grind quite a lot of ink, dip the brush into it, and transfer some of the ink to a small saucer. Then add water until the mixture is dark gray. Use plenty of water and ink, as this time you will be soaking it up in a large brush and it will disappear quickly. Use brush No. 6.

As in the horizontal bone stroke, the direction of the stroke is at right angles to the line of the brush hairs. The only real difference is that the stroke for a stalk section is a vertical one. In making this stroke, hold your arm up off the table, with elbow out, and grasp the brush approximately halfway up the handle. Hold the top of the paper steady with your left hand. Dip the brush fully into the mixture of ink and water, so that it is dripping wet. Lay the side of the brush down on the paper with the tip pointing directly to your left, straight across the paper and parallel to the top edge (Fig. 33). Now lift the handle of the brush until it is vertical, keeping downward pressure on the brush hairs at the place indicated by the top arrow in Fig. 34. Then pull the brush over the paper toward you (in the direction of the second arrow) for about three or four inches. Stop at this point and press down even harder on your brush. Twist the handle in a counter-

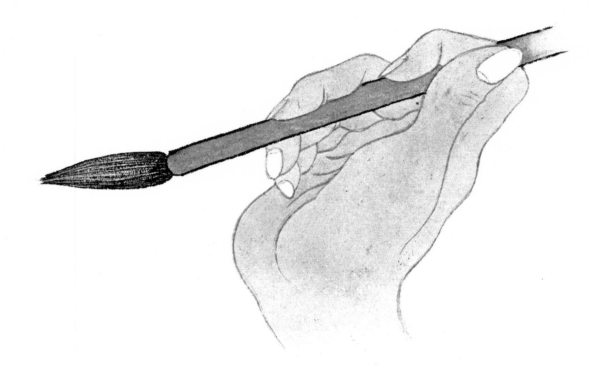

33. Starting position for painting a section of bamboo stalk.

clockwise direction, so the brush hairs move slightly toward the bottom of the paper, and then twist back to the original position, as indicated by *(a)* and *(b),* keeping downward pressure steady all the while. Now lift the brush straight up off the paper. You should have a stroke approximately like that in Fig. 34.

Be sure to keep the paper straight in front of you and far enough away so you are not working too near the edge of the table. Get comfortable! Now try it again, starting the next stroke at a point where it almost touches the end of the first one. You will see that a series of these strokes, painted one after the other, produces a bamboo stalk. At first it may be easier to paint shorter sections until the brush is broken in and you have learned how to load your brush with the ink mixture. (Not enough ink

results in too bare an effect, and too much will produce large dark spots on the paper.)

Place your paper so you have the *length* of it on which to paint the rows of stalks. Say the rhythm of the stroke to yourself: "Press, stand up (on the handle), drag, press, lift." Try doing a page or two of these sections in rows, alternating the height of each joint, so that when accent strokes are placed across the joints they will not crowd each other.

Fig. 35 shows some of the mistakes which students are apt to make in painting sections of bamboo stalk. In *(a)* the brush was not loaded with enough ink. The mushroom look in *(b)* was caused by lifting the brush before pulling it down; *(c)* has too much twist, while *(d)* does not have enough.

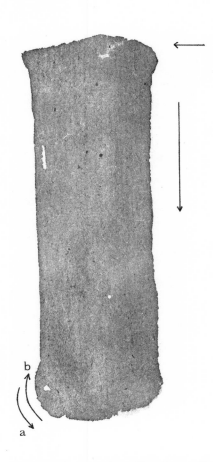

34. Stroke for a section of bamboo stalk.

35. Common mistakes made in painting the bamboo-section stroke.

36. Shading technique. *37.* Dry-brush technique.

Do your stalk sections look as they should? If not, check for the following possibilities:

Do you have the proper grip on the brush?

Are you holding the paper steady with your left hand?

Are you lifting the brush handle until it is vertical?

Is your arm up and *off* the table?

Are you keeping steady pressure on the brush hairs?

Are you dipping into the ink mixture after each stroke to reload your brush?

Did you read the directions over again?

If you do not have a good flat base on each stalk section, press down harder at the end of the stroke. Sometimes this conscious pressure is sufficient without any twisting of the brush, and sometimes it is necessary to twist the brush only slightly. Experiment a little along these lines, remembering that the stroke should always end with the brush tip still pointing to the left. After the stroke is perfected, increase your speed. If this stroke is formed too slowly, it results in dark splotches on the paper, and you may run out of ink before reaching the end.

After you have become fairly proficient, try another method of painting stalks. After dipping into the gray ink mixture, touch just the tip of the brush to the black ink still on the inkstone. As you make your stroke, this will produce a darker shading on the left side, lending an appearance of roundness (Fig. 36).

Dry-brush technique is very effective and you should attempt this next. Dip the brush into the ink mixture, and then roll it across a piece of newsprint to remove most of the ink before painting each section. Dry-brush strokes do not completely color the paper but leave irregular patches of paper showing through (Fig. 37).

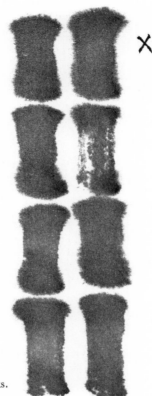

38. Mistakes in painting bamboo stalks.

39. Proper effect at the top and base of a stalk.

All sections of a bamboo stalk are not the same length; they are short near the base, gradually lengthening as they grow up and out, and then becoming gradually shorter again at the tip. This is equally true of the smaller stems. Do not place two or more stalks in a painting exactly parallel to one another, as they then look like railroad tracks and do not conform to nature; and do not place two or more in a group so that their joints are at the same height, as this is uninteresting and leaves no room for accent strokes. Fig. 38 illustrates both of these errors. For the proper effect at the top of the stalk (Fig. 39), press and then brush upward, lifting the brush quickly. At the base of the stalk, press and brush downward, again lifting quickly. Some artists start their strokes at the base of the stalk and work upward, so you may want to try this method.

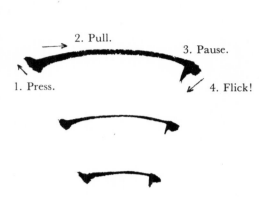

2. Pull.

3. Pause.

1. Press.

4. Flick!

40. Accent strokes for bamboo stalks.

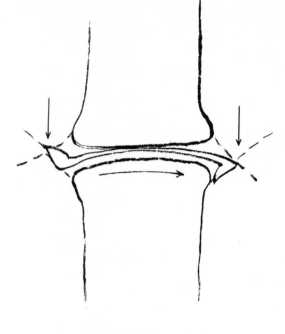

41. Proper width of accent strokes.

Between the sections of bamboo stalks, Chinese artists place a stroke, which I call an accent stroke, to accentuate the joint. It is an exaggerated version of the bone stroke. Use very black ink and brush No. 2. The arm should lie parallel to the stalk and directly over it, swinging like a pendulum from the elbow as the stroke is made. Hold the brush at a slant, as you did when beginning the bone stroke. With the tip of the brush pointing to the upper left, press down on the paper. Lift slightly and bring the stroke over to the right in a rising and falling arc. Press on the brush again and pause. Then, with a quick flicking motion, pull the stroke toward the lower left as you lift the brush off the paper. Repeat the rhythm to yourself as you make the stroke: "Press, pull, press, flick!" (Fig. 40). I had one pupil who murmured, "Sit, over, sit, BOINK!" with marvelous results—so you can see it's not what you say, but how you say it that counts.

Each end of the stroke should extend beyond the side of the bamboo stalk as far as the arrows in Fig. 41, and the points of pressure should be about the same size. Really *press* at these two points. Remember it is an accent, so do not be afraid to accentuate! It should be a sharp, clean-looking stroke, so if your line seems too heavy, try rolling off any excess ink on newsprint first. (This is one rule which cannot be repeated too often—roll that brush.) Two other variations of the accent stroke may be used after you have mastered this one. These variations (Fig. 42) are used when the stalk stroke is started at the base and pulled upward.

In Fig. 43, the accent stroke *(a)* is correct and can be compared to the others in the figure which show some of the more common mistakes made by students. The flick at the end of the stroke in *(b)* is curved in the wrong direction, while the flick in *(c)* runs back into the stalk instead of accenting the side of it. The stroke in *(d)* is too timid and should instead be bold to accent the joint. The stroke in *(e)* just droops down with no flick at all and drags the whole feeling of the painting down with it.

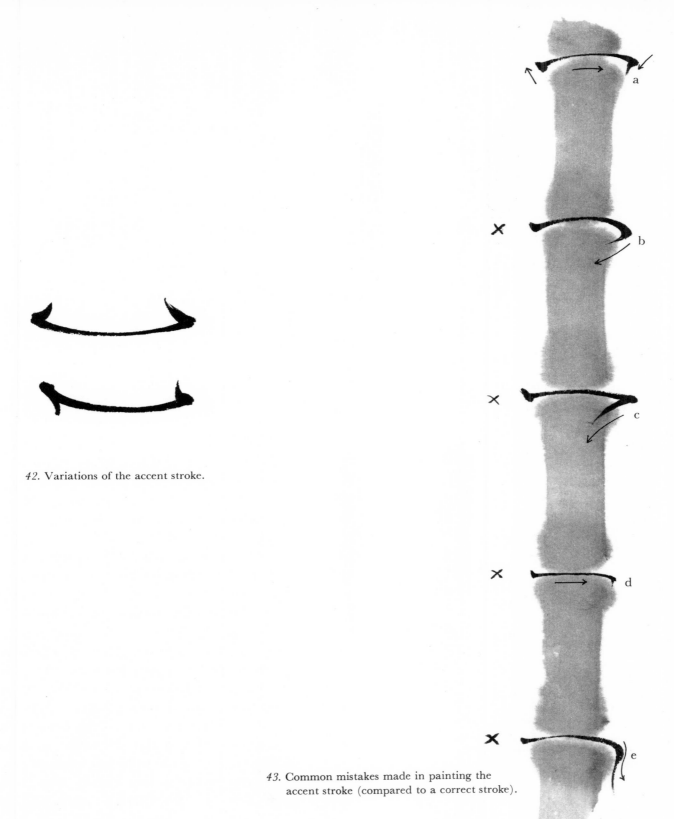

42. Variations of the accent stroke.

43. Common mistakes made in painting the
accent stroke (compared to a correct stroke).

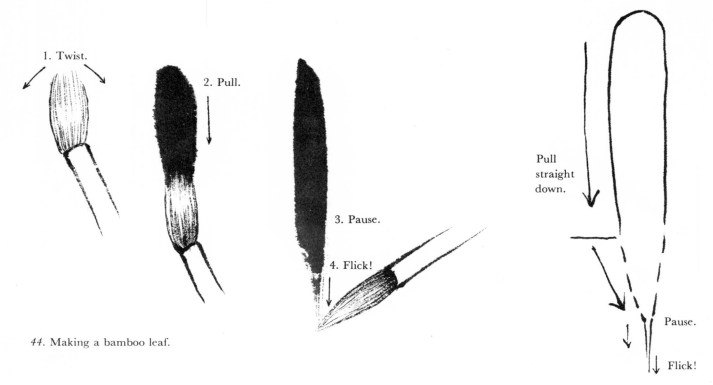

1. Twist.

2. Pull.

3. Pause.

4. Flick!

Pull straight down.

Pause.

Flick!

44. Making a bamboo leaf.

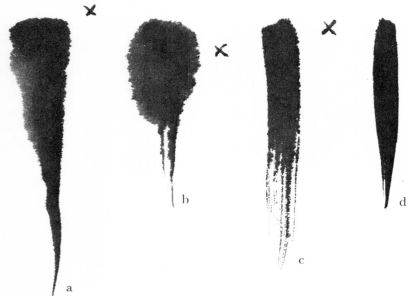

45. Common mistakes made in painting bamboo leaves.

Bamboo leaves and stems are usually painted after the stalks are placed. Mix some more ink and water, making a darker shade this time. Use a long full brush, No. 4, to paint the leaves. Start by practicing the stroke for one leaf.

With the underside of your arm and wrist resting on the table, hold the brush so the handle is slanted and the tip is pointing toward the top of the paper. Lay the entire length of brush hairs down on the paper (Fig. 44). Twist the handle slightly to the left and right to give a blunt end. Now pull straight toward you lifting the brush gradually until only the tip is still touching the paper. Pause and then flick the tip of the brush up off the paper to end with a point. The arm and wrist must rest on the table with the hand and fingers manipulating the brush; do not use your whole arm. Slant the brush far enough out from your hand so that there will be room to bring it back to the vertical position at the end of the stroke.

Fig. 45 shows some of the mistakes commonly made in the painting of bamboo leaves. The stroke in *(a)* is too triangular, and in *(b)* there was too much pressure at the

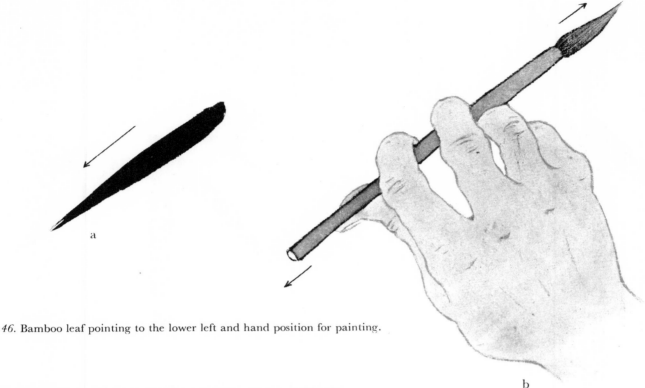

46. Bamboo leaf pointing to the lower left and hand position for painting.

beginning of the stroke and then the brush was lifted too quickly. The brush hairs split too much at the end of the stroke in *(c)*, but a little splitting, as in *(d)*, is acceptable.

To paint a leaf with its tip pointing to the lower left (Fig. 46*a*), the same technique is used but with a slight variation. Instead of stretching your fingers straight out in front of you, roll your hand over to the left so the brush is pointing to the upper right *(b)*. Lay the brush down on the paper and twist it slightly. Now roll your hand and arm back to the right, bringing the brush tip down to the lower left in a sweeping motion. Lean over your hand so you can see. For a leaf pointing to the lower right (Fig. 47), lay the brush down with the tip pointing to the upper left. This time, after laying the brush down and pulling part way along the leaf, pull quickly with the entire arm from the elbow to complete the pointed tip. Each stroke should be straight and knifelike. If it curves or if the head of the leaf is pointed, the leaf may resemble that of a willow or a peach tree (Fig. 48). To avoid this, push into the head of the leaf before pulling down toward the tip.

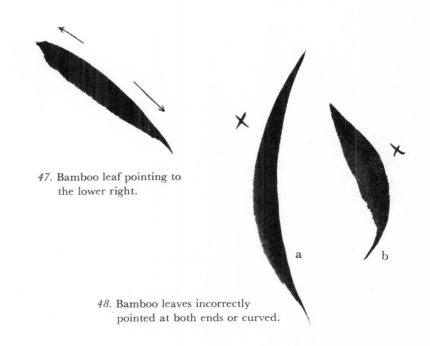

47. Bamboo leaf pointing to the lower right.

48. Bamboo leaves incorrectly pointed at both ends or curved.

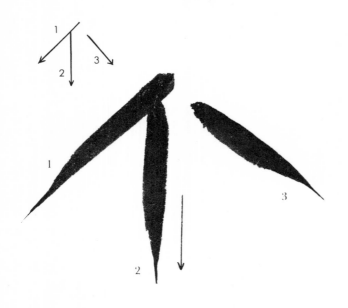

49. Group of three bamboo leaves.

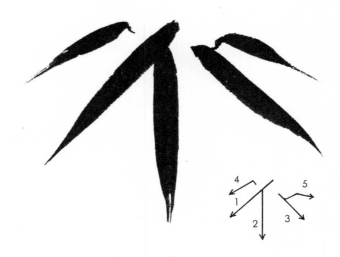

50. Group of five bamboo leaves.

Now practice combining these three leaves in a group (Fig. 49). The first stroke should point to the lower left. The second stroke touches the first and points straight to the bottom of the page—otherwise the composition of the group would be thrown off balance. The third stroke does not touch the others but stands apart and points to the lower right. Now you may put five leaves together in a group (Fig. 50); start with the first example of three and simply add two more. These two should be shorter and slimmer than the others, as they are seen from the side. Follow the illustrations as closely as possible, in the numbered order. Fig. 51 shows other ways of grouping leaves.

Fig. 52 shows some of the mistakes commonly made by students. In *(a)*, all the leaves curve up. Do not combine very large leaves and very small ones in the same grouping, as was done in *(b)*, although it is permissible to have some variation in the width and length of the leaves. In painting clumps of leaves, try for as much variation in their placement as possible; some leaves should touch, others should cross each other, and others should be separate. The grouping should not be like that in *(c)* in which the heads of all the leaves touch, or like that in *(d)* in which all the heads are separate. In *(e)* neighboring leaves have been painted so that they are lying parallel. The leaf in *(f)* is too short and fat, while that in *(g)* is too long and thin. In *(h)*, the leaves are clumped so that they fan out like the petals of a poinsettia. Sometimes the brush hairs will separate at the very end of a stroke (the tip of the leaf) giving a torn effect. This is quite acceptable as long as it happens on only a few leaves in a clump.

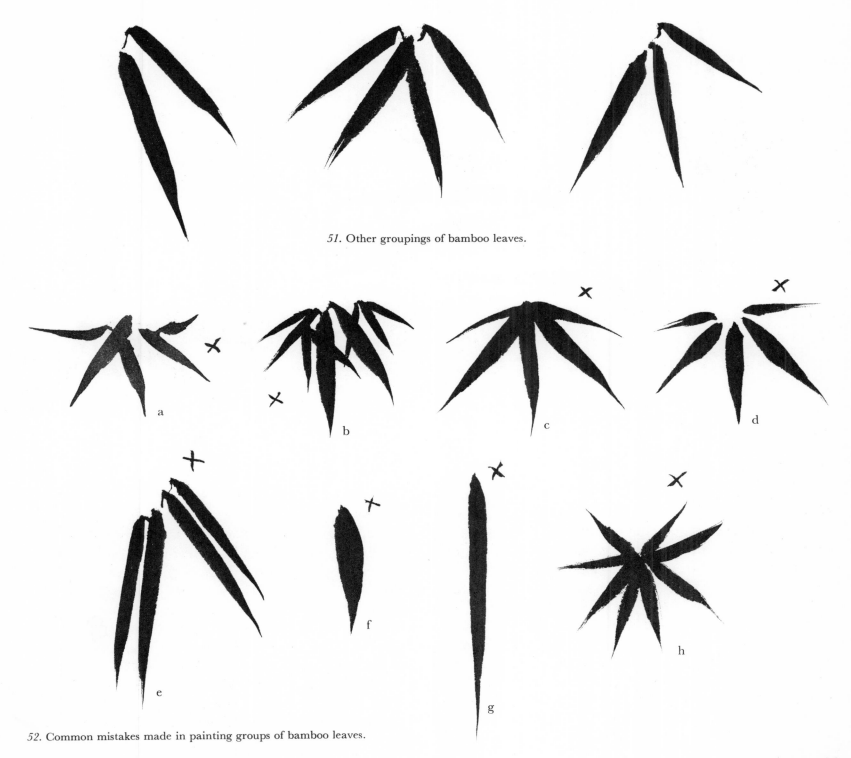

51. Other groupings of bamboo leaves.

52. Common mistakes made in painting groups of bamboo leaves.

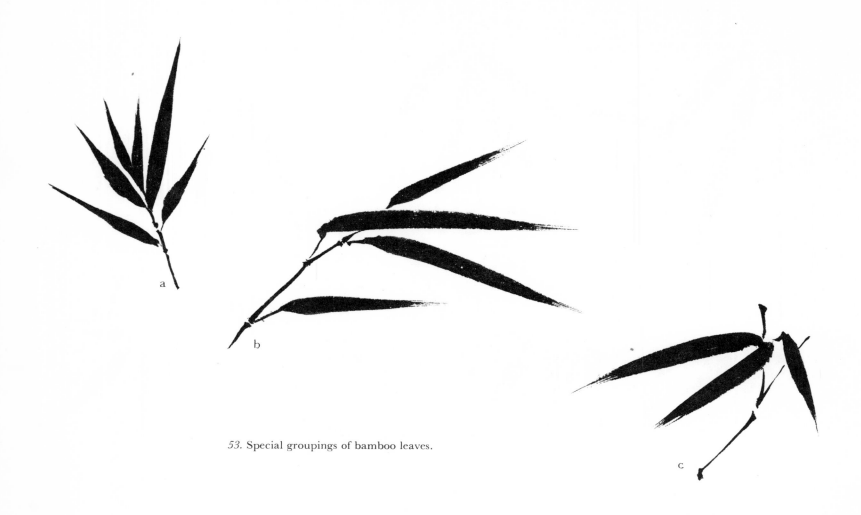

53. Special groupings of bamboo leaves.

New leaves do grow upward, but in Fig. 53 you will note that *all* leaves of the clump sprout up and out as in *(a)*. When painted in the wind, bamboo leaves should all blow in one general direction as in *(b);* in winter they should bend under the weight of the snow; and in rain, they should seem beaten down by the pelting drops as in *(c)*.

The next stroke, when painted in a series, constitutes the smaller bamboo branch or stem. It is an elongated version of the bone stroke, quite long, very straight, and slim (Fig. 54). Use brush No. 2. For stems that branch to the right, paint from the stalk to the tip. For stems that branch to the left, work down to the stalk from the tip. In other words, regardless of the direction of the stem, the stroke moves from left to right (Fig. 55*a*). The beginning of each stroke should almost touch the end of the stroke preceding it, continuing in a slight curve. The curve is achieved by changing the angle of the stroke at each joint rather than by curving the stroke itself, as shown in *(b)*. In fact, be very careful *not* to let the stroke curve or your efforts will appear to be a series of scallops like *(c)*. Young stems or branches are more supple than older ones, but all bamboo has a stiff, brittle quality; if you pulled a stem away from the stalk, it would spring back to it as if held by a rubber band. Stems grow upward from the stalk, and the weight of the leaves bends them outward and down at the tip.

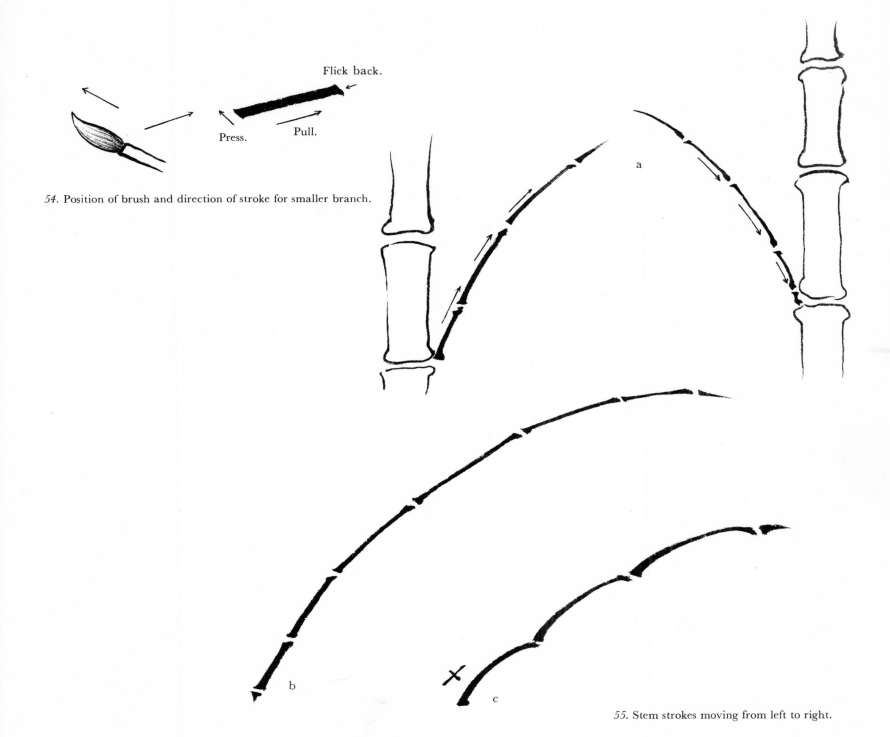

Flick back.

Press. Pull.

54. Position of brush and direction of stroke for smaller branch.

a

b

c

55. Stem strokes moving from left to right.

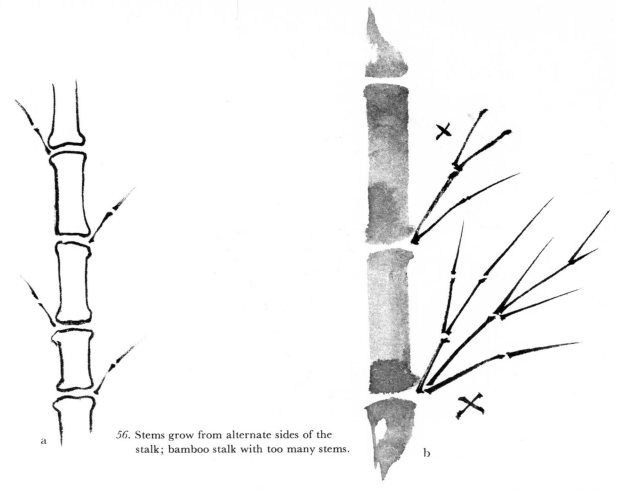

a

56. Stems grow from alternate sides of the
stalk; bamboo stalk with too many stems.

b

If your stroke seems awkward or ungainly, check the position or slant of the brush handle. You should be striving for long, straight strokes. One way to do this is to limit the number of sections (or bone strokes) you paint in each stem. Four or five should be sufficient.

Stems are secondary to the leaves, and they are usually added after the stalks and leaves have been placed. Sometimes they are only indicated, using a few strokes. On a growing bamboo plant, not more than two stems sprout from each joint, alternating up the stalk (Fig. 56a). This does not mean that you *must* paint two stems at each joint, or even one at each joint. The example in *(b)* has too many stems. It is better to understate, painting the stems only where groups of leaves need to be supported.

Now you are ready to put all the separate parts of the puzzle together: stalk, leaves, stems, and accent strokes.

Try the composition in Fig. 57 for your first painting. Place one large stalk A in light gray ink on the left side of the paper. Using darker ink, paint a clump of five leaves B close to the stalk, below the horizontal center of the paper. Now join the leaves to the stalk by painting in the stem C which disappears behind the leaves. Last of all, using very black ink, brush in the accent strokes D across the joints of the stalk. Accent strokes are not used on the small stems. Now you have completed a painting!

Sometimes a student will feel tense and nervous at the thought of starting an actual composition. Therefore you should plan not just one but four, five, or six of the same composition in a row. The psychological effect is very relaxing as you will be free of the feeling that you have only one chance to "make good." It may surprise you to see how spontaneous and confident your work will become.

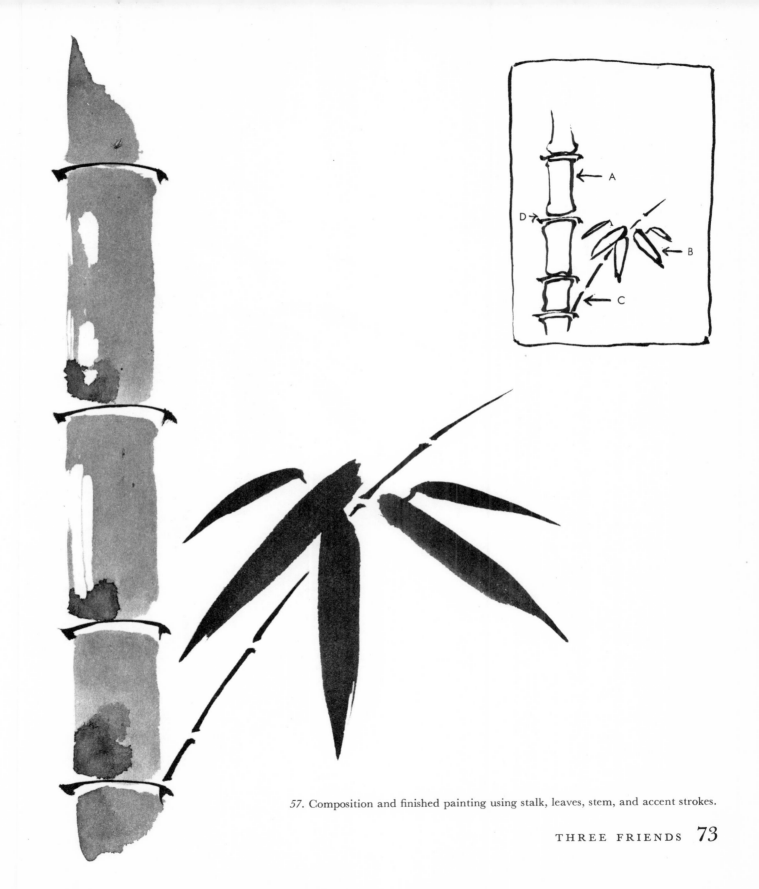

57. Composition and finished painting using stalk, leaves, stem, and accent strokes.

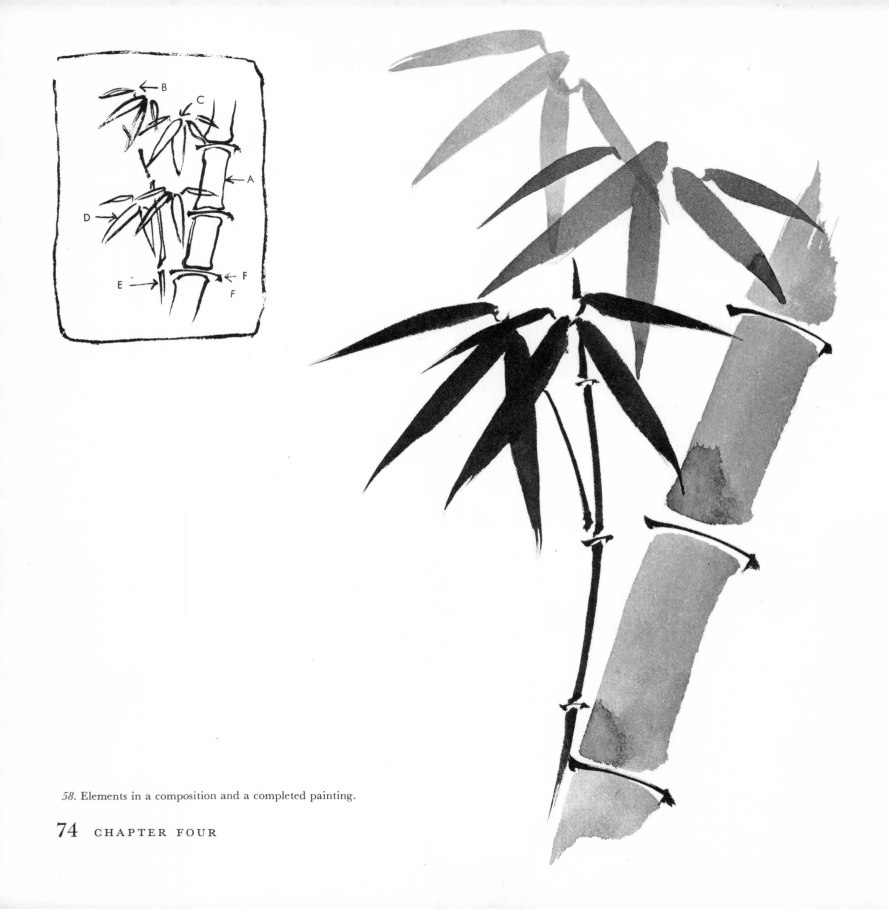

58. Elements in a composition and a completed painting.

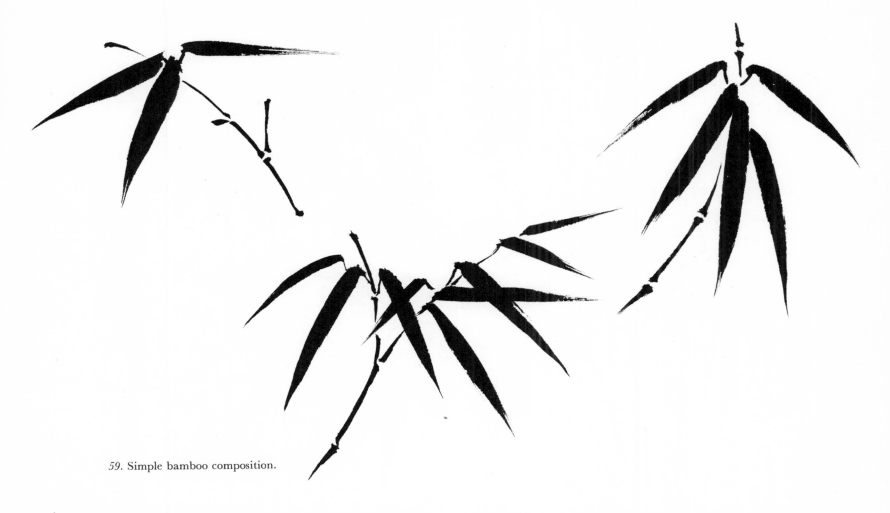

59. Simple bamboo composition.

For your next composition try painting two stalks (Fig. 58), using light gray ink for the larger *A* and darker gray ink for the smaller of the two *E.* To paint stalks in several different widths, simply select brushes with hairs of different lengths; the shorter the hairs, the narrower the stalk will be. Now paint three clusters of leaves, using a light gray wash for those in the background *B,* medium dark for those in the middle *C,* and a dark wash for those in the foreground *D.* Vary your ink shading by the cluster, not the individual leaf. Leaves of a very dark tone may cross over leaves of lighter tones or a stalk which is a light shade. Again, the darker tone indicates those in the foreground. The accent strokes *F* are of course black. The finished composition will look like the one shown.

Variations of the bamboo are endless. It is painted in wind, snow, rain, sun, and mist. It may also be painted with only one stalk and a few stems and leaves (Fig. 59) or as a tremendously complicated grove of trees (Fig. 60*a*). Groupings of tiny leaves for a bamboo grove should be done very quickly, using short flicking strokes *(b),* and the stalks in this example were painted in the same way as small stems on a large bamboo painting.

If you can develop a devil-may-care attitude when you start a composition, it will help you to produce a better painting and one with more spontaneous brushwork. By experimenting, it is possible to achieve much variation, which is most important, by shading with ink. If the strokes made in a composition seem wrong, start another.

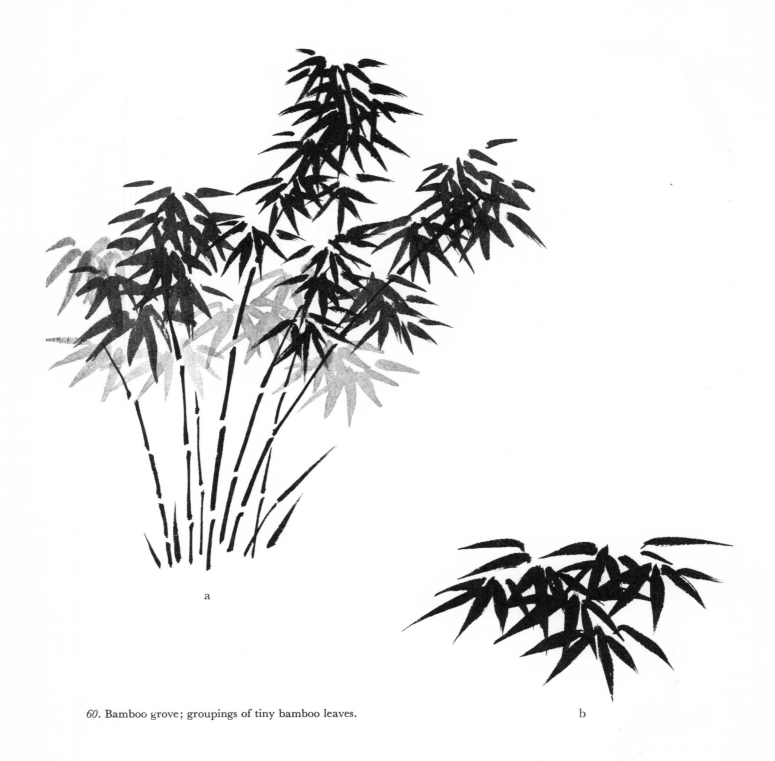

60. Bamboo grove; groupings of tiny bamboo leaves.

a

b

61. General outline for tree patterns.

Lesson 2: Pine, *Pai Miao* Style

Pine trees are like people of high principles whose manner reveals an inner power. They resemble young dragons coiled in deep gorges; they have an attractive, graceful air and yet one trembles to approach them for fear of the hidden power ready to spring forth. Those who paint pine trees should keep this meaning in mind. The brush will then effortlessly produce extraordinary results.

The pine is a decorative subject loved for its sinuous grace, ruggedness and venerable age.

—Mai-mai Sze, *The Tao of Painting*

The painting of any tree should begin with the trunk, and the pine is no exception. First make a quick, rough sketch of the general outline as in Fig. 61 (a "stick figure" for the trunk and branches, with a cloudlike outline designating the foliage areas), so you will have a clear idea of the shape of your tree.

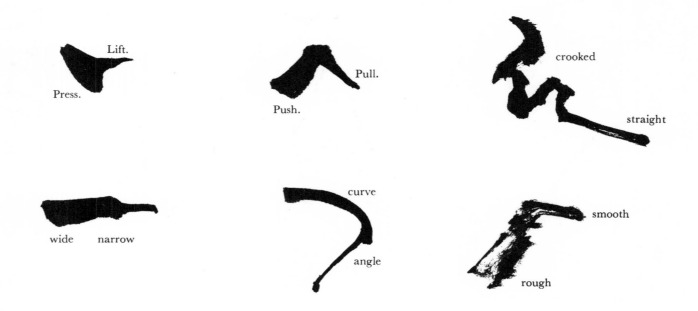

62. Combinations of opposites used in pine trees.

In painting most tree trunks and branches the strokes should show much variation, but particularly in a pine tree which is gnarled and has very rough bark. The strokes used are combinations of opposites (Fig. 62): press–lift, push–pull, wide–narrow, heavy–light, curve–angle, crooked–straight, rough–smooth, and so on. Those three basic strokes, the hook, teardrop, and bone, really come into play here. The brush should be held at an angle so the *side* of the tip of the brush makes the stroke.

Use brush No. 1 or No. 2 and a medium-to-dark shade of ink. To ensure a dry-brush effect in your strokes, remember to roll the brush across some newsprint at frequent intervals. First try painting a few strokes as a series of hesitations in an uneven line, without lifting your brush from the paper. It should be a continuous line until the ink on your brush runs out. Keep the stroke moving, sliding your arm and wrist lightly down the paper as you work downward. Practice until your strokes are similar to those in Fig. 63.

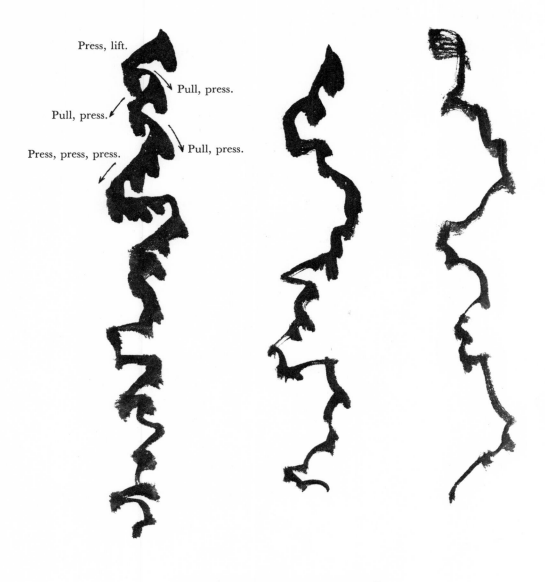

Press, lift.

Pull, press.

Pull, press.

Press, press, press.

Pull, press.

63. Series of hesitations in an uneven line.

64. General outline of a simple pine tree.

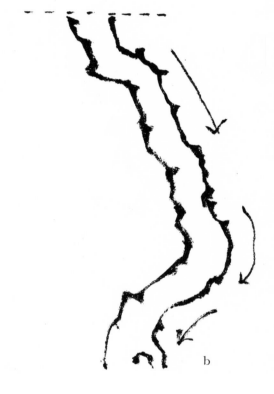

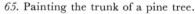

65. Painting the trunk of a pine tree.

Some pine trees are tall and slim and others are gnarled and twisted in outline. Their trunks are approximately the same diameter down the whole length, from the point where branches begin to the roots. You may find the brush runs away with you when first painting trunks, branches, and roots. Make an effort at the beginning to keep your trees simple, with few branches and small root formations, as in Fig. 64.

Begin the tree trunk about halfway down from the first branches (Fig. 65). Paint downward on the left side of the trunk to the root. Starting again from the center area, paint down the right side of the trunk, keeping the second line almost parallel to the first. Now begin the upper half of the trunk on the left side, again at the same point halfway up the trunk, and continue the stroke up this side of the tree until you reach the point where branches should fork off. Then go back to the center of the trunk and finish the right side of the upper half. This method

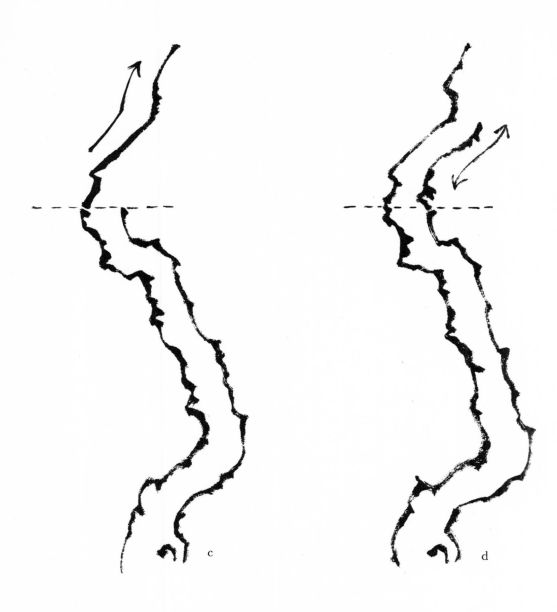

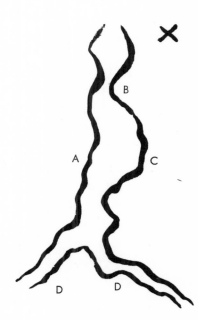

helps to place the trunk properly, but you may try starting your strokes just under the branches and working all the way down if it seems easier.

Fig. 66 shows some of the mistakes which students are apt to make in painting the trunk of a pine tree. On the side of the figure marked *A,* the stroke is too smooth. The point marked *B* is too thin, while there is too much bulge at point *C.* The root formations at the the points designated *D* are too large.

66. Common mistakes made in painting the trunk of a pine tree.

67. Direction of brush for nailhead strokes.

68. Long straight teardrop strokes.

Pine needle clumps are painted with two new strokes, the nailhead (Fig. 67) and the long straight teardrop. Use brush No. 1 or No. 2. To paint the nailhead correctly, it is important that the direction in which the brush is pulled (or flicked, in this case) be at a right angle to the line of the brush hairs as in *(a)*. If the brush tip points left, pull toward the bottom of the paper *(b)*; if the brush tip points to the top pull to the right or left. Only the tip of the brush touches the paper, as this is a very delicate stroke.

The long straight teardrop (Fig. 68) is easily made by using a quick, downward, tapping motion with the brush. Tap down, and let the brush snap back to its original position. With the emphasis on the downward motion, tap down and snap back.

Each cluster is a fan-shaped arrangement of about fourteen to eighteen needles (Fig. 69). I have separated the fan into three segments to explain more fully the direction each stroke should take. Begin at the left of the center segment *A* of the fan. Using the nailhead stroke, brush to the center of the fan, continuing around to the right.

When you paint the second segment *B,* start at the center and end at the outer edge, laying the brush down in the long straight teardrop stroke. This segment contains only three to five strokes. In the third section *C,* the strokes are again painted from the outer edge to the center in nailhead strokes. If you have trouble arranging the strokes so they meet in the middle, try placing a tiny dot at this point until all the needles seem to radiate from it. To make the transition between the first and second section easier, let the nailhead slide back into a teardrop, in a continuous stroke like the letter "V" lying on its side (Fig. 70). This fan-shaped grouping of needles is only one of many types which may be used, but the same technique in strokes should be applied to any grouping. In other species of pine, the needles form a complete circle or a cone shape (Fig. 71).

Be careful not to make the mistakes shown in Fig. 72. In *(a)* the needles do not meet in the center, while the needles in *(b)* are too pointed at the tips and too heavy in the center. The strokes in *(c)* are too thick.

69. Steps in making a cluster of pine needles.

70. Transition between first and second sections.

71. Round and cone-shaped clusters of pine needles.

72. Mistakes commonly made in painting a cluster of pine needles.

After you have become adept at painting one cluster of pine needles, the next step is to combine several clusters to form a bough (Fig. 73). There are many pitfalls here for a beginner, so be careful to stick to the rules. Avoid painting one cluster beside another in a straight line, as this makes the needles look too dense *(a)*. Instead, paint the clusters in a diagonal line, as this gives a thick yet feathery effect *(b)*. The needles of each cluster should overlap those of the one preceding it, and the needles should not be too close and yet should not be too separated *(c)*. Notice again that each cluster is painted at a slightly higher level than the previous cluster, in a stair-step sequence with the second row under the first and so forth *(d)*. Note that the beginning stroke of each succeeding cluster is at right angles to the center stroke of the preceding cluster and that it issues from the halfway mark of the preceding cluster's center needle *(e)*. When you are sure each stroke is correct, try to speed up and you will find the clusters easier to do.

When painting many fans of needles overlapping one another, be sure you paint only two needles, or three at the most, in section three of each cluster. Grouping a number of clusters into a large bough does take some practice. Working from left to right in the rising stair-step sequence will start you off, but you may wonder how to add more clusters of needles to a bough if it seems bare. The answer is simply to place more clusters here and there to fill out. The secret is to be sure that the center of a new cluster just touches the edge of the fan of needles next to it (Fig. 74).

It is very important that you be sure all the needles on one particular tree are almost the same size and type. The shape of the needles may vary slightly when they are painted quickly, as do those in Fig. 75, but they should not vary to the extent of those marked *x*. Do not group two different sizes of needle clusters in the same bough or tree (Fig. 76 *a*). Neither should you mix shapes of clusters, as in *(b)* in which the clusters on the left are round and those on the right, fan shaped.

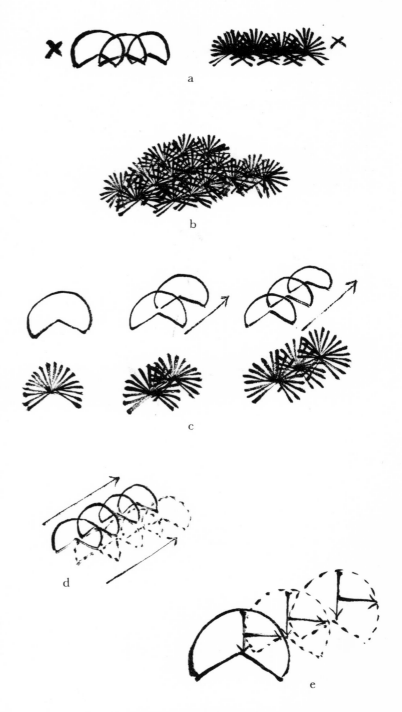

73. Arrangement of clusters of pine needles.

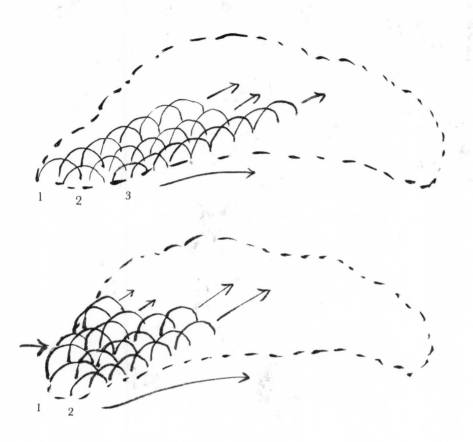

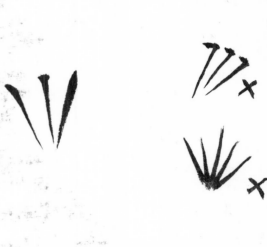

75. Acceptable and unacceptable variance
in the shape of pine needles.

74. Grouping of clusters of pine needles.

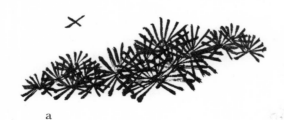

a

b

76. Pine needle clusters of different sizes and shapes used together.

Bridging the gap from the trunk to the pine needles are the branches. The transition from the trunk to primary (or double-line) branches is not so difficult. The branches should be painted to issue from the main trunk at irregular intervals so that they look natural (Fig. 77), not at regular intervals. As Fig. 78 indicates, you should paint the upper side *A* of the double-line branches first, and then the under side *B*. The twigs or single-line branches *C* come last. It is far better to have too few branches than too many. Remember always to keep the strokes moving from left to right regardless of whether the branch issues from the right or left side of the trunk.

The next step, from a large branch outlined by double lines to a smaller twig painted with a single stroke, is sometimes tricky for the beginning student. The technique illustrated in Fig. 79 should simplify it for you. Pressing down a little harder on the brush at the end of the double line before starting the single-line twig creates an impression of strength at this joint. Continuing on out with a series of bone strokes (Fig. 80 *a*), sometimes straight and sometimes curved or angled, lends a rugged look to the small branches and twigs. Pressure at the end of a twig again gives strength, but lifting the brush without first pressing at this point creates weakness *(b)*. Do not make the transition from a double-line branch to a single-line branch like the ones in *(c)*. The strokes there are much too smooth and the change is too abrupt. Rough strokes and pressure points are absolutely essential.

77. Branches of natural and unnatural intervals.

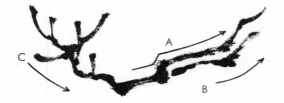

78. Steps in painting branches.

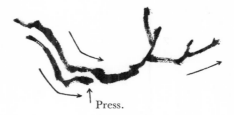

79. Transition from a large to a smaller branch.

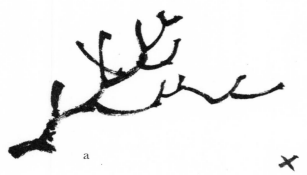

a

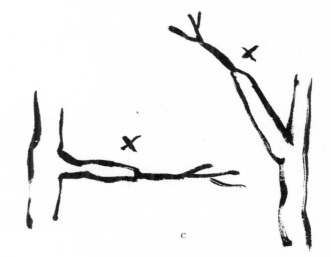

b

c

80. Proper and improper strokes for small branches and twigs.

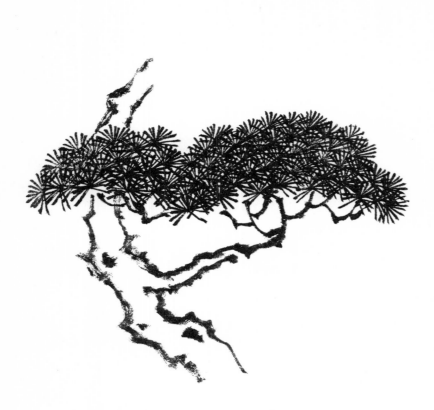

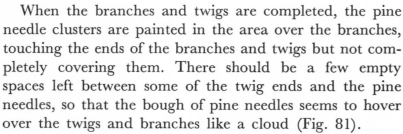

81. Position of a bough of pine needles.

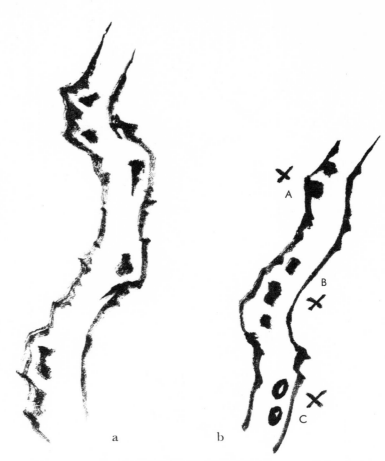

a b

82. Proper and improper methods of painting knotholes in a pine tree.

When the branches and twigs are completed, the pine needle clusters are painted in the area over the branches, touching the ends of the branches and twigs but not completely covering them. There should be a few empty spaces left between some of the twig ends and the pine needles, so that the bough of pine needles seems to hover over the twigs and branches like a cloud (Fig. 81).

Since pine trees usually have many knotholes, you may dot in a number of these at places on the trunk where there is a slight bump or swelling, indicative of the spot where a branch has broken off the main trunk (Fig. 82). Knotholes are more interesting and natural if their shapes vary as in *(a)*. Use a modified hook stroke for some, a teardrop for others, and so forth. Knots near the base of the trunk will naturally be larger than those at the top.

Knotholes should ordinarily be placed at either side of the trunk, away from the center area but not touching the outline. Some of the mistakes which beginning students are apt to make are shown in *(b)*. Those knotholes at the point marked *A* are placed too close to the outline of the trunk, while those at *B* are centered in the trunk, looking like a row of buttons. Knotholes should not be rings, as are those at point *C* which are too circular.

Paint the roots of the tree with a short, curved bone stroke. Press on the brush at the beginning of the stroke with force, lifting slightly as the brush moves over to the right. This will give the effect of shadow under the root. Keep the root system small and simple (Fig. 83 *a*); too many roots as in *(b)* will make your tree look like an octopus.

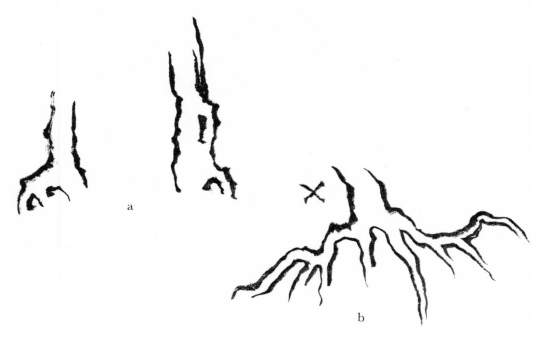

83. Pine tree with simple roots; too many roots.

84. Proper and improper strokes for painting bark.

After the tree is completed, you may want to paint in a little bark to further indicate the roughness of the trunk. With a mixture of gray ink and a very dry brush, use a light touch. Slanting the handle to the right (tip pointing left), press on the side of the tip of the brush and move in a circular motion reminiscent of penmanship exercises. Make several irregular circles, breaking the pattern here and there as the brush moves up the trunk. The result should look like *(a)* in Fig. 84 if you use light shading and a dry brush. The brush was too wet in examples *(b)* and *(c);* in *(b)* the circles are too precise, in *(c)* the effect is too jumbled. Leave the area around the knotholes blank; the bark here is very smooth. On larger branches, paint small irregular dots rather than circles or ovals. Use restraint in painting the bark—only a hint of it is desirable.

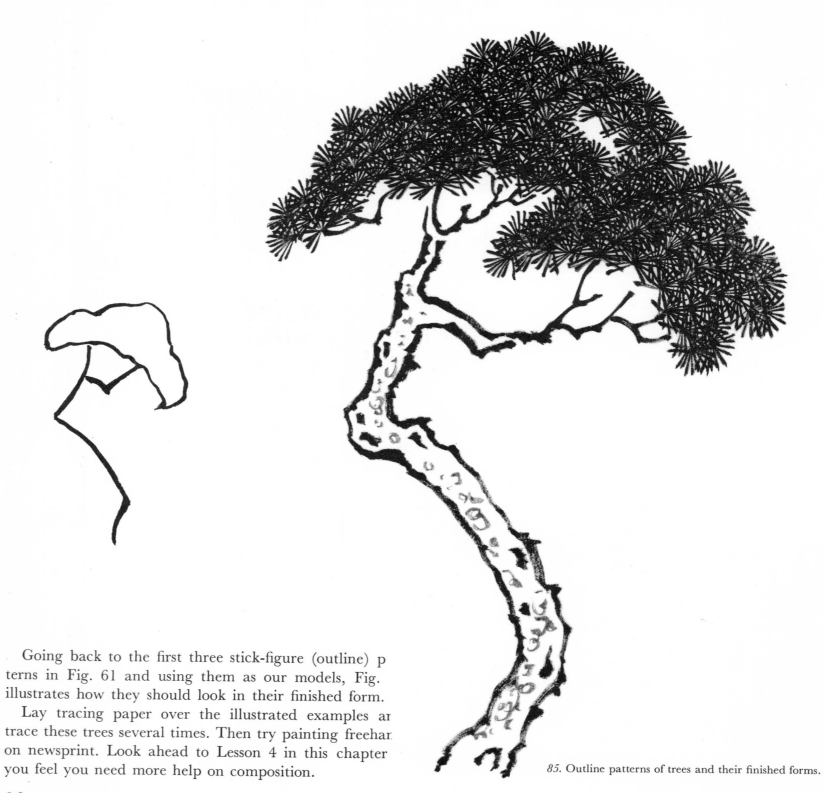

Going back to the first three stick-figure (outline) p
terns in Fig. 61 and using them as our models, Fig.
illustrates how they should look in their finished form.

Lay tracing paper over the illustrated examples ar
trace these trees several times. Then try painting freehar
on newsprint. Look ahead to Lesson 4 in this chapter
you feel you need more help on composition.

85. Outline patterns of trees and their finished forms.

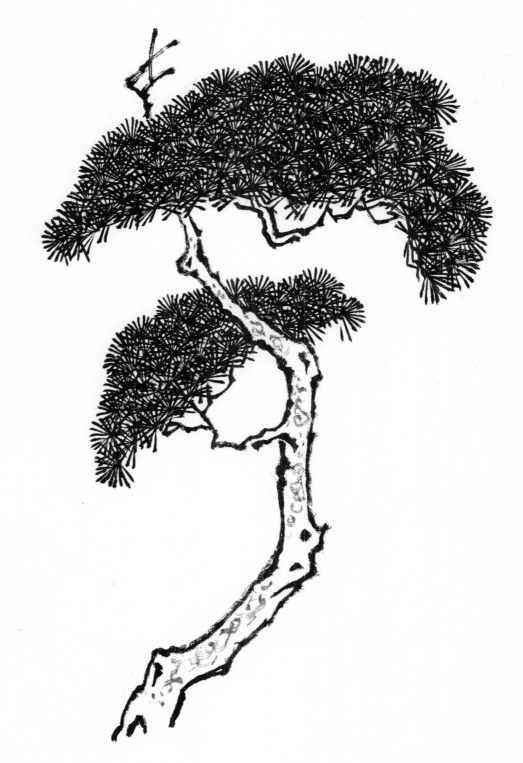

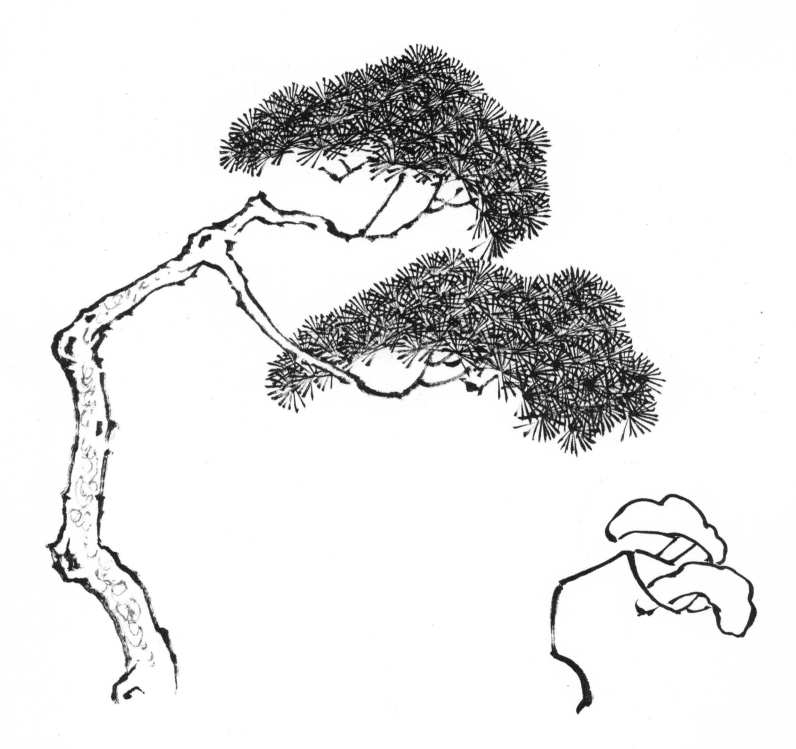

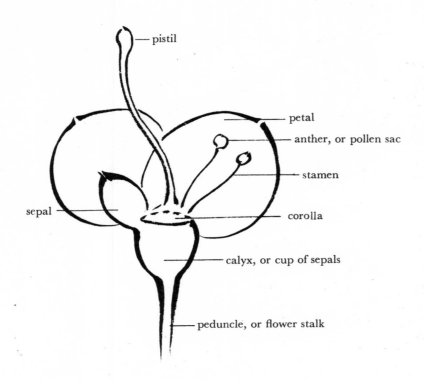

86. Parts of a flower.

Labels on figure:
- pistil
- petal
- anther, or pollen sac
- stamen
- sepal
- corolla
- calyx, or cup of sepals
- peduncle, or flower stalk

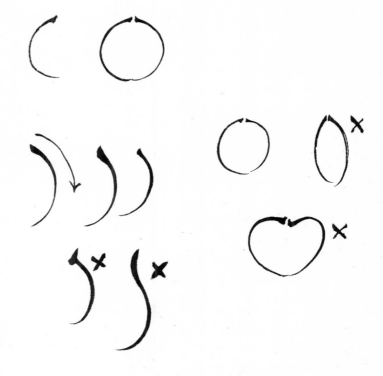

87. Curved strokes for plum petals.

Lesson 3 : Plum, *Ku Fa* and *Mo Ku* Style

The purity of the bamboo and the strength of the pine are
manifest in the plum. (Chung-Jen, 11th century)
— MAI-MAI SZE, *The Tao of Painting*

The painting of plum, like bamboo, can be a lifetime
study in itself, and in fact many Chinese artists concentrate
on this one facet of their art to the exclusion of all others.
The plum is painted in either *ku fa* or *mo ku* style and
sometimes in a blending of the two. It is one of the flowers
included in paintings of the four seasons, in which it
depicts winter. Fig. 86 shows the various parts of a flower.
We will begin by studying the *ku fa* or outline style. Start
with the flower petals, using brush No. 1 or No. 2 and a
light gray ink mixture. Stay up on the tip of the brush to
achieve a delicate line; the handle should be vertical.

The stroke used in outlining flower petals is called a
rattail. It begins heavily and trails out to a fine line, simply
by lifting the pressure gradually. It is permissible, but not
necessary, for the beginning of this stroke to look like a
nailhead.

The shape of each petal of a plum blossom should be
round rather than oval or heart shaped (Fig. 87). Beginning
at the outer left tip of the petal, paint a curved rattail
stroke, ending at the base of the petal to complete one side.
Begin again at the tip and complete the right side in the
same way. Be sure that the curve comes down gracefully
from the tip without too much pressure at the start of the
stroke or too much "S" curve.

Buds may be painted with one, two, or three petals showing. They are quite small at the tip end of the young branches or shoots but large and plump near the main branch (Fig. 88). Paint a bud in the same way as you painted a single petal.

Next try an open flower as it would be seen from the side. Using light gray ink, paint the center petal first, then the two side petals and finally add two more at the back of the flower, showing only their tips (Fig. 89). Do not let the base of the flower become bowl shaped, but instead keep it in the shape indicated.

Sepals and calyx are added after the flower petals are completed (Fig. 90). They should be painted with darker ink and a heavier stroke. Start with the center sepal, then paint the one on the left, then the one on the right, and finish with the calyx at the base as shown. Be sure that they all are close together.

The anthers or pollen heads are then placed in an arc just above the three foreground petals (Fig. 91). Anthers should be painted with a thicker brush, so use No. 7 for this dotting stroke. Hold the brush vertically, touching just the tip to the paper, and rotate it until a dot is formed. The anthers should be kept uniform in size and shape, and they should be evenly spaced, as in the example; they should not be carelessly painted.

To show a flower in full bloom from the back, first place the stem and sepals (Fig. 92 a). Paint the petals and anthers afterward (b). Parts of the five petals, overlapping each other, should show on either side of the stem. As it did for the side view, the stroke for each sepal begins at the tip, curves in a rattail, and ends at the base where the sepal joins the calyx. Applying heavier pressure to the brush and a darker shade of ink than was used for the petals will help to indicate the difference in texture and substance between the delicate petals and the leathery sepals. A few stamens may be painted between the petals, with only their tips and anthers visible. A suggestion is enough.

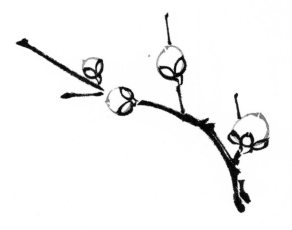

88. Large and small buds on the same branch.

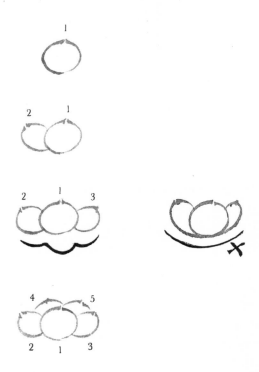

89. Order of painting plum petals (side view).

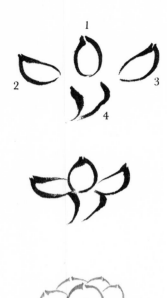

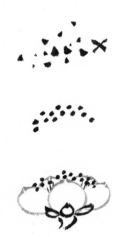

90. Order of painting sepals and calyx.

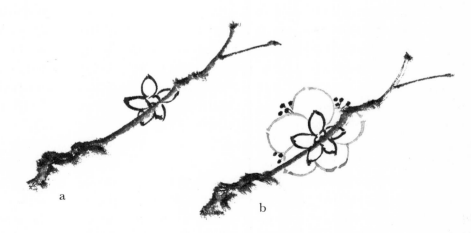

91. Stamens and anthers complete the plum flower.

a

b

92. Order of painting the back view of the plum blossom.

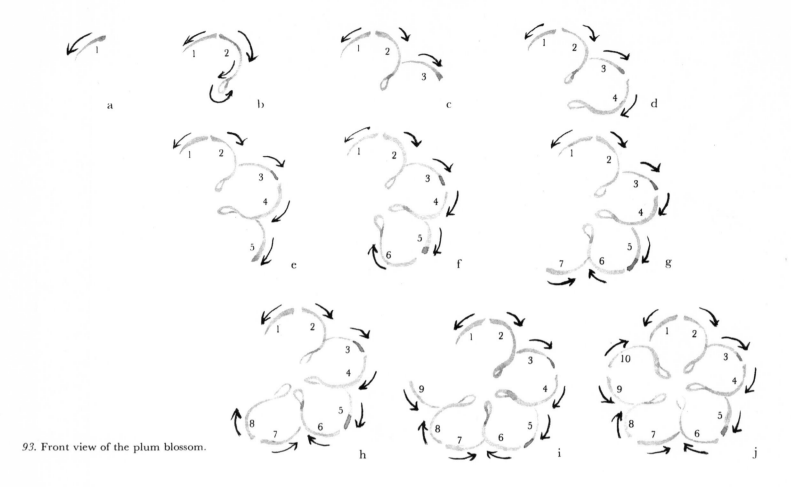

93. Front view of the plum blossom.

In *ku fa* style, the front view of a fully opened plum blossom is the most difficult to master, but practice will soon solve any problems you may have with it. The five petals should be placed in the form of a star, with the tip of each petal equidistant from the next (Fig. 93). Begin by painting the top petal. The first stroke, a very short one, is made from the tip of the petal to the left, ending about one third of the way down the side of the petal. The second stroke curves from the tip of the petal around the right side, down toward the center of the flower where it circles back into itself in a loop. The second petal is started to the right of the first, and this time the stroke is pulled out to the tip in a long curved teardrop. Continue on around, completing each petal before starting the next. Follow the numbers and arrows in Fig. 93 carefully. As

before, trace these buds and flowers on tracing paper first, and then try them freehand on newsprint. You may end up with six or seven petals on your first few freehand tries at the full-face flower, so you must learn to judge your distance. Practice and careful review of the instructions and illustrations will help you to produce lovely blossoms.

After the petals are finished, using the same brush but darker ink, place a small circle, the corolla, at the very center of the flower. This is painted with two curved bone strokes, not with a single stroke (Fig. 94). The stamens ray out from this circle in long rattail and long teardrop strokes (Fig. 95). On the left side, work from the tip of the stamen back to the circle with the long teardrop; on the right side, work from the circle out in a rattail stroke. All these lines must be fine as strands of hair.

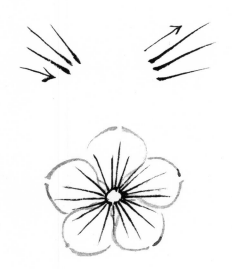

94. Strokes for the corolla.

95. Position of stamens.

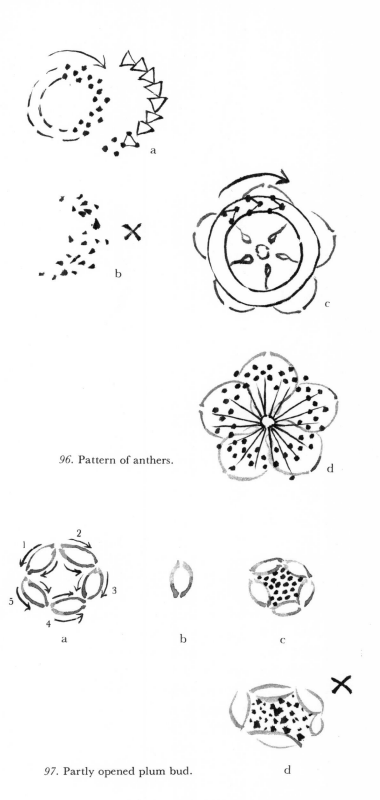

96. Pattern of anthers.

Next, pollen dots, or anthers, are placed symmetrically following a triangular pattern, not haphazardly (Fig. 96 *a, b*). Be sure that each dot is round. The ring of dots should fall in the area where the petals overlap *(c)*. After the anthers are placed in their pattern, add a few more here and there to soften the effect and give a more natural look as in *(d)*. The dots need not touch the end of each stamen but can fall casually.

When a partly opened bud is shown full face, it is a ring of five petals painted in the order shown in Fig. 97 *a*. Each petal is an outlined oval shape made by two rounded bone strokes *(b)*. Dots representing the anthers are then massed in the center as shown in *(c)*. Poor results are seen when, as in *(d)*, both the strokes and the dots have been done much too carelessly.

97. Partly opened plum bud.

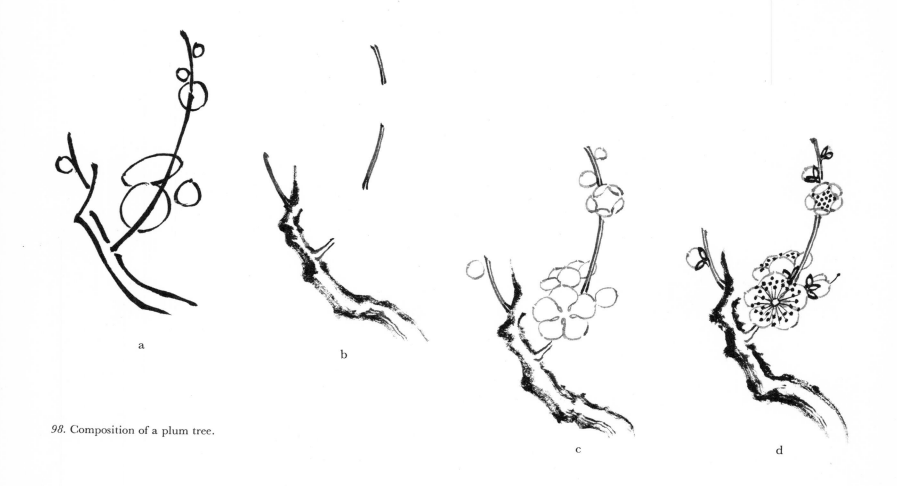

a

b

98. Composition of a plum tree.

c

d

To the Chinese, one of the fascinating qualities of the plum is the miracle of a gnarled old trunk still able to bear delicate fresh blooms. This is the contrast for which to strive, so when painting the petals and stamens it is important to make them very fragile and to use a light shade of ink. When painting the sepals, calyxes, and stems, a medium shade of ink is appropriate, and for the trunks use a rough technique and very dry brush with medium to dark ink shading.

After making a stick-figure pattern *(a)* in Fig. 98, the trunks and stems are placed first in the composition of a plum tree *(b),* leaving spaces for the flowers. This is not easy to do, so plan to start with a very simple composition. Notice that in the illustration a dry brush was used on the trunk and a wet brush on the young branches or shoots. The flowers are clustered around and grow out of the straight stems or shoots *(c),* not directly from the bark of the trunk or large branches. Finally, the sepals, stamens, and anthers are added as in *(d).* After much practice you will find that you can visualize the complete composition

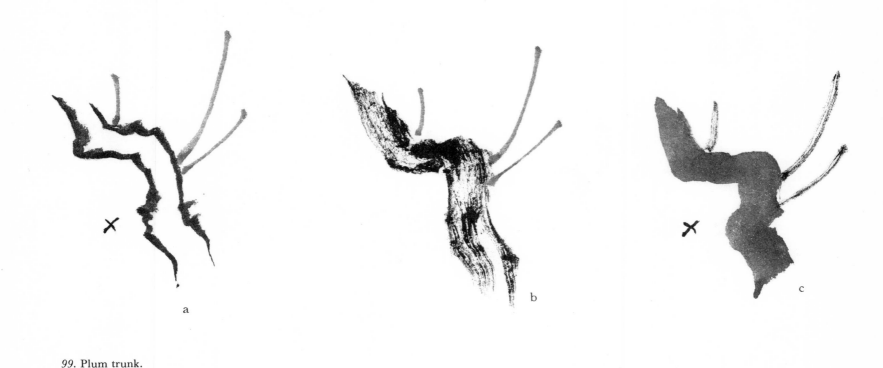

99. Plum trunk.

in your mind's eye before you start to paint. First, however, trace the illustrated examples before trying a painting of your own. Making a stick-figure outline or copying other compositions will be helpful too. A *kao tze* may also be used. *Kao tze* (pronounced gow dzuh) means pattern, original copy, or draft. It is used extensively by Chinese artists when working in the *ku fa* style. The idea is worked out in the *kao tze* and mistakes corrected, and then the thin paper or silk is placed over it and the painting is traced.

The plum also is painted in the *mo ku* style which was used for bamboo in Lesson 1. For a monochrome, black ink is brushed on with many variations in shading. Use dark ink for the trunk and main branches, a medium shade for the stems, sepals, and calyxes, and very light ink shading for the petals. When using the *mo ku* style, the trunk should not be outlined as it is in Fig. 99*a*. The trunk should be painted with a dry brush, and the stems with a wet brush to indicate their smoother texture *(b)*. A wet brush would make the trunk look soft, and a dry stroke would make the stems look too rough *(c)*.

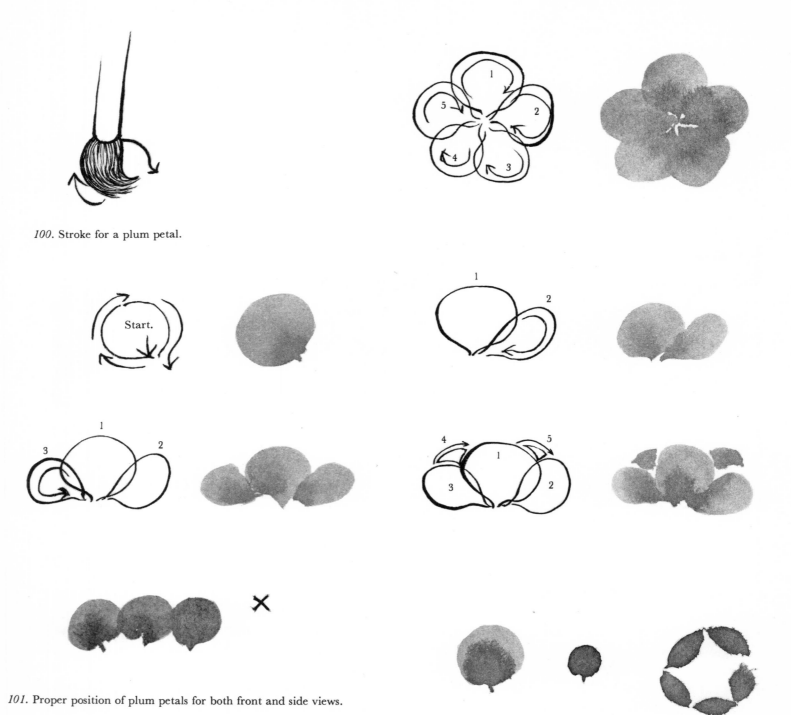

100. Stroke for a plum petal.

Start.

101. Proper position of plum petals for both front and side views.

102. Plum buds.

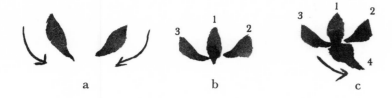

103. Stroke for sepals and calyx for a plum blossom.

104. Mo ku sepals and ku fa petals.

105. Stamens and their proper positions, and anthers added to plum petals.

Each petal of the flower may be made in one stroke in *mo ku* style. Use a full, fat brush such as No. 7. Hold the brush upright in your hand and give it a complete circular twist (Fig. 100), ending at the center of the flower before lifting the brush. Fig. 101 indicates the order and direction for painting the petals in a full-face plum blossom. For the side views of the blossoms, some of the petals are slightly oval. Follow the arrows and number sequence as indicated for guidance in how to manipulate the brush for these strokes. The petals should not lie in a straight line. Fig. 102 illustrates a large bud, a small bud, and a full-face bud which is opening.

Only one stroke is used for each sepal (Fig. 103). Lay the brush down heavily and then lift, leaving a slight tail on the end of the stroke *(a)*. Paint the sepals in the order indicated. Begin at the tip of the sepal and end where it joins the calyx *(b)*. The calyx is painted next, with a similar but larger stroke made with heavier pressure on the brush. The tail of the calyx must point toward and touch the stem from which it grows *(c)*. Sometimes the sepals and calyx are done in *mo ku,* even if the petals may be *ku fa* (Fig. 104). Stems or shoots are simply elongated bone strokes. Stamens and anthers are added in the shade of ink used for sepals (Fig. 105). Remember that the stamens must issue from the corolla at the center of the flower as shown in the above examples.

106. Moss dots.

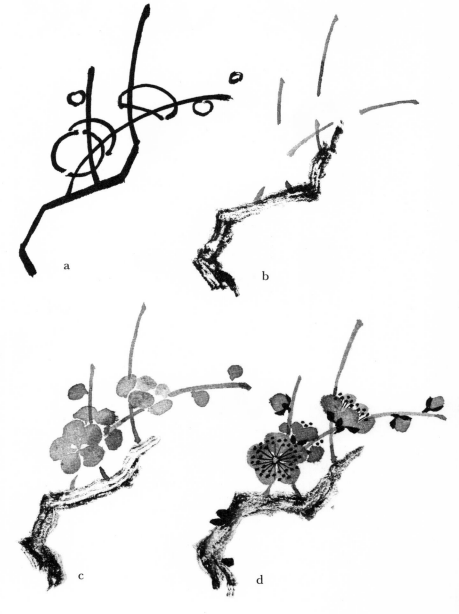

107. Composition of a plum tree.

When painting in *mo ku* style, the trunk should be made with one large brush stroke rather than the two outlining strokes, but still using the dry-brush technique. Stems also are done in one stroke, but with a wet brush. For a finishing touch, a few large dotting strokes may be scattered at random along the main trunk and larger branches. These moss dots, which should be oval in form, are made with dark ink using brush No. 7. Press the side of the brush hairs to the paper and lift up again as you did when painting the long straight teardrop stroke for pine needles. Try to keep the dots alike in their general shape and size (Fig. 106). Do not let the moss dots "wrap around" the trunk, pointing in all directions. Instead, the dots should be limited in number and approximately uniform in shape.

Try tracing the composition in Fig. 107 and then paint it yourself. After you have made the stick-figure pattern *(a)*, begin by painting the trunk and branches first *(b)* and then add the petals *(c)*. The accents, sepals, stamens, anthers, and moss dots are added last *(d)*.

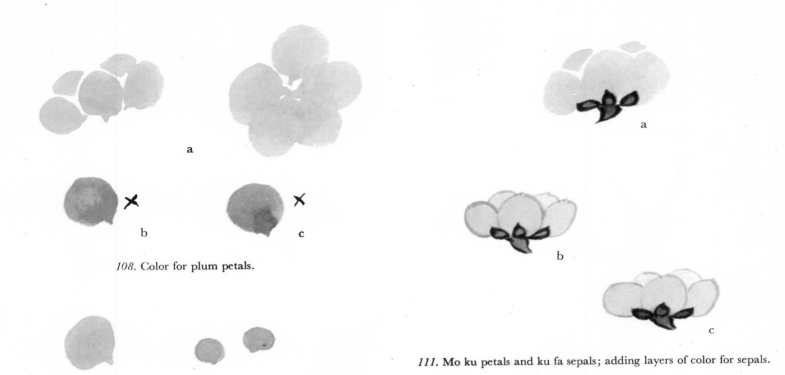

108. Color for plum petals.

109. Color for plum buds.

110. Green for plum sepals and calyx.

111. **Mo ku petals and ku fa sepals; adding layers of color for sepals.**

112. Color for plum anthers.

When painting the plum in color, follow the rules in Chapter 6 for coloring any flower. In this lesson I will simply list the colors to use for plum. *How* to use them is another matter, so whether you are a professional artist or a beginner, you should read that chapter before attempting to paint with Chinese pigments.

Plum petals are a pale shade of pink, sometimes almost a salmon pink (Fig. 108 *a*). The shade in *(b)* is too orange, and that in *(c),* too red. The proper color for blossoms is obtained by adding a touch of lemon yellow to magenta plus clear water. All buds are darker than open flowers (Fig. 109), and they may be a still deeper shade when they are very small. Sepals and calyxes may be either moss green (Fig. 110 *a*), made by adding yellow ochre to blue, or wine red. The color in *(b)* is too blue. *Mo ku* petals may have *ku fa* sepals and calyx (Fig. 111 *a*), and if the sepals are painted in outline style, the first layer of color may be green *(b)* and the next layer red *(c),* resulting in a blending of the two. The pollen dots should be made bright and outstanding with a thick mixture of white and lemon yellow (Fig. 112).

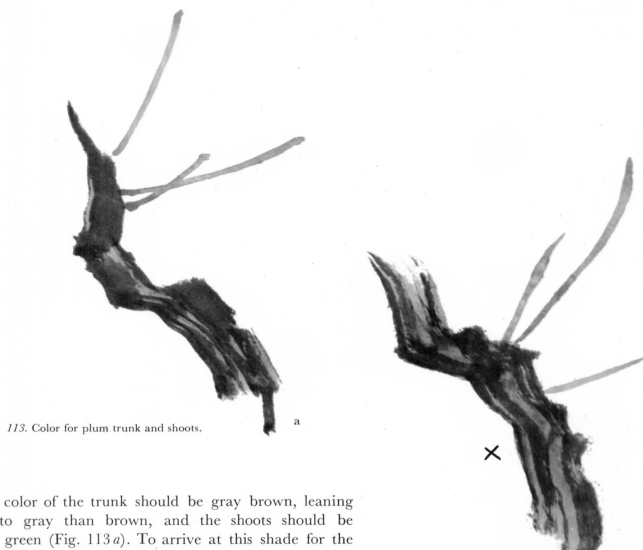

113. Color for plum trunk and shoots.

a

b

The color of the trunk should be gray brown, leaning more to gray than brown, and the shoots should be yellow green (Fig. 113 *a*). To arrive at this shade for the trunk, simply add a little black ink to a mixture of rust brown and water. Do not use rusty brown for the bark or blue green for the shoots *(b)*. Also notice in *(b)* how limp the shoots look when they are not painted as a bone stroke. If you find that your colors for the petals, sepals, and stems are too bright, a touch of black ink should be added to these mixtures too. Usually just dipping the tip of the brush into a dark gray wash without taking the ink directly from the stone is sufficient—a little goes a long way.

 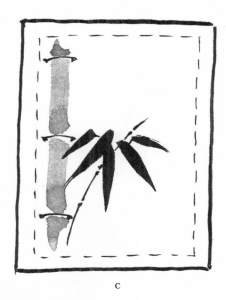

a b c

114. Framework of a composition.

Lesson 4 : Composition

You may be saying to yourself, "But I know nothing of composition. How do I start out when I want to compose a picture? What do I do first?" Most people feel they are short on originality and wonder how they can possibly come up with an idea.

Let us take the case of bamboo painting. There is little we can do about the fact that most of us do not have a grove of bamboo growing conveniently in the garden to give us inspiration. However, you can find patterns to follow if you look around you. Do you have a Japanese tray with bamboo painted on it? Perhaps you have some china teacups with a bamboo design, or even wallpaper or place mats. You will find ideas for bamboo compositions in books on Chinese art in libraries or bookstores, or possibly on cards and note-paper. These reproductions may not contain the proper strokes (you will soon be able to distinguish good from bad), but they will suggest ideas you may want to borrow. Do not be afraid to copy. This is the Chinese way of assimilating the necessary knowledge of the subject.

When you have your idea or plan for a composition, the next problem is to place it correctly on the sheet of paper. To help you over this hurdle, here is a formula or framework on which to build. On a piece of newsprint, lightly pencil off nine squares (Fig. 114a). Plan your painting so the brushwork occupies at most four or five of these squares *(b)*; the squares which are left empty act to balance the rest of the painting. In this way you will always be sure of having enough space, a very important part of any Chinese composition. Leave a margin of one inch or more on all four sides of your work *(c)*.

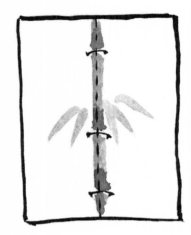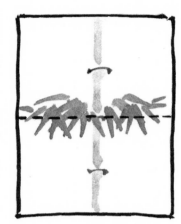

115. Painting cut in two.

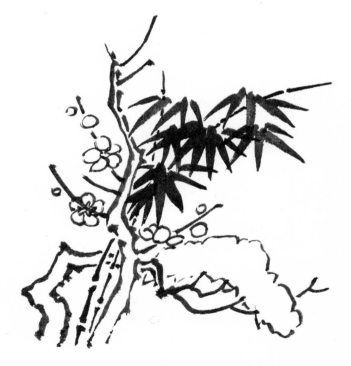

a

As in most schools of painting, the Chinese never "cut" a picture in two (Fig. 115), vertically or horizontally. The nine-square pattern will also help you to remember to place the bulk of your painting on one side or the other, with the horizontal planes being filled above or below the central area. Soon you will be able to visualize mentally your nine-square pattern. It should be used to check the balance of any composition.

When copying or perhaps transposing an idea for a painting (Fig. 116), I have found it helps my students to follow this formula:

1. Using your smallest brush, paint a stick figure of the idea on newsprint with black ink *(a)*.
2. Elaborate on the stick figure *(b)*.
3. Cover any areas that are not correct with small pieces of newsprint, torn to shape and pasted down *(c)*. Or cut whole areas apart, shift them around until you like the new arrangement, and then tape them together with transparent mending tape.
4. Lay tracing paper over this arrangement and trace the corrected composition. This tracing will be your *kao tze (d)*.
5. Lay paper or silk over the *kao tze* and again trace to complete the final painting *(e)*.

b

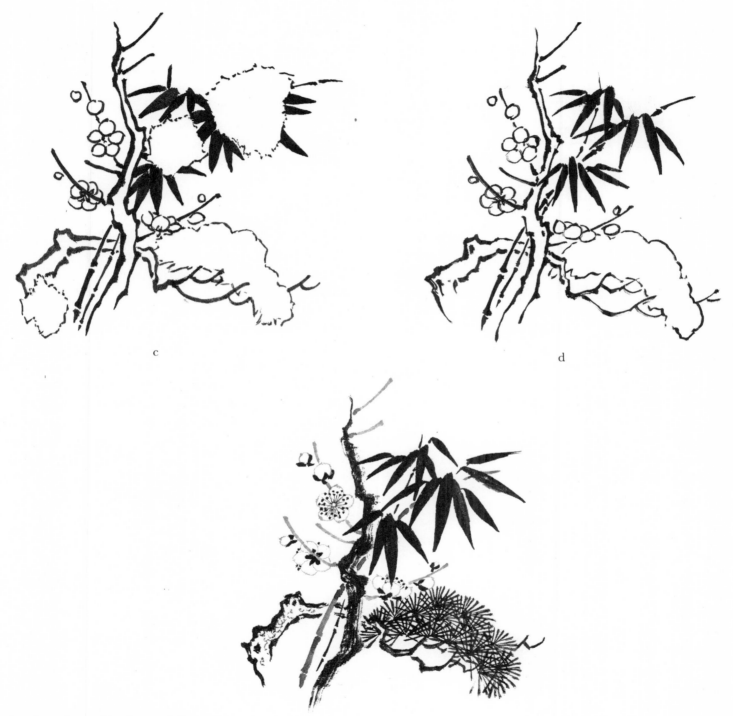

c

d

116. Order of copying an idea for a painting.

e

Schooled in the sportsmanlike attitude that it is "not quite cricket" to copy and trace, one may find the idea a hard one to accept. The Chinese concept of this method, however, is that it is invaluable to the student while he is studying. Copying should not be used as a crutch after techniques have once been learned.

In the *mo ku* manner of painting, you will not want to lean on a *kao tze* after you have become confident of your strokes and general technique, as this particular style should be spontaneous and free. When painting in *ku fa,* however, even the most accomplished artist will continue to use a *kao tze,* which is based on his own composition.

We are all born with talent for something. Some incline toward music, some have a gift for literary expression, and others, the aptitude for art. Still others love to cook or garden creatively. The ability to create does not come overnight, and only after a firm foundation has been laid can we start to build. In painting, this foundation consists of learning the rules, practice, experience, and then more practice.

In thinking about fashioning a composition for a painting, I find myself always returning to the creation of life as a comparison. Inspiration starts with the conception of an idea, a composition as yet only mentally visualized. Then follows the period of gestation as the idea is nurtured in the mind. Afterward comes a time of labor as the concept is worked out on newsprint and *kao tze.* And finally comes the triumphant moment when the painting is completed on silk or paper and a work of art is born.

The time has come to stop for a while and look back at what you have accomplished. Are you perhaps having trouble with your strokes? Go back and review that first lesson on strokes in Chapter 3. Are you writing or tracing characters before each painting session? This is extremely important and cannot be overemphasized. The amount of time you give to practice has a direct effect on the quality of your work, so if you have not had time to practice a good deal, do not be discouraged over work that does not seem "up to snuff."

Remember to check what by now may seem like little things, such as the brush. Is it the right size for the work you are doing? Is it getting a little frayed or worn out? Maybe you should try a new one, or one of a different size. Is your paper the right type for the style of painting you are doing? In *ku fa* style, the outline may go on absorbent paper easily enough, but this paper is not right for a color wash. You should use non-absorbent (sized) paper or silk if you plan to color a *ku fa* painting. On the other hand, *mo ku* style needs the absorbent (unsized) paper for its own special and interesting effect.

Just as important as practicing is taking the time for some quiet thought and study. Even if this additional time is difficult to come by, you will find it well worth the trouble.

5

Landscape Painting

To look at the autumn clouds makes the soul soar as a bird, to feel the wind of spring makes the thoughts go far and wide . . . to open the picture and prepare the board, to exert one's self with strange mountains and seas, with green forests and the soaring wind, with the foaming waters and the rushing cascades —how wonderful! It needs only the turning of the hand to bring down the brightness of the spirit into the picture! Such is the . . . joy of painting. (Wang Wei, 5th century)

—OSVALD SIRÉN, *The Chinese on the Art of Painting*

THE CHINESE consider landscape the highest form of painting, because it may contain every living thing. Landscapes are painted according to definite rules, most of them laid down centuries ago. These rules are a help to the student but do not bind the artist when he is ready to start forming his own style, because they are simply a framework on which to build. A landscape is composed and painted in the following order:

1. Trees
2. Foliage
3. Rocks and other land
4. Figures and/or animals
5. Dwellings
6. Boats
7. Water
8. Distant hills and mountains

This order should be followed for each painting. For example, let us say you are composing a landscape which contains trees, rocks, and a house. The house is to be placed in front of one of the trees, but the house cannot be painted until the trees are finished. A space is left for it and it is then painted in its proper sequence, after the trees and rocks are completed.

Lesson 1 : Trees

When beginning the study of trees, it is useful to go out of doors, into the country if possible, and really look at trees and their foliage in relation to the landscape. The pine trees you have already studied have a gnarled and rough texture. Other trees may have straight trunks and limbs and smooth bark. The branches of the tree in Fig. 117 *a,* for instance, are known as stag-horn branches, those in *(b)* as crab-claw branches, and *(c)* has twisting branches. Several types of trees may be clustered together in one landscape painting for an interesting and varied grouping. Many varieties of trees grow in China, but they are painted

117. Trees with stag-horn, crab-claw, and twisting branches.

simply as certain types: trees with outline foliage, those with "dot" foliage, and those with bare branches. Under these rather broad headings come names of the actual varieties: willow, cedar, pine, *wu t'ung* or plane tree, and others. Trees are also grouped by seasons; for instance, flowering fruits are typical of spring and bare branched trees suggest autumn or winter.

As mentioned before, the Chinese think of the largest and most important tree in a painting as the host and of those gathered around as the guests. The stick figure in Fig. 118 is an example of the way three trees could be combined in a group, the darker tree *(a)* being the host and the lighter trees *(b)* and *(c)* being the guests. The host usually stands in front of the others, but if the composition demands it, the foliage, branches, and even the trunk of a guest tree may appear in front of the host. A slightly darker shade of ink used for the host serves to point up that tree's relative importance.

The barks of various trees also differ. Some trees are tall and straight with smooth bark, others are short and

118. Stick figure of a group of three trees.

119. Horizontal and vertical barks.

knobby with rough bark, and still others are like the very rough and rugged pine. Fig. 119 illustrates a tree with horizontal bark *(a)*, and *(b)* shows a tree with vertical bark. Using brush No. 2, practice by tracing these tree trunks and branches. Follow the original lines as closely as possible, being sure to use the right strokes and shades of ink. Then try copying each tree freehand on newsprint.

When you feel ready to paint a tree of your own composition, there are several important points to keep in

mind. Be especially careful to place the branches correctly when the line of the trunk and branches are separated by areas of foliage. In Fig. 120*a* the line continues correctly, but in *(b)* the lines of the branches which are in the opening of the foliage have jumped to the side. Remember to keep the root formations small. Finally, be frugal with branches, both in number and length. Notice in Fig. 121 how wet brush strokes soften a tree trunk and how ugly is the result of painting too many branches. A tree which has shed its leaves is the only type which should have many branches; but even on this kind, do not let your brush run wild!

Most tree trunks are painted in outline style, but small trees in the middle and far distance may be painted in *mo ku*. In this case use only one brush stroke to model the entire trunk and one stroke for each branch. Pine trees in the far distance become simplified. First paint the trunks and branches in single strokes and then add dotting strokes for the needles (Fig. 122 *a*). Another way to paint trees in the distance is to first place the trunks with long straight teardrop strokes and then lay the brush tip down horizontally in a quick tapping motion for the foliage *(b)*.

120. Branches separated by foliage.

121. Result of wet brush and too many branches.

a

b

122. Trees in the distance.

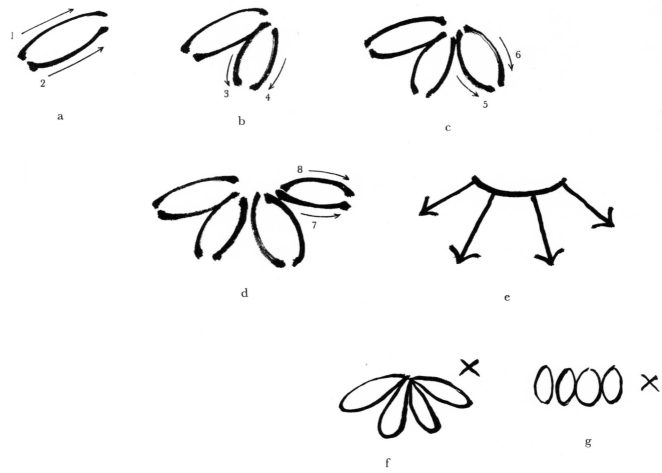

123. Painting wu t'ung leaves.

Lesson 2 : Foliage

A landscape may contain either *ku fa* or *mo ku* foliage, or a combination of the two; variety makes a more pleasing composition. Illustrated in this lesson are some of the many types of foliage used in Chinese painting. First learn the strokes and methods used, then trace the examples given, and afterward copy them freehand on newsprint. When painting leaves in *mo ku,* try to arrange them so some leaves cross each other; in *ku fa* the leaves should never cross but should lie next to each other in patterns. In this

lesson we shall take as examples three types of foliage and show how to paint them in both styles.

1. WU T'UNG OR PLANE-TREE LEAF, KU FA. These leaves are painted in small groups of four, or sometimes five, beginning with the leaf on the left side. Follow the arrows and number sequence in Fig. 123. A pair of rounded bone strokes are used to outline each leaf, which should be painted so that it slants in a direction slightly different from the leaf before it. It is important to fan the group out in an imaginary concave arc *(e),* not from one central point

124. Wu t'ung leaves of different sizes.

a b c d

e f g

h

125. Placement of wu t'ung-leaf clusters in the first row of a large group.

a

b

c

d

126. Placement of second row of wu t'ung leaves.

(f) or in a straight row *(g)*. Do not mix sizes (Fig. 124) or shapes of leaves. An effect of flat pattern or design is more desirable than photographic or three-dimensional resemblance. In painting a large group or bough of leaves, work from the top down. The first row becomes an uneven chain of leaves, in which the fourth leaf of each cluster may be considered the first leaf of the next, and so on (Fig. 125). When each cluster is painted separately, the unfortunate result looks like *(h)*. The second row of leaves should be started just below and slightly to the right of the first cluster in the row above (Fig. 126).

Continue to stagger the groups of leaves in this way in each row, and when you have finished, they will appear to be growing naturally. Extra leaves may be added after the bough is completed (Fig. 127).

Place each group of leaves immediately against its neighbors, except where you want to show a gap in the foliage. But these openings or gaps should appear here and there for a natural effect. To fill in an especially large opening, an extra branch or two may be painted, but be sure they stem out properly from the main trunk (Fig. 128). Practice painting these leaves until the construction of both clusters and boughs seems easy and your groupings are similar to the illustrations.

WU T'UNG OR PLANE-TREE LEAF, MO KU. Use brush No. 2 or No. 7. Each group of five leaves is a combination of a modified hook stroke and four teardrop strokes (Fig. 129 *a*); the hook stroke is used for the first leaf, and then there is a series of teardrop strokes. On each downward stroke, press fairly hard for a rounded tip but do not rotate the brush hairs. Then lift the brush as you return to start the head of the next leaf *(b)*. Just as in the *ku fa* style, you must change the direction of each stroke slightly so the leaves fan out from a concave arc *(c)*, because straight strokes *(d)* result in an uninteresting line of "M"'s. Be especially sure that the angle of the second leaf is correct *(e)*. An additional leaf may be placed after the cluster is finished *(f)*.

These clusters are grouped together in the same way as the outline leaves, but in this case the strokes may cross each other here and there (as in the groupings of two, three, and four clusters in Fig. 130). The finished bough of foliage should appear dense, and yet each stroke must be distinct. These leaves may be used as foliage on bushes or trees, or over the tops of rocks or hills where no branches are visible, as shown.

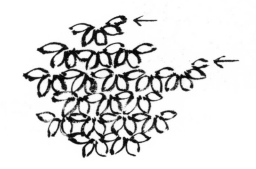

127. Extra leaves.

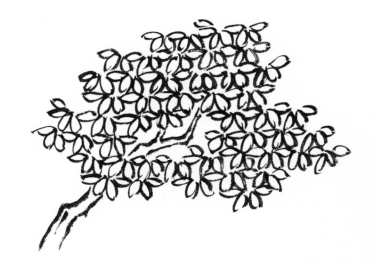

128. Extra branches from main trunk.

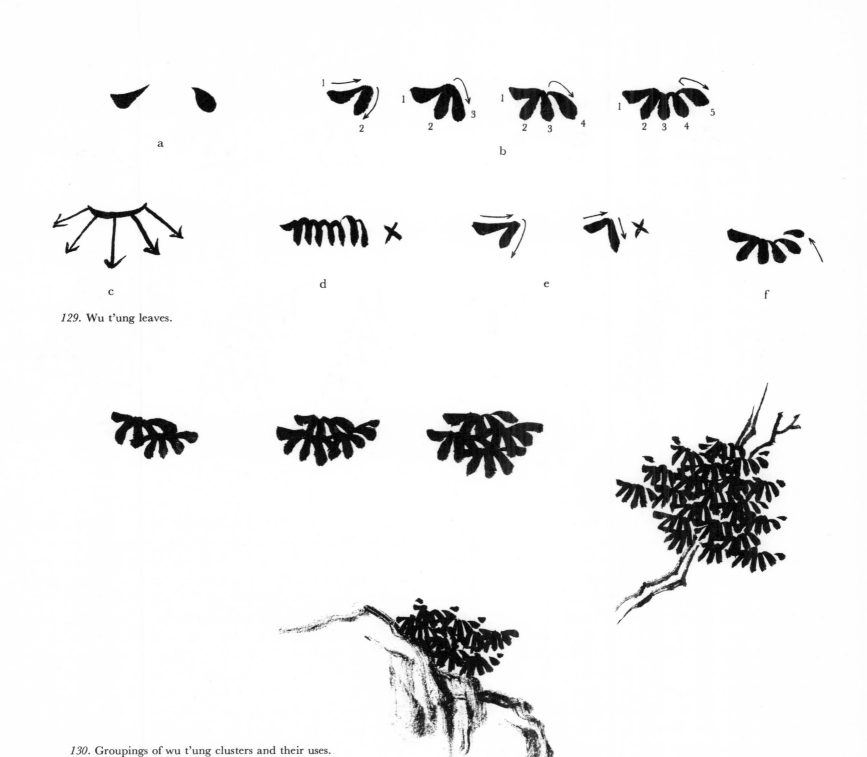

129. Wu t'ung leaves.

130. Groupings of wu t'ung clusters and their uses.

131. Strokes for a triangular leaf.

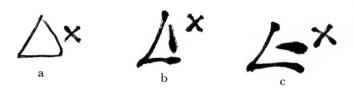

132. Common mistakes made in painting a triangular leaf.

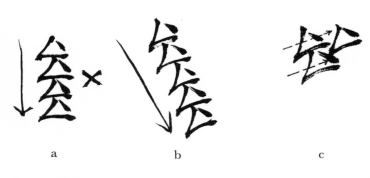

133. Direction of rows of triangular leaves.

d

2. TRIANGULAR LEAF, KU FA. This is the foliage of what is called the red-leaf tree in China. Tinted a rusty pink or rouge red, it is useful when a bright spot of color is needed. Paint a bone stroke from the apex of the triangle to the lower left corner, and then without lifting the brush, proceed to the right in another short bone stroke (Fig. 131 *a*). Lift the brush and then dot in the third side of the triangle with a short straight teardrop *(b)*, being careful that the tip of the brush is pointed toward the apex. Mistakes commonly made are shown in Fig. 132. In *(a)* the strokes are too smooth, in *(b)* the angle is too acute, and in *(c)* the teardrop is not pointing to the apex.

After practicing single leaves, you may try putting several together as in Fig. 133. To avoid painting them all in a vertical line *(a)*, slant each row slightly from the upper left to the lower right *(b)*. Start the second triangle directly below the first and so on, beginning each new triangle at the center of the base of the last triangle *(c)*. Paint five or six triangles in a row. Then start a second row to the right and at about the middle of the top triangle in the first row, continuing down this row in the same way. They will look like those in *(d)*. Any mass of foliage should have irregular outlines. These should not be too angular or too rounded, but slightly scalloped with a few extra leaves added here and there to soften the edges. The cloudlike outline in Fig. 134 *a* is filled with triangular leaves, with extra leaves *(b)* added to soften the outline. Generally, the foliage of the red-leaf tree is used on small trees or low bushes, but it may also be utilized with great effectiveness for larger trees.

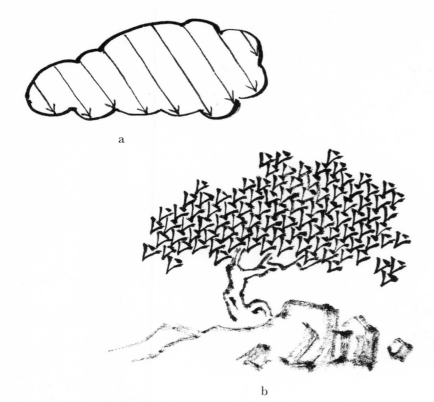

a

b

134. Triangular leaves in a cloudlike outline.

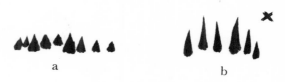

a

b

135. Triangular leaves.

136. Shape of a mass of triangular leaves.

a

b

c

137. Triangular leaves for ground cover.

TRIANGULAR LEAF, MO KU. Use brush No. 7. The dotting stroke for the triangular leaf is painted with a short tapping motion, using only the tip of the brush to achieve the triangular shape. The strokes must be made with the handle held vertically (Fig. 135 *a*), not at an angle *(b),* and the tapping is done quickly and even a little carelessly. These strokes may overlap sometimes, and the size of the individual dots may vary somewhat. When used for foliage on trees or bushes, the mass outline should be similar to that made with the *ku fa* technique (Fig. 136). When used as mossy ground cover, the dots should travel across the top of the slope or hill in an uneven line. As in Fig. 137, start in the center of the group and work toward the left *(a),* return to the center and work to the right *(b)*. The dots should diminish in size from the center out *(c)*.

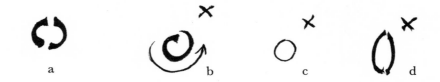

138. Proper and improper strokes for a round dot leaf.

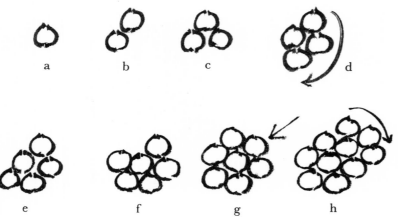

139. Grouping round dot leaves.

3. ROUND DOT LEAF, KU FA. Use brush No. 1 or 2. This type of foliage is similar to that of the *wu t'ung* tree except that the leaves are circular. Each leaf is outlined by two rounded bone strokes, painted from the top of the leaf to the bottom (Fig. 138 *a*). The leaf should not be done in one stroke *(b),* should not be too smooth *(c),* and should not be oval *(d).* The first leaf is surrounded, working clockwise, by a ring of six or seven more leaves, all with edges touching (Fig. 139). The mass of leaves is built up by continuing this procedure. Use one of the leaves on the perimeter as the center leaf for another group and surround that one with more circles. This type of foliage is used both for trees, which are usually rather straight and tall (Fig. 140), and for low bushes.

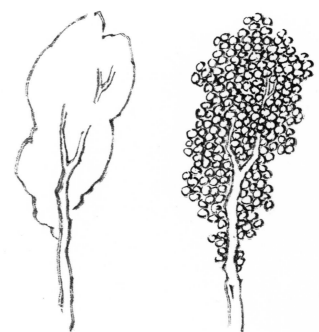

140. Tree with round dot leaves.

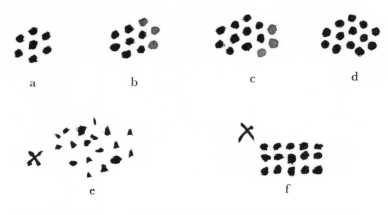

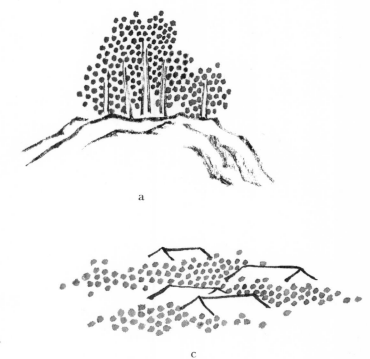

141. Round dot leaves and common mistakes made in painting them.

142. Uses of round dot-leaf foliage.

ROUND DOT LEAF, MO KU. Use brush No. 7. This dot is painted in the same way as anthers on the plum. Hold the brush vertically, touch just the tip to the paper, and rotate the brush until you have a small round dot. The rest of the dots are placed in the same manner as the *ku fa* leaves; however in this case the edges of the dots should not touch and each dot should be equidistant from its neighbors (Fig. 141). The dots marked in *x* are either much too carelessly painted, or much too straight and stiff. Keep the edges of the mass of foliage uneven by adding a few more dots around the edges at random. This kind of foliage may be used on trees, low bushes, distant trees, foliage on rocks (Fig. 142 *a, b*), and to represent misty, indistinct greenery in the far hills or mountains. It is also very useful for filling areas between houses *(c)* or any other place where there is too much empty space in a composition. Use common sense, however; they should only be placed where shrubbery or forests would naturally grow. When painted in the distance, the dots should be smaller and of a lighter shade of ink.

A　　　　　　　　　　　　B　　　　　　　　　　　　C

D　　　　　　　　　　　　　　　　　　E

Fig. 143 illustrates other types of foliage which you may want to use after you have worked on *wu t'ung* leaves, triangular leaves, and round dot leaves. The *ku fa* foliage in *A* through *F* is colored as follows: *A* is yellow green; *B* is rouge red; *C* is yellow ochre or green; *D* is mineral green; *E* is blue green; and *F* is mineral blue. The *mo ku* foliage *G* through *L* may also be colored, but in this case be sure to check Chapter 6 for the instructions on coloring pine foliage, as these are done in the same way. Either the *ku fa* or *mo ku* style may be used in your compositions, but it is preferable to combine trees with both styles of foliage in each group. Of course, *mo ku* and *ku fa* foliage are never combined on any *one* tree. Fig. 144 illustrates the correct type of trunk to combine with each type of foliage.

F

143. Additional types of foliage in mo ku and ku fa.

G

H

I

J

K

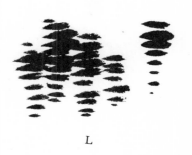

L

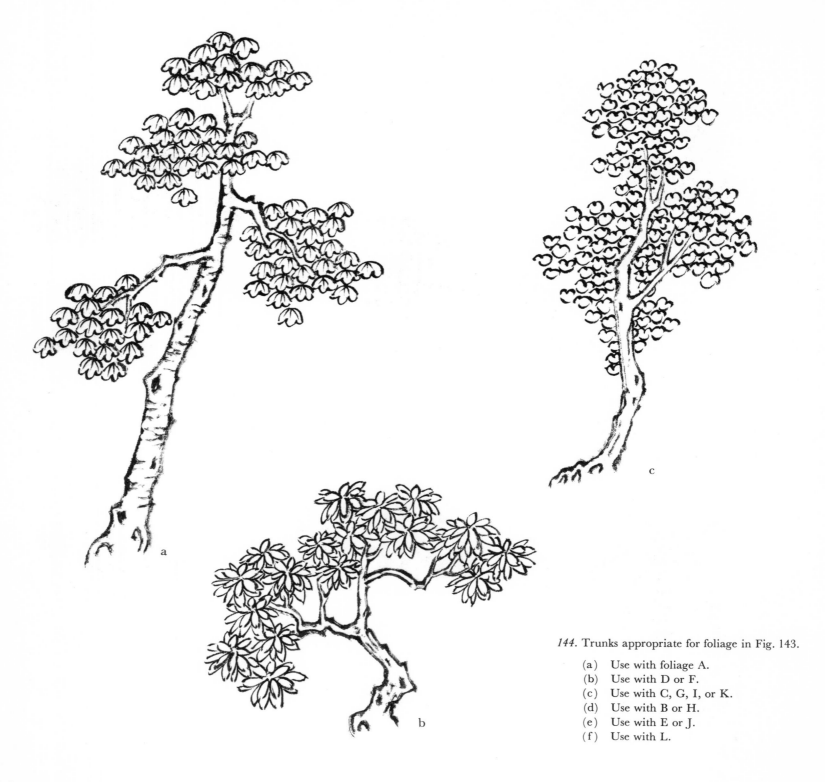

144. Trunks appropriate for foliage in Fig. 143.

(a) Use with foliage A.
(b) Use with D or F.
(c) Use with C, G, I, or K.
(d) Use with B or H.
(e) Use with E or J.
(f) Use with L.

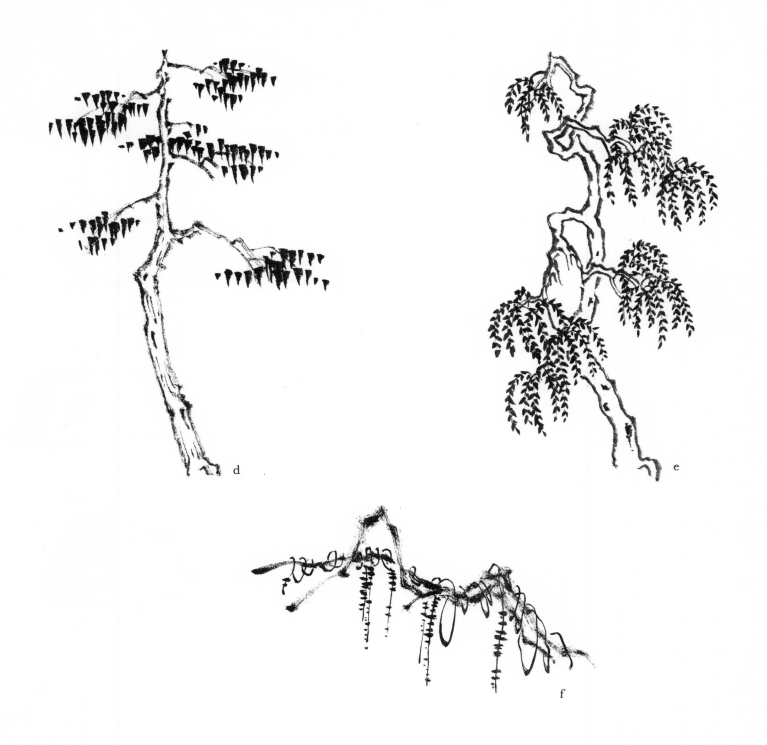

d

e

f

Lesson 3 : Rocks and Other Land

Give some thought to the quality of rocks, to the material that goes into their composition. They are hard, so a bold stroke should be used; they are rough, so the brush should be dry. Sometimes the stroke is started with a partially wet brush and ended with a dry brush as the ink flows out, but a wet brush alone is reserved for very smooth pebbles or boulders in a stream. Rocks take on many strange shapes, but they may be broken down for our purposes into a few geometric patterns (Fig. 145): the triangle, square, rectangle, pentagon, and so forth. The Chinese poetically refer to the three dimensions as the three "faces" of a rock, these faces being created by the modeling brush strokes.

Use brush No. 3 or No. 4 and a medium or dark shade of ink. Hold the handle of the brush at a slant so the *side* of the tip touches the paper, pointing to the left. Begin with a rock in a simple triangular shape. Start the stroke on the left side at the base and pull from the base to the apex in a bone stroke (Fig. 146 *a*). Pause, and then continue down the right side to the base, pressing heavily on the side of the brush hairs for the length of this stroke *(b)*, the brush still pointing to the left. Press even more firmly at the end of the stroke and lift. Go back to the starting point and close the base of the rock with another bone stroke *(c)*, heavier than the first side, but lighter than the second. The same general technique may be used for all rocks, no matter what their size or shape.

Be careful not to make the mistakes in Fig. 147: *(a)* is too wet and smooth; *(b)*, too concave; *(c)*, too round; and *(d)*, again too wet and smooth.

Now try a rock with five sides. Start as usual on the left (Fig. 148). Then cross over the top and bring the brush down heavily on the third, or right, side. Begin again at the starting point and brush over to the right in a shallow "V" stroke, closing the base. This V-shaped stroke brings the rock out on top of the ground; a flat base will give the illusion of a half-buried rock.

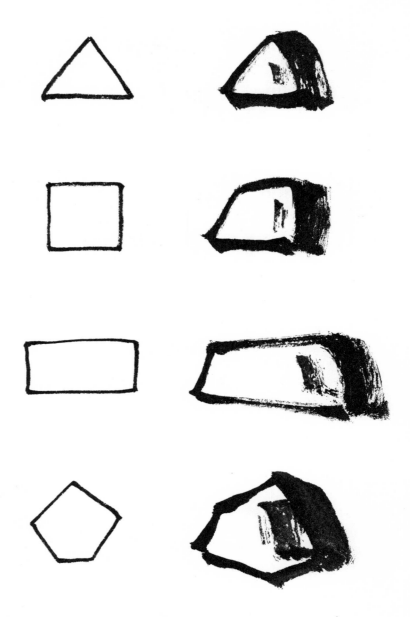

145. Shapes for rocks.

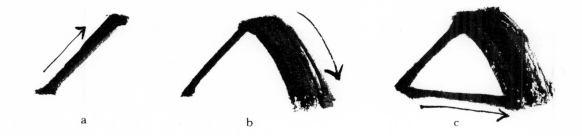

146. Painting a triangular rock.

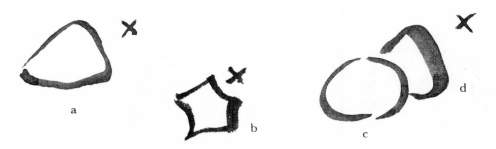

147. Common mistakes made in painting rocks.

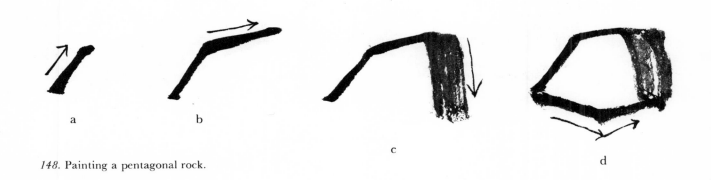

148. Painting a pentagonal rock.

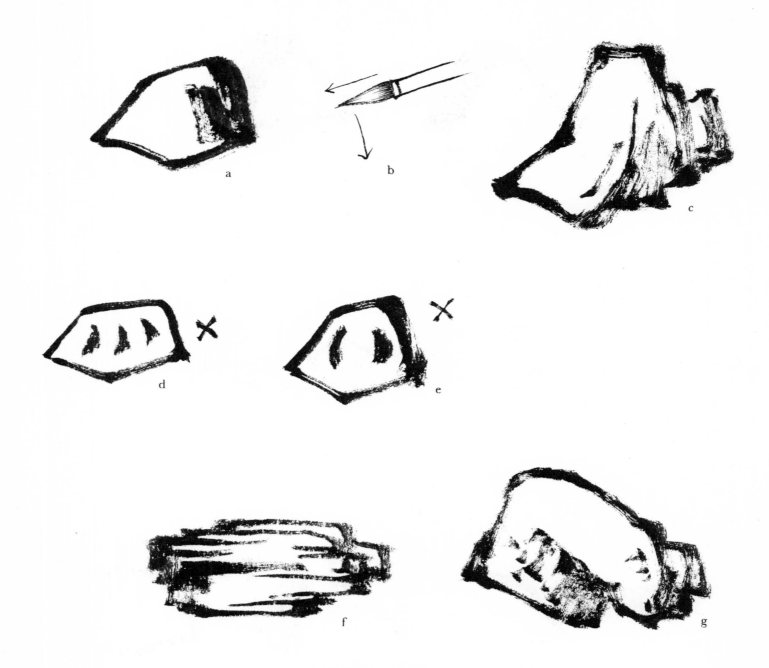

149. Modeling strokes on a rock.

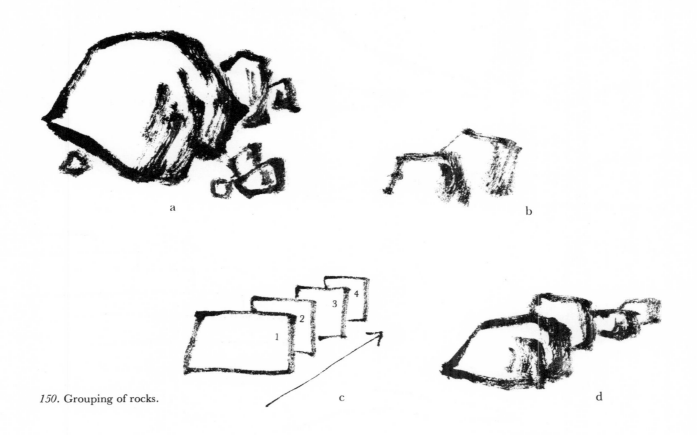

150. Grouping of rocks.

More strokes should be brushed in on the right side or face of the rock to create a suggestion of shadow (Fig. 149 *a*). These modeling strokes are usually done with the brush tip pointing to the left and then pulled down as in a bamboo stalk *(b)*, but you should brush upward on some modeling strokes *(c)*. Modeling strokes should always be kept to one side or the other of a single rock or group of rocks, not daubed on helter-skelter *(d, e)*. In another type of rock formation, the modeling strokes are horizontal *(f)*. The modeling strokes also have fascinating names, such as the axe cut *(g)*, and a number of others are listed at the beginning of Chapter Three, Lesson 1.

To the Chinese, all rocks are alive with *ch'i,* the spirit which pervades all nature. They think of a group of small rocks as children gathered about the father, a large rock (Fig. 150 *a*). There are many other descriptive terms for rocks, such as alum head, water-chestnut top, and so on.

There are a few more points to keep in mind. Rocks projecting from water should not have their bases painted *(b)*. To create the illusion of perspective, paint some rocks behind each other *(c)*. Follow the pattern and place the rocks in a rising stair-step sequence *(d)*. After you have tried a few small rocks of your own, trace the ones that are illustrated and then copy them freehand on newsprint. When painting rocks, keep uppermost in your mind the primary rules: dry brush and rough bold strokes.

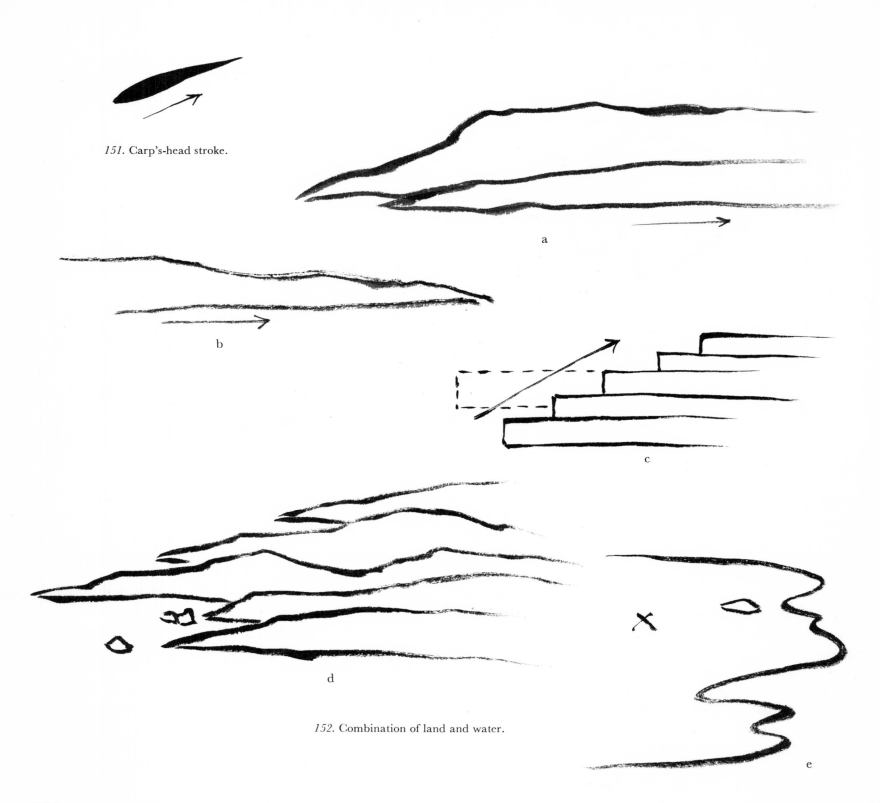

151. Carp's-head stroke.

a

b

c

d

152. Combination of land and water.

e

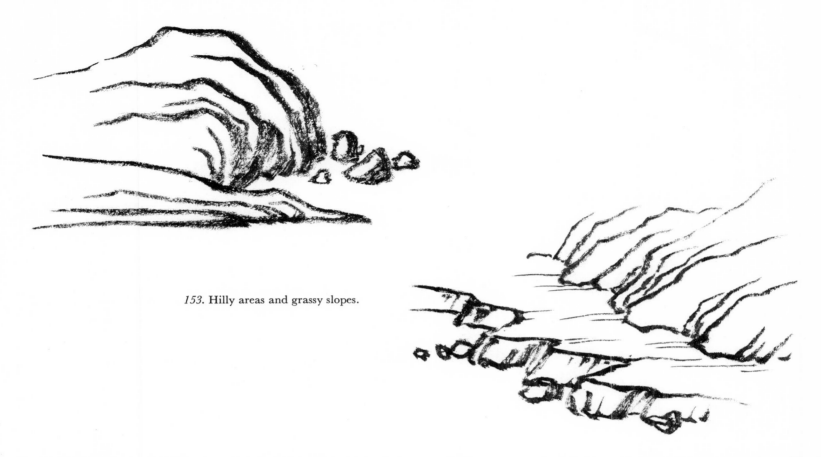

153. Hilly areas and grassy slopes.

Small hills, flat grassy areas, and points of land reaching out into water are all painted with the same technique. The brush should not be dry, as it is when painting rough rocks. The stroke for these land areas is called a carp's-head because of its resemblance to the head of a fish. It is made by holding the brush handle at a slant, the tip pointing to the left. Instead of dragging the brush hairs at a right angle to the direction of the tip, this time pull *with* the hairs of the brush, so the stroke travels from left to right as in Fig. 151.

For land jutting out from the right (Fig. 152 a) press at the beginning of the stroke, lifting, rolling, and pressing the brush as it moves across the paper. Press and lift again, in an undulating rhythm. Finish the stroke over the top and then at the base of the slope, ending in a rattail. Reverse the process for a point of land issuing from the left (b),

still of course adhering to the left-to-right motion. To be sure your points of land "lie down" on the water, again follow the stair-step pattern (c). For sake of variety, have some points jut out farther than others and add a few small rocks. The stroke over the top of the slopes should rise and fall in an uneven line, but the base should always be fairly horizontal (d). Do not try to outline a water area as in (e). Remember that the points of land must lie behind one another.

Hilly areas or grassy slopes are painted with a smoother stroke (Fig. 153). When painting these areas, use the same technique of pressing and lifting the brush to obtain an undulating line. Sometimes these strokes begin and end with very light pressure, for a very thin line; at other times they are started with the carp's-head stroke and ended with a heavy stroke, such as is used in painting rocks.

Lesson 4 : Figures and Animals

Figures and animals when included in a landscape are painted very simply and are generally quite small in comparison to the size of the over-all painting. They are considered not too important a part of the landscape, only incidental to it. Figures are usually classified as literati (poets, teachers, philosophers, or merchants) who are clothed in long robes or as laborers (fishermen, farmers, and apprentices) who are clothed in coat and trousers, which are sometimes shortened to bare their arms and legs.

Philosophers are shown wandering through the hills, talking (Fig. 154 a), walking or riding along paths in the woods, standing and meditating on nature, or perhaps seated, reading (b). Others may be drinking wine (c) or tea (d), or playing musical instruments such as the moon lute (e). Those of the working class carry their master's packages or other bundles (f), brew and pour tea, sweep (g), peddle their wares (h), or work at their trades. The philosopher type of figure should have sloping shoulders and a drooping languid posture, while the laborers naturally have better developed physiques.

The strokes used in painting people and their clothing are light in shading, wet, and smoothly rounded to convey the substance of skin and cloth. To indicate folds of clothing, bone strokes, rattails, and long teardrop strokes are used, singly or in combination. Start by tracing one of the figures. If you follow the rules for painting figures while tracing, it will help you when you are painting them freehand.

a

b

154. Literati and laborers.

c

d

e

f

g

h

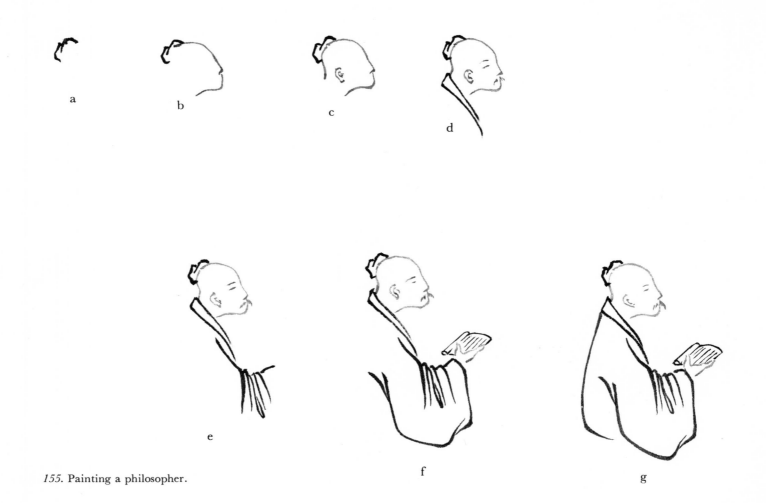

a

b

c

d

e

f

g

155. Painting a philosopher.

If a hat or other headdress is worn, it is painted first, using black ink (Fig. 155 a). If there is no headdress, start from the crown of the head and paint down over the forehead. Continue down over the face and under the chin, using a very fine stroke and a light shade of ink (b). Begin again at the crown, this time stroking in the back of the head and down the neck (c). Complete the suggestion of the features, although they are often left out entirely on small figures. Continuing from the back of the neck, add the collar in black ink (d). Next, come down over the

top of the sleeve to the elbow and wrist in a medium shade of ink (e). The back of the sleeve, and in this case also the hand holding the book, are done next (f), bringing the stroke from under the armpit to the end of the sleeve and up to the wrist again. Now paint the line of the back from the neck to the waist (g) and then the stroke or strokes from the waist to the hemline (h). The next stroke is started under the sleeve for the front of the robe (i), and last is a connecting bone stroke for the hem of the garment (j). Complete the hair, mustache, eyes, and brows in black ink.

h

i

j

156. Recent Chinese clothing.

a

b

c

d

157. Headdresses.

The Chinese did not study anatomy for the painting of figures, but instead the folds and drapery of the figures' clothing, which were to them more important in telling the story. Dress styles frequently are of the Sung dynasty, the period in which landscape painting reached its highest peak of excellence. Do not make the mistake of dressing your figures like the one in Fig. 156. Clothing of that sort was worn recently in China and is not appropriate for landscape painting. The headdress worn by the higher classes was sometimes simply a length of cloth, wrapped about a bun of hair at the crown of the head (Fig. 157*a*), or a stiff hat of black silk *(b)*. Laborers should wear straw hats *(c)* or a cloth tied around the forehead to keep the sweat from dripping down into their eyes *(d)*. The figures shown in the mountains or along the roads are men, as women stayed in their homes and courtyards as a rule—but if traveling, they should be seated inside a sedan chair or cart.

In painting flesh, the shade of ink should be very pale; for clothing, a medium shade; and for shoes and hats, very dark.

Small animals and birds are also included in some land-scapes. Favorites for country scenes are farmyard animals or fowl (Fig. 158), such as chickens or ducks, waddling about in their yards. Cranes, geese, or ducks are often depicted flying or swimming, and horses or donkeys make trusty mounts for their masters. A flight of birds in the distance can be indicated by painting a series of small V-shaped strokes, a combination of the teardrop and a flicking stroke. The bird in the foreground would of course be the largest, with the others diminishing in size as they recede into the distance. Change the angle of the wings on each bird a little so they will seem to be buffeted by the wind.

158. Birds and animals in a landscape.

a

b

c

Lesson 5 : Dwellings

Next in the order of painting a landscape are houses, bridges, temples, and walls or fences.

Houses in the country generally have grass or thatch roofs (Fig. 159 a) and walls made of mud. The eaves of the roof should extend well beyond the walls to create the appearance of a low building hugging the ground. In (b) we see a country house in the near distance. Houses in towns or cities, and sometimes those in a country village (c), have tiled roofs as a rule. The lines for the tiles are painted very precisely as they must all be parallel. The walls, doorways, and windows as well as any small railings or balconies should be painted in detail with each stroke straight and true. In (d) and (e), note how intricate town houses are, with their tiled roofs, marble balustrades and stairs, pillars, lattice windows, and decorated eaves and roof lines. Obviously this type of house is the more difficult to portray, so it would be wise to start with country houses, the lines of which may be a bit shaky anyway. The difference in the precision required can be seen by a comparison of the doorway to the courtyard of a city house in (f) or the city gate in (g) with the rustic gate in (h). The technique for bridges, temples (i), and walls or fences is the same. If they appear in a country setting, use casual strokes; if of intricate construction, more precise lines are needed. First trace the houses and other examples in the illustration and then copy them freehand on newsprint.

d

f

g

h

e

i

159. Country and city dwellings.

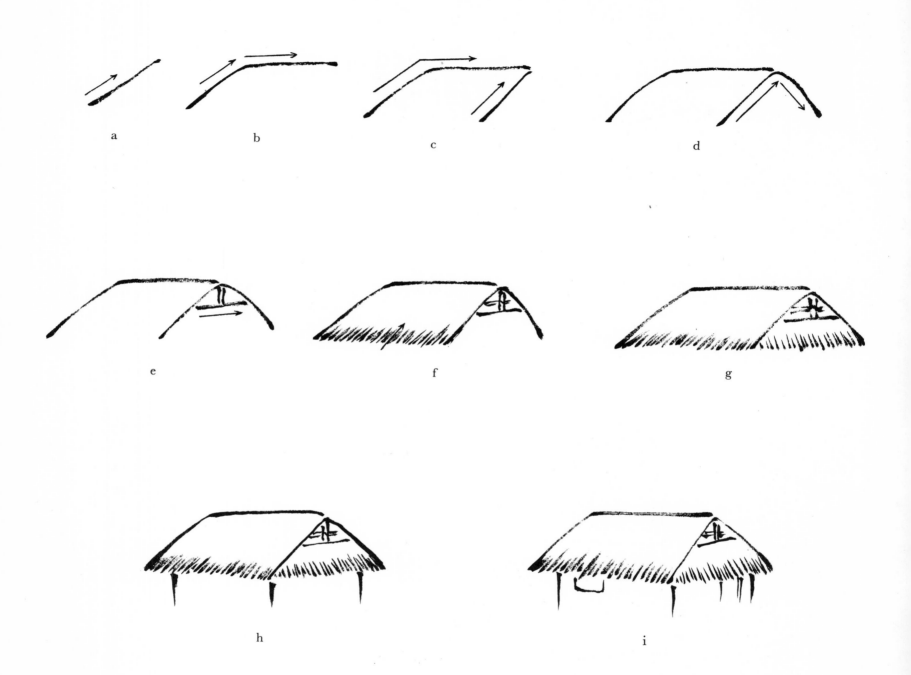

160. Painting a country house.

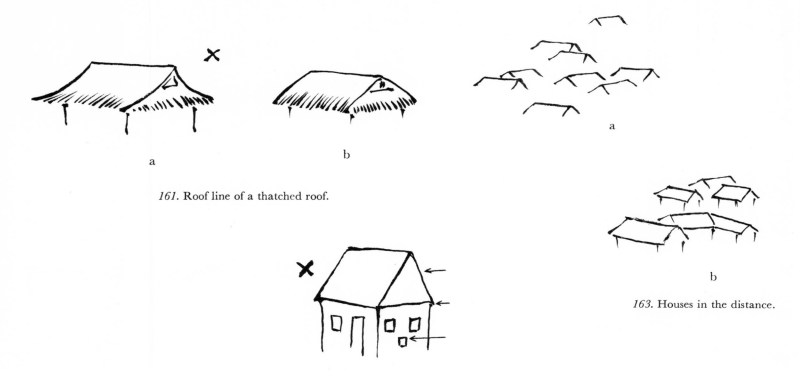

161. Roof line of a thatched roof.

a

b

a

b

163. Houses in the distance.

162. Common mistakes made in painting houses.

For a country house use brush No. 1 or No. 2 and a medium shade of ink. Start by painting the roof line, for which you first pull up from the eaves on the left and pause at the peak (Fig. 160 *a*). Then continue across the top of the roof with a bone stroke *(b)*. Pull up again with a modified hook stroke, this time from the eaves in the right foreground *(c)*, and continue down again in a long straight teardrop *(d)*. Fill in the cross line of the roof with another bone stroke *(e)*. Then with a dry brush indicate the thatch by painting a row of short rattail strokes along the line of the side eaves, in the direction indicated in *(f)*, and a row of short straight teardrop strokes along the line of the end eaves *(g)*. A nailhead stroke descending from the eaves at three points will place the walls *(h)*. Set these strokes well in from the corners and keep them short to give the house a low, squat appearance. One window and a door, which are usually enough apertures, may be placed

in the walls *(i);* a little irregularity in the strokes outlining these openings adds to the rustic atmosphere. The Chinese say doors and windows are the eyes and eyebrows of a house, and they caution the student not to put in too many as the house would then be like a person with three eyes and four eyebrows . . . a monstrosity! Also, be careful not to let the slope of the roof line on a thatched hut look like that of a tiled roof (Fig. 161 *a*); thatch should droop toward the ground *(b)*. Fig. 162 illustrates the faults most often found in beginners' work: too steep a roof, walls placed too far out under the eaves, and too many windows and doors. When you are painting houses in the distance, remember that those in the far distance show only the roof lines (Fig. 163 *a*) and those in the middle distance show more of the eave lines and the walls *(b)*. This technique used for the country cottage may also be applied to city dwellings. The same order of strokes is also used for gates.

Lesson 6 : Boats

There are many kinds of boats, ranging from small skiffs, fishing boats, and pleasure barges to river or sea-going junks. In painting any of these craft, use a medium shade of ink and brush No. 1 or No. 2. Trace the examples in this lesson first and then practice painting each one free-hand on newsprint. The near side of a boat is painted first, beginning with the line of the deck (Fig. 164*a*). Then add the hull lines, lifting the brush before the lines are completed, so that they seem to disappear below the water level *(b)*. Next, on the deck is usually painted a house or shelter *(c)*, which is given a cover of straw matting *(d)*. Space must be left for the figures, which are painted next *(e)*. The final stroke adds the far side of the deck *(f)*.

Shelters are built on most boats and are usually covered with woven rattan or straw matting, which the enlarged illustrations in Fig. 165 will help you to paint. First outline the shed in the same way as you outlined thatched roofs *(a)*, and then outline the pieces of matting and the window and paint the inside supports *(b)*. To paint the straw, first make horizontal and crisscrossed bone strokes, which should curve if the mat curves *(c)*, and then add more bone strokes for the various weaves *(d)*.

164. Painting a boat.

a

b

c

d

d

e

f

165. Painting a straw-matting shed.

166. Various boats and boatmen.

The larger the craft, the more complicated will be its construction, for the obvious reason that more people should be manning it. On a large junk the sails may be hoisted or furled (Fig. 166a), and at times it has a small skiff tied alongside. Figures on large junks ought to be occupied with tasks such as pulling on the lines of a sail, poling, mending nets, or perhaps keeping the boat from hitting rocks or cliffs by means of long bamboo poles (b). In a small skiff the figure may be seated, looking out over the water, or standing to pole the boat. Boxes, jars, or baskets containing vegetables, oil, or fish may be piled on the deck (c). A boat might also be at anchor in a quiet harbor (d). Passengers on a barge or skiff are generally seated, looking out at the water (e), conversing, or perhaps drinking tea.

Boats in the distance, be it the near distance (Fig. 167a), the medium distance (b), or the far distance (c), are the simplest of all. For those in the far distance, paint only the sail, or the sail and one small stroke to suggest the hull. Using a lighter gray shade of ink also helps to place them in the far distance.

167. Boats in the distance.

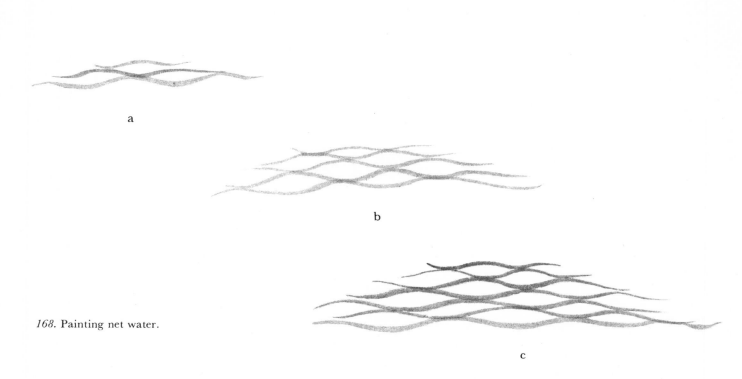

a

b

168. Painting net water.

c

Lesson 7 : Water

To the Chinese, water is the blood which flows through the veins of the mountains, so it too has *ch'i* or spirit. It is classified in many ways: net water, waterfalls, rushing streams, quiet pools, and ocean waves and crests. The ink should always be a very light shade and the brush wet. Use brush No. 1 or No. 2.

Net water, rippled by the wind, gets its name from its resemblance to fishermen's nets. It is painted by holding the brush handle slanting at an angle, resting the arm and side of the hand *lightly* on the table, and pulling the stroke from left to right. Alternate pressing with lifting and let the brush move in a smooth undulating motion. After you have completed one wavy line, the second should be placed just under it, with the crests of this line of ripples touching the troughs of the first line. This is continued until as much area as you wish has been covered, but be careful to keep the area in the general form of a diamond. For

example, if you have already completed three rows of waves for the start of a patch of net water (Fig. 168 *a*), two more lines of waves are added below these, each line longer than the one before *(b)*. The sixth and seventh rows may reach the widest point, and then the lines begin to shorten *(c)*. More rows are added until the diamond-shaped pattern is formed *(d)*. Let some rows be long or short at random, as an absolutely perfect diamond would not be natural. A square patch is much too stiff *(e)*, so be careful to watch your pattern as it progresses. Net water may be used near the banks of rivers or lakes *(f),* or it may be placed around boats, rocks, or reeds out in the water of quiet rivers or lakes.

The same technique when exaggerated into high waves may be used for ocean water, but here, extra strokes should be added to model each wave and to represent crests of foam (Fig. 169). The water of a rushing stream is painted in smooth swirling lines, scalloped here and there, and fingers of foam are surrounded by tiny circles of spindrift.

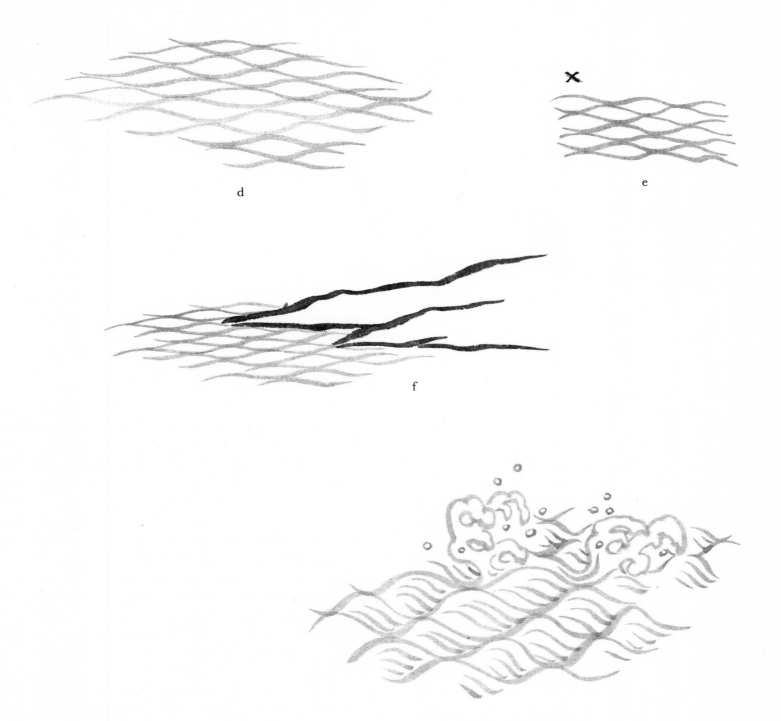

169. Ocean waves and crests.

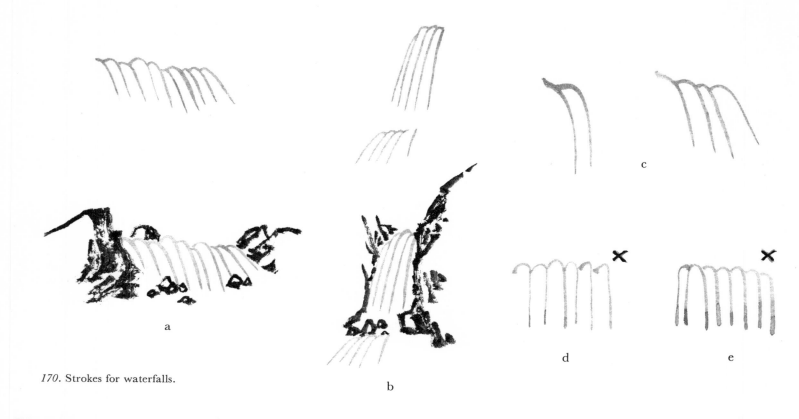

170. Strokes for waterfalls.

Waterfalls are placed in rocky formations (Fig. 170). Whether they are wide and shallow *(a)*, or high and narrow *(b)*, the water is painted first and the surrounding rocks second. The fall of water is painted with rattail strokes which rise in an arc and then fall downward *(c)*. Small rocks may be placed at the head and foot of the falls after the water is completed. The beginning of each rattail issues from the side of the preceding stroke, but do not let these strokes look like walking canes *(d)*. The water is usually shown falling to the right or left, not directly to the front *(e)*. There should be some variation in the height and width of the arc of each stroke, with the general slant of the top of the falls going in the same direction as that of the flow.

Since reeds grow in ponds and lakes, notes on painting them are included here. The stems rise out of the troughs and billows of net water. Use a quick, flicking rattail stroke and dark ink. As reeds are usually blown by the wind, the stroke may curve as it comes up out of the water. Let the strokes for the stems point in at least three different directions (Fig. 171), making some stems curve up, some out, and others bend over. Remembering to travel down into the troughs and up over the billows, start with the stems *(d)* and then add leaves *(e)*. Leaves, which should be quite small, are placed on the stems with a stroke like that used for bamboo. Start the leaf stroke with the tip of the brush pointing toward the roots and lined up with the stem *(f)*, not at a right angle to the stem *(g)*. Then flick away from the stem. Place the leaves at varying angles to give a feeling of wind blowing. Some should point up, some out, and some down, but all in the same general direction (either to the right or the left, but not both). Do not let the reed patches blow in different directions either *(h)*. Stems should be thickly massed, but few leaves grow on these reeds. Too few stems and too many leaves give the stilted effect seen in *(i)*.

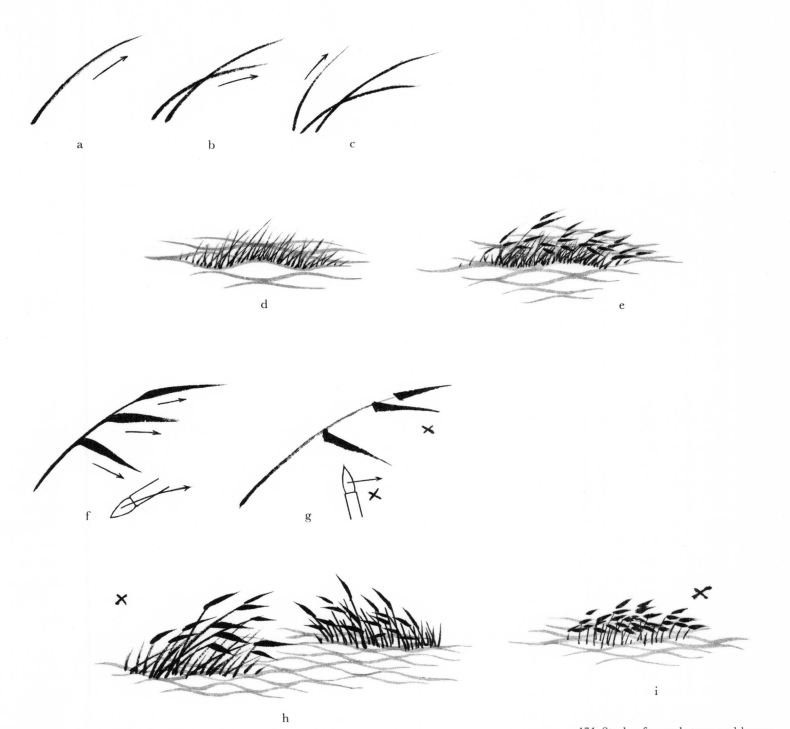

a b c

d e

f g

h i

171. Strokes for reed stems and leaves.

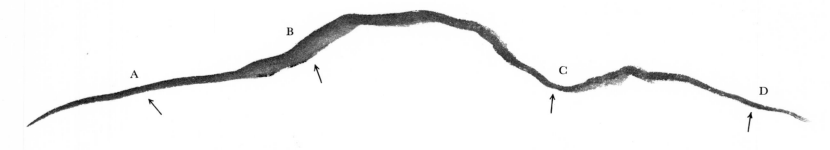

172. Painting a mountain range.

Lesson 8 : Distant Hills and Mountains

Strokes for painting distant mountains are very similar to those used for water. In this case there is much more freedom in the undulating motion however, and the brush should be twirled in the fingers as the stroke crosses the paper. For distant mountains, use a light shade of ink and a wet brush because their outlines are dimmed by mist. Start each hill or mountain range with the brush off the paper, pointing to the left. Your hand can touch the paper lightly as the brush is in motion, because the muscle tension should be in the upper arm. Swoop down on the paper in the manner of an airplane landing (Fig. 172*A*). Twirl the brush, pressing and lifting to make the stroke thin in some places and thick in others *B,* with undulations to indicate the valleys *C* and the mountain crests. End the stroke by lifting gradually like an airplane taking off *D*. If you always begin and end the strokes this way, the hills will seem to be surrounded by mist. This rule should be observed even more carefully when painting ranges of mountains lying behind other ranges. Notice the degrees of shading in each of the mountain ranges in Fig. 173*a*. Working from the front to back, the pressure on the brush becomes lighter, the line finer, and the shade of ink lighter with each succeeding row. Some of the mistakes more commonly made by students in painting mountains are shown in *(b)*. The brush strokes are too heavy, too uniformly dark, and each stroke is connected to the other strokes, giving a sluggish and dreary look to the hills. Remember that mountains should be majestic and awe-inspiring.

The method for painting clouds is like that used for painting turbulent water: smooth, sometimes scalloped strokes painted in very light ink. Notice that even though Fig. 174 is very smooth, you can still see the effects of the varied pressure on the brush which modeled each stroke.

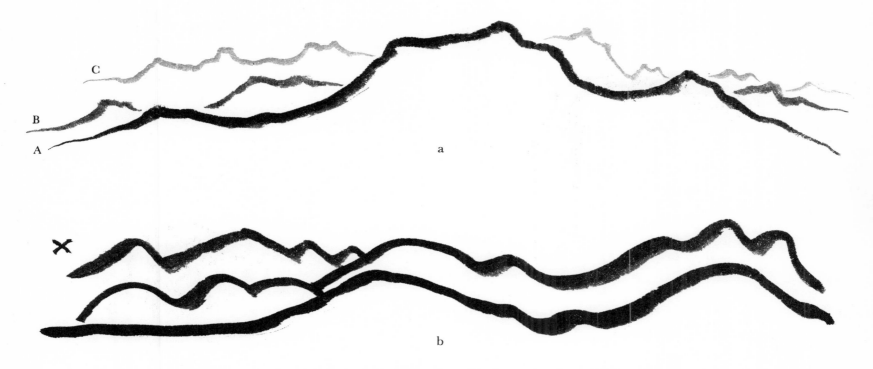

173. Rows of mountain ranges and common mistakes made in painting them.

174. Cloud formations.

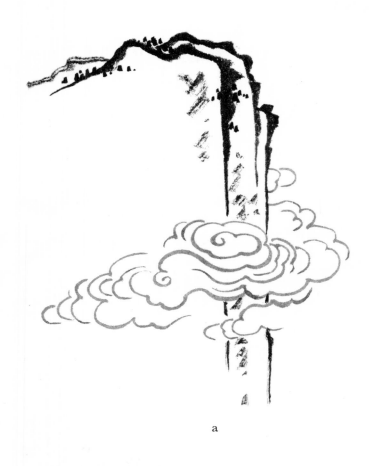

a

b

175. Clouds in a mountainous area.

Clouds should not be placed in an open sky. In Chinese painting they seem more at home in the high mountains, wrapped like scarves around craggy peaks or veiling parts of waterfalls or foliage. The clouds may be outlined in the strokes just described (Fig. 175*a*), or the cloud area of the painting may be left completely untouched *(b)*. In this case, the ink or color wash is brought to a point *near* the cloud and then clear water is washed between to soften the edge of the ink wash. More extensive instruction in this technique is included in Chapter 6.

176. Nine-square pattern.

a

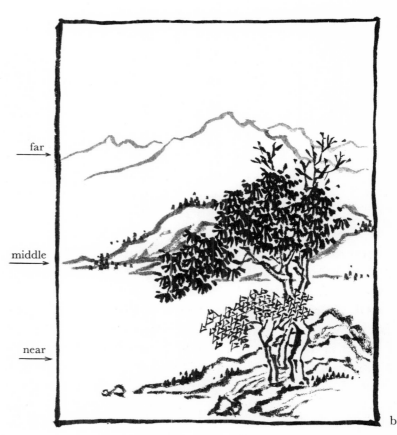

b

177. Relative distances in a painting.

Lesson 9 : Landscape Composition

The principle of balance is important in all composition, so the test of the nine-square pattern (Fig. 176) may be used on a landscape too. When utilizing a medium as permanent as Chinese ink, it is also a great help to prepare a *kao tze* so that mistakes can be corrected before the final painting is traced. Not much emphasis is placed on perspective in Chinese painting, but distance is nonetheless clearly indicated by dividing the composition into three sections representing near, middle, and far distance (Fig. 177 *a*). Trees and hills in the foreground are located in the lowest part of the painting; those in the middle distance are placed in the center; and those in the background, in the top section of the composition *(b)*.

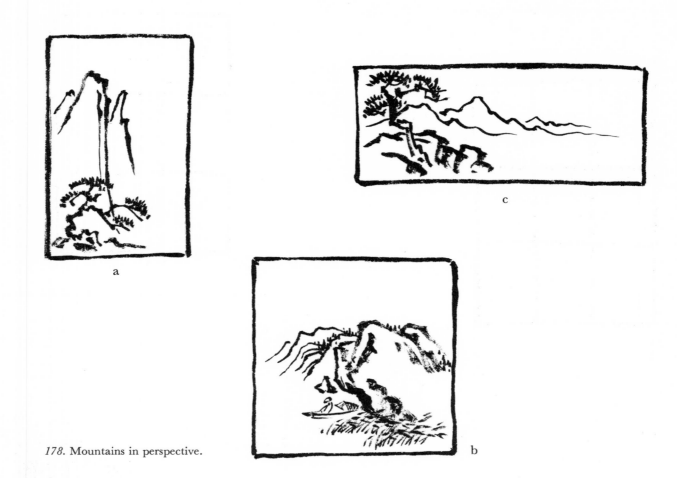

178. Mountains in perspective.

Mountains are drawn in such a way that they convey the impression of perspective in height (Fig. 178*a*), depth *(b),* and on the level *(c).*

One of the most important rules to consider when planning a composition is to give one element the place of honor. If a tree is to be the main point of interest, all the rest of the landscape is subordinate to the tree. A mountain may be the portion of the composition which you wish to emphasize, in which case trees, figures, and so forth would take a secondary place. Do not place this point of primary interest at dead center but have it lie to the right or left and above or below the middle plane of the painting.

A crowded composition is one of the "twelve faults"

spoken of by a critic of the 13th century. Jao Tze-jan said, "like a full stomach, it no longer has any expression." Fig. 179 is a prime example of an overcrowded composition. It includes each of the eight elements mentioned in this chapter: trees, foliage, rocks and other land, figures and animals, dwellings, boats, water, and mountains. To avoid overcrowding, it is wise to choose only three of the eight elements for a single composition. For example, plan a composition containing only trees, mountains, and a house (Fig. 180*a*); or foliage, water, and a dwelling *(b);* or a boat, mountains, and figure *(c).* It is better to err on the side of oversimplification at first than to find your painting has been "overfed" and has no expression.

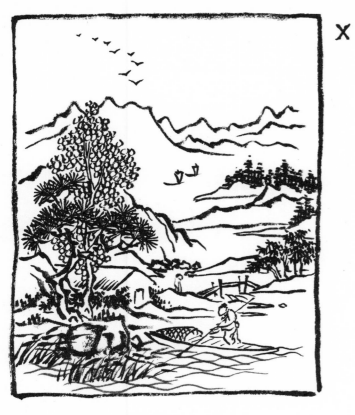

X

179. Overcrowded composition.

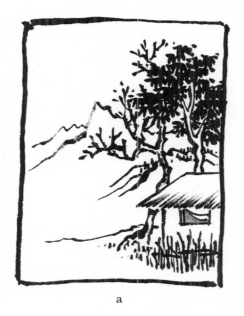

a

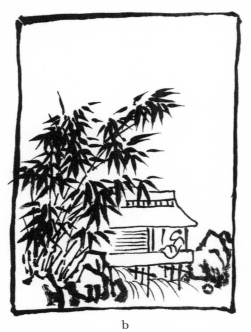

b

180. Compositions containing three elements.

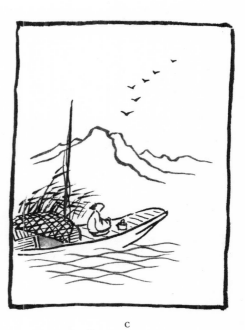

c

6

Use of Color

Ah! Considering the vastness of the heavens and the earth, looking around at people and things, reading polished essays, listening to the brave utterances, all these things go together and make a whole and colorful world. . . . Today so many people live in limited and colorless worlds. How may they be offered a fuller life and contentment? Pictures are one means, so let us speak of painting.

—MAI-MAI SZE, *The Tao of Painting*

THE METHODS used for coloring Chinese paintings differ in several ways from those of Western art. For the *ku fa* style, layers of flat color washes are built up, one after another, until the desired intensity is reached. Clear water is used throughout the process for blending colors from dark to light shading. Color is applied carefully, completely covering all the outline strokes. When used on Oriental paper or silk, the black ink is permanent after it is dry and has had time to set. Color may be brushed over the black lines any number of times without fear of the ink's running or bleeding into the color. This may not be true when Oriental ink is used on any other type of paper, so be careful. Experiment to be sure.

When painting *mo ku* style in color, less care is needed. In fact, water-color or pastel paper may be used, because the color is applied in one wash using stronger hues. Accent marks in black ink are brushed on top of the color.

For *ku fa*, a non-absorbent paper is generally best; for *mo ku*, absorbent paper, which is made in many grades, sizes, and degrees of absorbency, will produce the best effects. If you are able to obtain Oriental rice paper, rub it between your fingers to determine which side is smooth and which is rough. Use the smooth, sized side for *ku fa* and the rough, unsized side for *mo ku*. Experiment with various papers a little to see which is best for your purposes. If the ink does not flow onto the paper smoothly, there may be oily spots on the paper's surface. Silk also has this fault sometimes. Try rubbing the spots with a piece of wool or with dry-cleaning fluid on a soft cloth before painting over them. Scrubbing a little with the wet brush will also help the ink and color to go on more smoothly. Painting silk is obtainable in bolts of various widths. It is especially sized for use with Oriental inks and pigments and is strong but very sheer. For this reason, it is easy to use when tracing.

Colors are of two types, vegetable and mineral. Fig. 181 illustrates vegetable colors made in Japan and available either separately or packed in sets of twelve. Molded in cake form, these give the artist the soft, subtle effect neces-

157

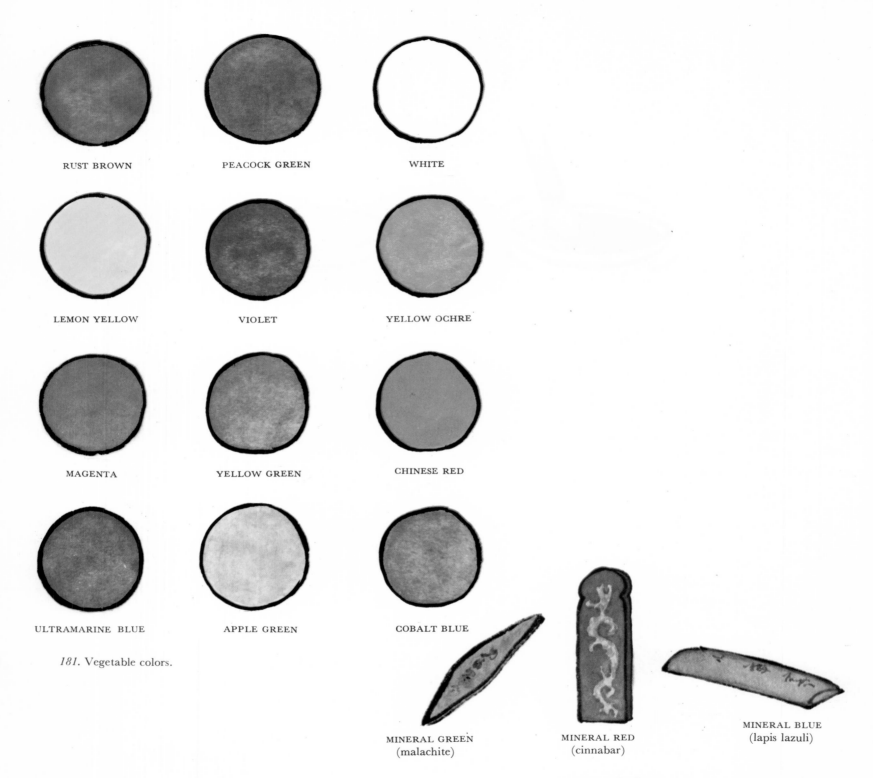

RUST BROWN

PEACOCK GREEN

WHITE

LEMON YELLOW

VIOLET

YELLOW OCHRE

MAGENTA

YELLOW GREEN

CHINESE RED

ULTRAMARINE BLUE

APPLE GREEN

COBALT BLUE

181. Vegetable colors.

MINERAL GREEN
(malachite)

MINERAL RED
(cinnabar)

MINERAL BLUE
(lapis lazuli)

182. Mineral colors.

183. Transferring color to the saucer.

sary for landscapes. Mineral blue and mineral green also are available in this form.

Mineral colors are usually made in stick form (Fig. 182) and can be ground on a stone just as the ink stick is, or come in powder form which is then mixed with glue and water. Semiprecious stones such as lapis lazuli and malachite are used extensively for this purpose. Mineral colors, being very bright, are used mainly for flower and bird painting, ornaments on headdresses, or for special accents. However, one school of landscape painting was built around the use of mineral blue and green on rocks and mountains. If it is not possible to find Oriental colors, you may try using tempera when doing *mo ku,* although the others are preferable.

No matter which form you use, colors are mixed in the same way. For each color, place a small amount of water in a small bowl or saucer. Pull a wet brush around in a circular motion on the color to pick some of it up (Fig. 183 *a*) and then dip the brush in the water again and stir around the saucer *(b)*. To mix two shades, take the major color first and add the minor to it. For landscapes or for toning down too bright a hue, a small amount of black ink is usually added to make the color more subtle. Touching just the tip of the brush to the inkstone is enough, so go slowly and carefully when adding black. Graying by mixing two complementary colors is seldom practiced by the Chinese. Some schools advocate a gray wash, made by mixing a little black ink from the stone with water, over all sections of the painting as a first coat. Each time the brush is dipped in a bowl of color wash, stir a few times to be sure the color is well mixed and then press the brush against the side of the saucer to remove any excess color.

Brushes for applying color should be large and full, like No. 9. They are kept for this purpose only and never used with black ink. You should have a minimum of four of these brushes and reserve one for use with clear water only. This brush must be ready at all times to apply washes of clear water or to blend water into color in certain areas. Have two bowls of water ready, one for clear water and the other for rinsing brushes.

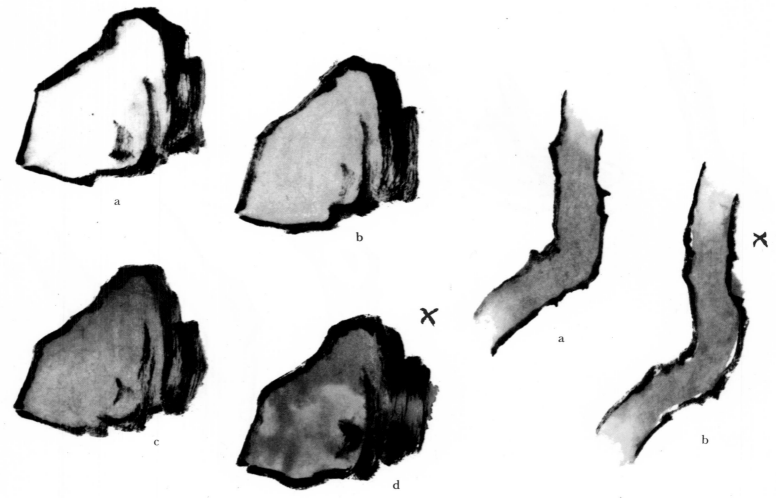

184. Coloring a rock.

185. Sealing color to the outline.

For the sake of caution, the first layer of wash applied to a *ku fa* painting should be clear water. If there were oily places on the silk or paper, the ink might still bleed a little in these areas. The layer of water will then be slightly grayed, and this sets the ink outline for all succeeding coats of color. Each coat should be pale, and the color should be applied in three, four, or more layers. This gives a more permanent color which is more easily controlled and results in the subtle, misty look so typical of Chinese paintings. Another good reason for building the color up so slowly is that any mistakes will not be so notice-

able if you have used a pale wash. On a rock for example, the first layer of color after the clear water wash (Fig. 184 *a*) is always brown *(b)*. Two more washes of color are then applied; the first is another layer of brown and the second is green, blended with water, used only over the upper half *(c)*. When only one layer of wash is applied, the result is too bright and the demarcation lines show *(d)*.

Use care when coloring over a *ku fa* painting to see that the wash covers the black ink outline. The color is then sealed to the outline just as meringue is sealed to the crust

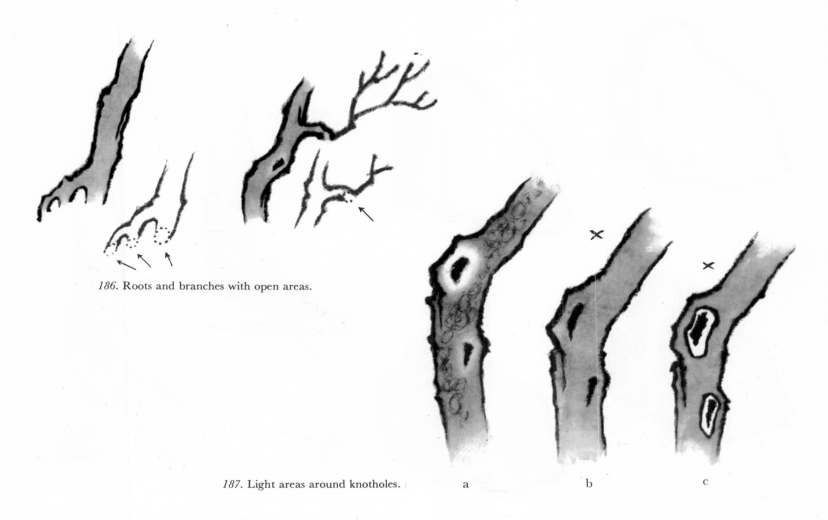

186. Roots and branches with open areas.

187. Light areas around knotholes.

a b c

of a pie (Fig. 185 *a*); otherwise the color recedes from the outline in some places and goes beyond it in others *(b)*. Use the tip of the brush to smooth the color wash along the edges.

Use absorbent facial tissues or soft paper towels to act as a blotter under the silk or paper when coloring, using weights of some sort on the corners to hold the material flat. Change this tissue as often as is necessary, as the color may transfer back onto the painting again. Tissues are used for blotting each color wash after it has been applied, but keep turning the tissue so you will not smear color from it onto your painting.

Color is applied in the same order as the ink outline was painted in a *ku fa* landscape: first trees, then foliage, rocks, etc. Begin with the branches of each tree and work down, putting a dot of clear water at any open or not completely outlined places, such as the roots and branches (Fig. 186). Knotholes should have a ring of water brushed around them because they are lighter than the rest of the tree (Fig. 187 *a*). In these areas, bring the color just to the edge of the water so the color and water will blend together as they touch. In *(b)* there are no light areas to emphasize the knotholes, while in *(c)* the surrounding light areas are too obvious.

It is important to keep the clear water brush absolutely free of other colors. It will pick up some tints in the blending process, so each time this brush is used, dip it into the water bowl, rinse, and shake the excess back into the bowl before using the brush again. Always use this brush, not the brush holding the color, for blending.

In a small area with an open side, it is possible to bring the color almost to the edge and then blend with water. In a large area, however, it is wise to cover the open side with water first and then blend color into it (Fig. 188 *a*). As shown in *(b)*, the areas to which water and paint are applied are distinct. After applying the clear water and then the color, blend the color using the clear water brush and blot with tissues *(c)*. If a coat of color is allowed to set without blending with water, it will leave a line of demarcation, so work fairly quickly in these open-end areas. *Mo ku* foliage is painted like the larger *ku fa* areas, and pine needles *(d)* are a good example. A border of water should be placed along the open edge of the cluster of foliage *(e)* before color is filled in. If only the color is applied with no water as in *(f)*, the edges will not be properly soft.

A small section which is completely enclosed may be washed with color only (Fig. 189), but it is safer in a larger enclosed space to cover at least part of the area with water first. A good rule to follow is: if a flat wash is desired, cover the entire area with water; if the color is to be graduated, cover only the lighter part with water and blend the color into it.

Fig. 190, a summer scene painted in four steps, may help you understand the process for painting summer, spring, or autumn landscapes. First the ink outline is applied to non-absorbent paper or silk by tracing over a prepared *kao tze (a)*. A clear water wash on all areas takes care of any bleeding of the black ink and effectively sets it for the succeeding coats of color *(b)*. Then two layers of color are brushed on, both layers covering all of the parts of the painting which are to be colored *(c)*. Two more color washes are applied, and a mountain without outlines is added to show great distance *(d)*.

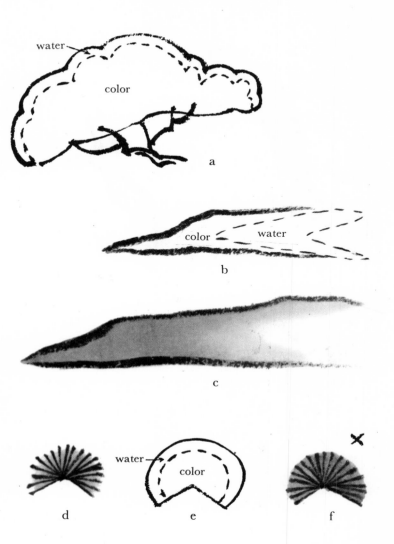

188. Blending of water wash and color.

189. Wash for a small, enclosed space.

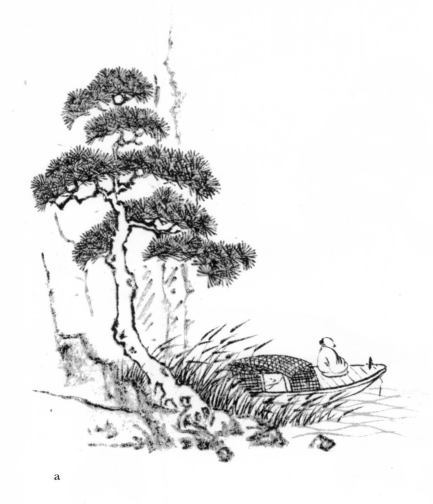

a

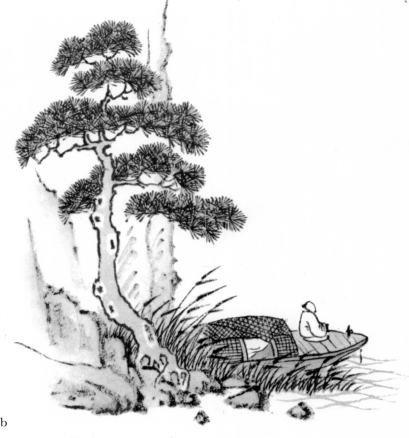

190. Painting a summer landscape.

b

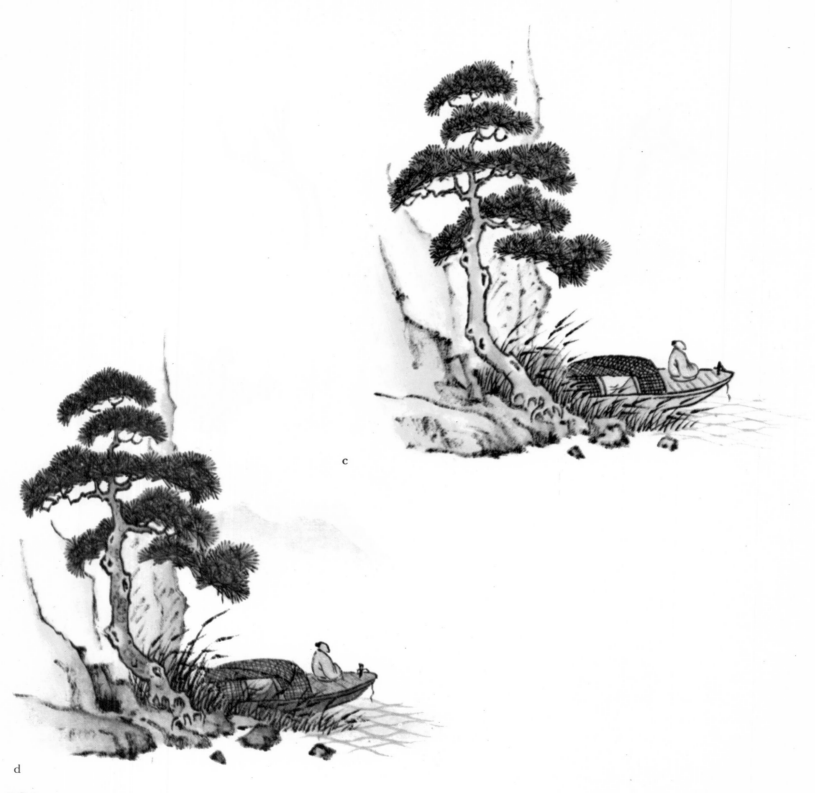

c

d

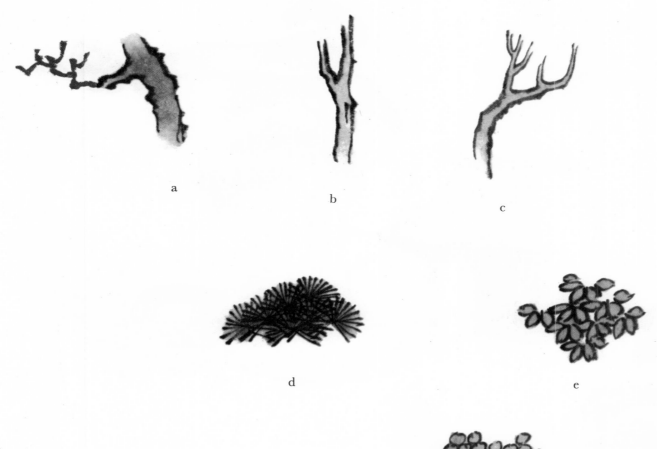

Following are suggested colors to use in landscape:

Pine trunks and branches—rusty brown. In Fig. 191 *a* rust brown was mixed with a touch of black.

Other tree trunks—gray browns. For *(b)*, a small amount of yellow green was added to rust brown. For *(c)*, more black was added to the mixture used in *(a)*.

Pine needles—blue green. For *(d)*, cobalt blue was mixed with yellow green and then black was added.

Other foliage—yellow green for spring; moss green, yellow, rust, etc. for summer and autumn. For the plane tree in *(e)*, yellow green with a touch of black was used; for the circle foliage in *(f)*, yellow green with yellow ochre; for the red leaf in *(g)*, rust brown with a touch of magenta.

191. Color for trees and foliage.

a

b

192. Coloring elements in a landscape.

Rocks and land—brown or gray brown always for first coat (because soil lies under the grass), sometimes layered over with moss green, yellow, rust, etc. for summer and autumn. For the land in Fig. 192*a* a layer of rust brown and then a layer of blue green was used; for the rocks, rust brown with black.

Houses—gray, beige, or brown for walls; blue gray for tile roofs; soft rust red for pillars and railings; yellow ochre for thatch. In *(b)* the gray walls and passageway are black ink grayed with water; the roof, ultramarine with black; and the pillars, rust brown with magenta. In *(c)* the thatch is yellow ochre mixed with a touch of rust brown. The beige walls are rust brown diluted with water.

Water—pale gray blue, used only in outlined areas.

Reeds, grasses, and moss dots on rocks—green, blue green. For the reeds in *(d)*, first a layer of yellow green was ap-

plied and then a layer of blue green. For the water, cobalt blue was used with a gray wash.

Boats—mahogany brown for wood; yellow ochre for matting; pure white for distant sails. For the wood of the boat, magenta was mixed with rust brown and black.

Figures, clothing—light mineral blue, beige, or brown mixed with black.

Mountains—gray brown for near; gray blue for distant. For *(e),* the first wash for the near mountains was rust brown with black and the second was yellow green with black. For the far mountains, cobalt blue mixed with gray wash was used.

Clouds—pale gray blue, only in outlined areas, laid on in diffused or shaded bands of color. The clouds are cobalt blue mixed with a gray wash.

Sky—no color at all; leave blank.

c

d

e

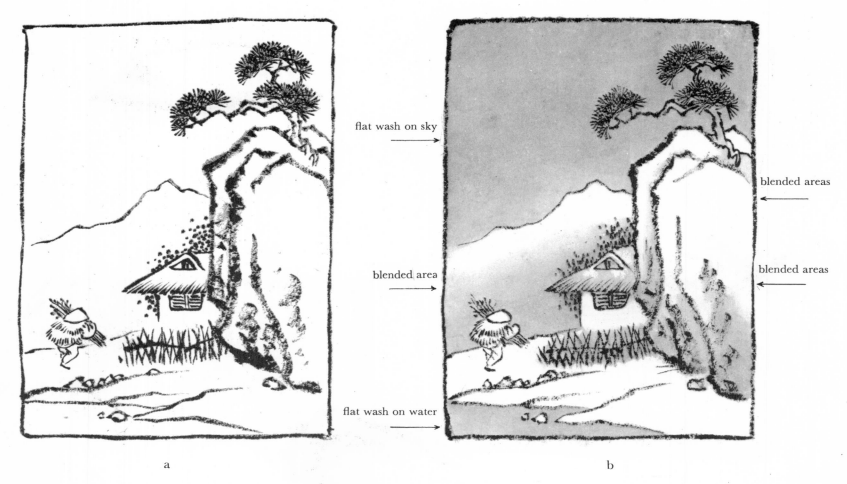

flat wash on sky

blended areas

blended area

blended areas

flat wash on water

a b

193. Painting a winter landscape.

For winter scenes, different rules are followed than for summer scenes. The outline is done first, being careful to omit modeling strokes from the tops of hills and rocks (Fig. 193 *a*). Sky and water areas are then covered first with a clear water wash and next with a layer of gray wash which is carefully blended with clear water *(b)*. Two more layers of gray wash are applied to build up a dark gray and then the first coat of the colors is painted *(c)*. You must blot after each area is colored to avoid a patchy effect. In this example, three more layers of gray wash were added, making six coats in all, and two more of color *(d)*. By build-

ing up the color and gray wash gradually, a smooth effect is achieved. Pine needles are shaded a dark gray, although the trunks are generally colored rust brown. Always leave the tops of mountains and rocks white, shading from dark gray below. Notice that this process is directly opposite to the method of coloring in a summer, spring, or autumn landscape. White as a color is not applied in this type of snow scene, but the "white" areas representing snow, in reality the silk or paper itself, look white by contrast with the gray areas. Spots of color may be introduced by including figures, houses, boats, or yellow bamboo groves.

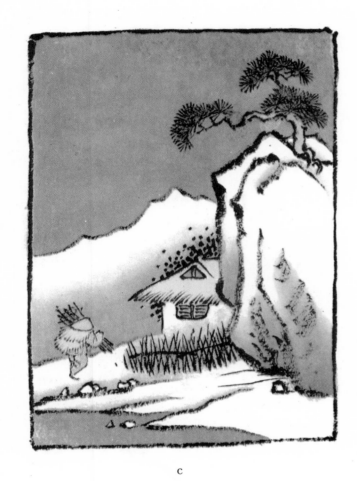

c

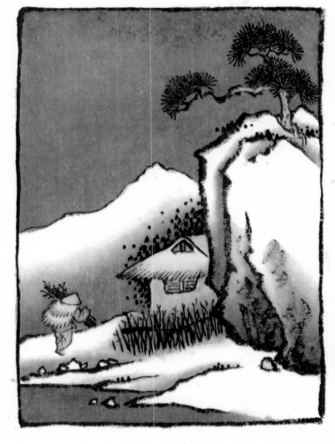

d

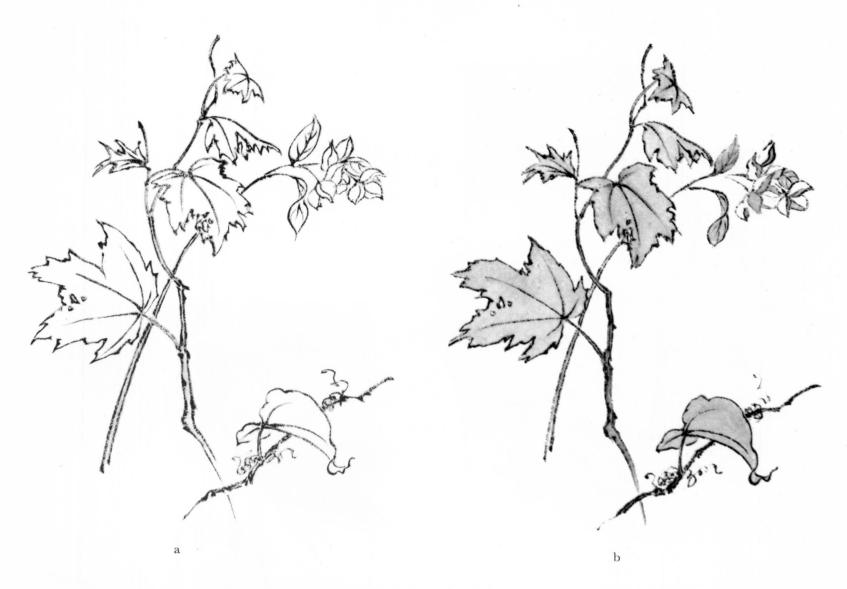

a

b

The technique of applying color to *ku fa* painting is the same for flowers, landscapes, or any other type of composition. In Fig. 194, a composition of leaves and seed pods, first the outline was done *(a),* then a clear water wash was applied followed by the first pale wash of the colors, which were yellow ochre, rust brown, and yellow green *(b).* These layers of colors were repeated and the rust brown edges of the holes eaten in the leaves indicated *(c),* and then the third and fourth washes were added to deepen the color *(d).* The thing to remember when using *ku fa* style for any painting is that the color washes should be built up in this way: the first coat of color is applied to all parts of the composition; then a second coat is washed over all parts, and so forth. Do not build up two or three coats on any one section before going on to the next because it is hard to judge how many layers will be needed when you are unable to make a comparison with the rest of the individual motifs in the painting.

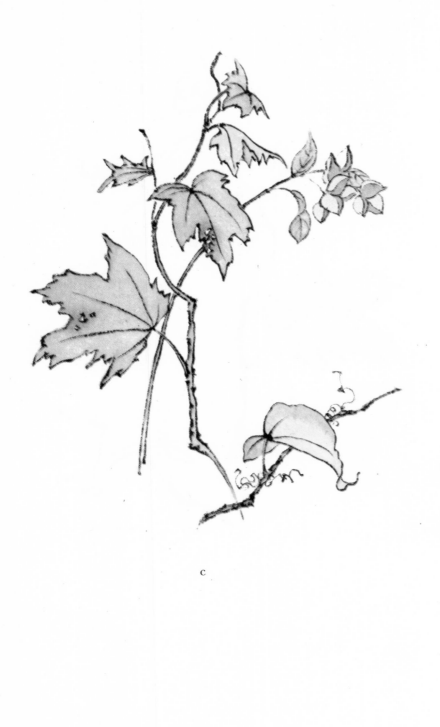

194. Painting a ku fa composition.

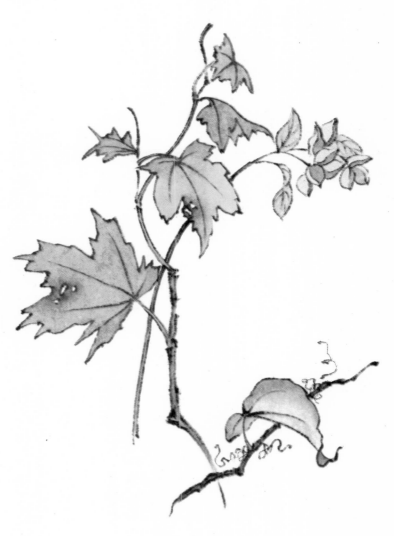

d

7

Flowers, Birds, & Insects

All the plants in the world rival one another in their beauty and give pleasure to the hearts and eyes of men. They offer great variety. Generally speaking, the wood-stemmed plants may be described as having a noble elegance, the grasses a soft grace.

—MAI-MAI SZE, *The Tao of Painting*

Lesson 1 : Flowers

Flowering plants are divided into two types, perennials (ligneous or those with woody stems) and annuals (grasses or herbaceous plants). The two main styles of painting, *ku fa* and *mo ku,* are both used for flowers. Generally, after the plan or conception of a floral composition is complete, the flowers and buds are painted first, the stems and stalks next, and the leaves last. This general rule holds true for all varieties of flowers painted in the outline style. The peony is a typically Chinese flower and can serve as a basic type for guidance in painting others.

KU FA. Use brush No. 1. The flowers are outlined with a very light shade of ink, and the strokes are extremely delicate (Fig. 195 a). If the strokes are too heavy and the ink too dark, the flower will look like *(b)*. Slanting the

handle a little, paint with just the tip of the brush, vary the length and width of the strokes as the brush outlines each petal *(c)*, so that the outline is not just a line. Whether it is a peony bud *(d)*, a half-opened flower *(e)*, or a fully opened blossom *(f)*, start at the center of each flower. Paint the petals in the foreground first and work from the tip to the base of each petal unless, because of the petal's position in the flower, it is easier to work from the base to the tip. Following the left to right rule, paint the foreground petals, then those on either side, and then the background petals. The stroke should be heavier at the tip of the flower, becoming finer as it reaches the heart. The peony has a ragged tip which can be painted in a series of tiny hook strokes, smoothed out at the outer edges of the petal.

The ink used for the sepals, calyx, leaves, and stamens should be a darker shade and the strokes heavier, to emphasize the difference between the delicate flower and the sturdier leaves, stems, etc. After the flowers are completed, paint the sepals (Fig. 196a), followed by the stems. Leave spaces for leaves if they are to cover the stem at any point. The peony plant has a grouping of three leaves *(b)* that grow at the end of a stem which then connects to the main stalk, and each leaf has a main vein with smaller

173

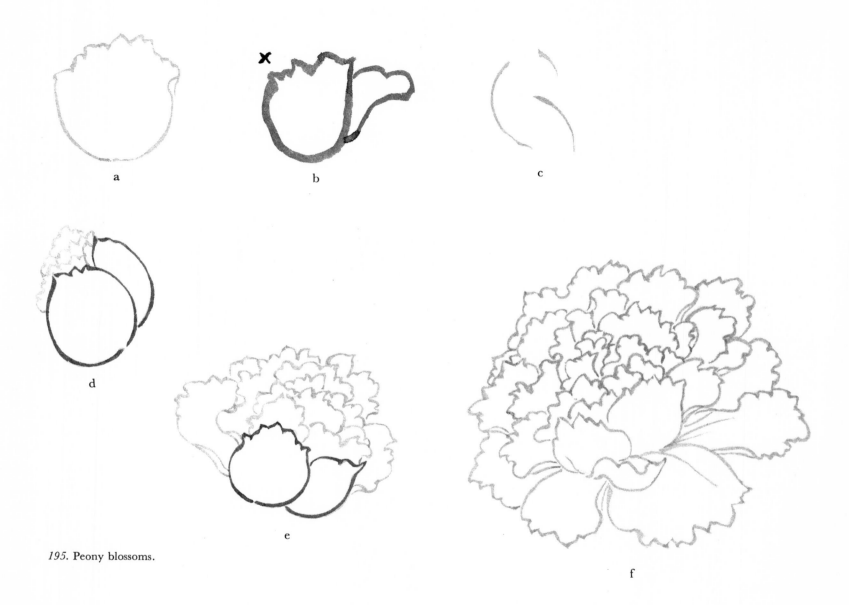

195. Peony blossoms.

auxiliary veins. After completing the stem, paint these three veins and then outline the leaves with a ragged edge somewhat like that of the petals. Be careful when painting the smaller veins, which are nailhead strokes *(c)* that run out and down toward the tip of the leaf. Line the brush up with the main or central vein, as it is in *(d)* rather than in *(e),* and pull away quickly in a curved nailhead stroke.

Peony stamens are scattered among a few of the inner petals, showing just the tips and anthers. Use a curved bone stroke to outline them, two strokes for each anther (Fig. 197 *a*). For *mo ku* style the anthers are dotted in, using the triangular-shaped dot *(b)* described in the lesson on tree foliage. Be sure the anthers are the proper shape for the particular flower.

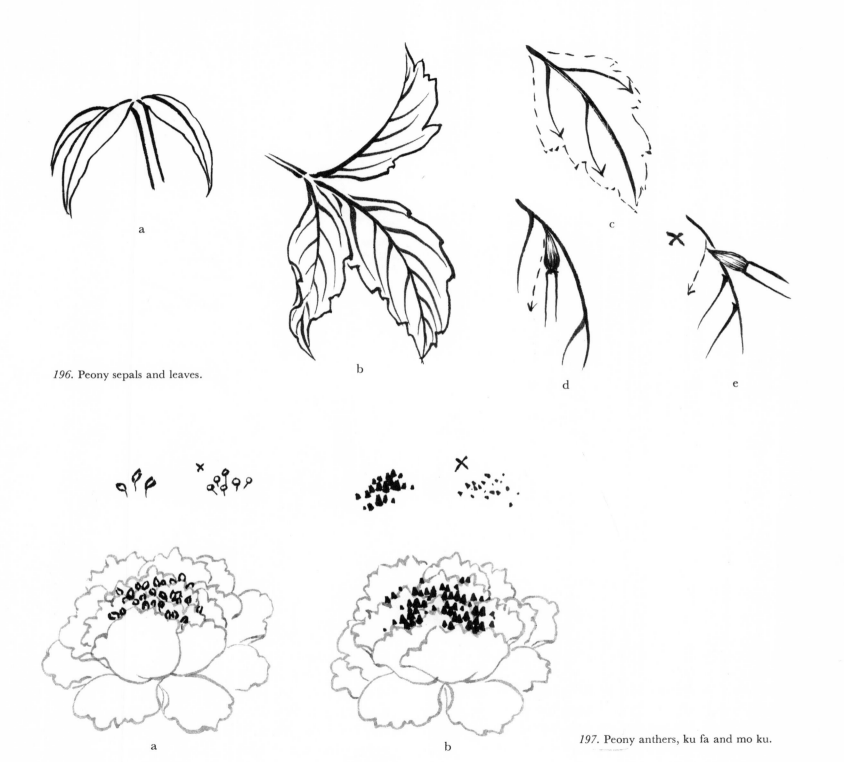

196. Peony sepals and leaves.

197. Peony anthers, ku fa and mo ku.

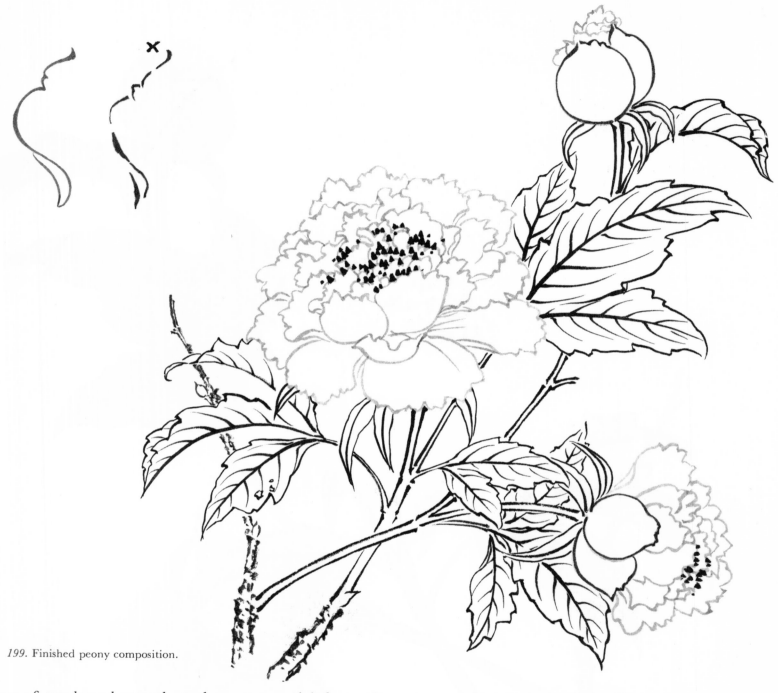

199. Finished peony composition.

Delicacy of touch and smooth strokes are essential for flower painting. Particularly in the outline style, the stroke should flow in an uninterrupted line, undulating but unbroken (Fig. 198). Do not start and stop in the middle of a stroke. Shaky or uncertain handling of the brush shows up quickly, but practice will soon give you the necessary control. As before, trace the example shown (Fig. 199) and then try it freehand. Give some attention to the variation in shading and the use of wet and dry brushes.

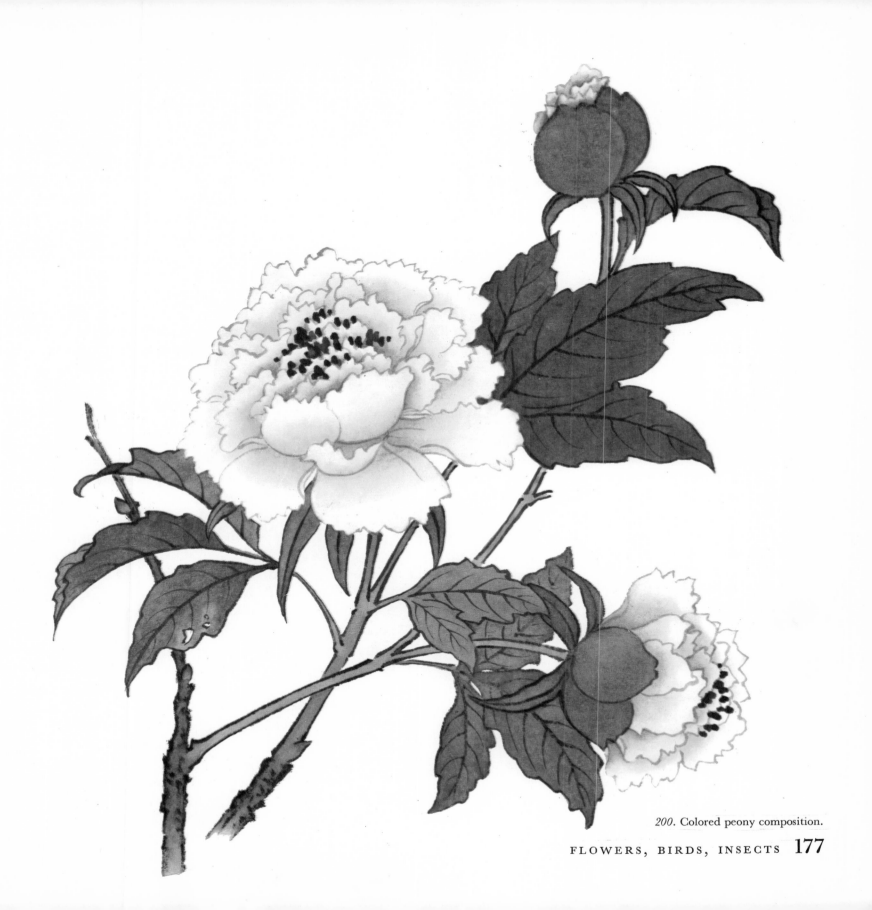

200. Colored peony composition.

There are some general rules which should be followed for coloring flowers like the peony. Begin with the flower itself, applying a delicate wash in shades of pale pink or lavender. On this particular species of flower, the color is deepest at the base of the petals and shades out to white at the tips, so a wash of clear water should be placed on each petal from the tip almost to the base, covering the outline strokes completely. On some other flowers, however, the color is deeper at the tip of the petals and fades to a lighter shade at the base. Study the flower you plan to paint so that details such as this are correct. Brush in the color at the base of the peony petal, blend it with the clear water brush, and then blot it with tissues. There should be two or three light layers of the color wash to build up the shading properly. While the first coat of color should always be very pale and should be blotted immediately, the succeeding coats may be somewhat deeper in color and you may wait a few moments before blotting. Remember to add a touch of dark gray ink mixture if your color seems too bright.

The leaves and stems are a soft yellow green or wine red, depending on the variety. The front or face of the leaves is darker then the back or under side, and the stems are also lighter than the front of the leaves. If the end of the stem is left open, water should be placed at this point so that the color will fade out to nothing. Anthers on the peony are wine red or yellow in color. The color mixing guide for the painting in Fig. 200 is as follows:

Flowers—magenta mixed with a touch of rust brown.
Stems—yellow green.
Calyx and sepals—yellow green first coat; blue green second coat.
 Leaves—yellow green first coat; blue green second coat.
 For backs, magenta mixture second coat.
Woody stems—rust brown mixed with black.
Anthers, mo ku style—magenta or yellow.

The Chinese sometimes paint flowers with the roots of the plant included as part of the composition, while at other times, the stems, with ends broken or sliced off at an angle, are tied in a bundle with a strip of grass or raffia (Fig. 201). Simplicity is the key to the Oriental look; this is not the place for Victorian bouquets.

Study many types of plants before trying to paint them, so that you can answer such questions as: How large are the leaves in proportion to the particular species of flower? Does the leaf have many veins, a few, or none? If there are veins, are the auxiliary ones placed regularly or irregularly on the main vein? How do the leaves grow from the stem? Are the leaves smooth or ragged, shiny or dull?

In painting other flowers, try sketching them first in pencil from different angles and at various stages of bloom. Then go over the pencil sketches with the proper brush strokes in ink to outline them. A flat look should be the final effect rather than one which seems three dimensional. Be guided by illustrated books on flowers and plants or by prints which may be found in art supply houses, book stores, or libraries. Do not be afraid to copy directly from these sources, as you will learn from them and eventually be able to construct your own original compositions.

The illustrations will help you with coloring various flowers. Remember that the first coat on all leaves and stems, regardless of what species of flower, is yellow green. In Fig. 201, the rose leaves are two coats of yellow green; the rose flowers are rust brown mixed with magenta; the thorns, tipped with magenta; and the raffia, a first coat of rust brown and a second coat of yellow ochre. The daisy petals are white; the anthers, yellow ochre; and the leaves, a first coat of yellow green and a second of blue green grayed with black ink wash. In Fig. 202, the chrysanthemum petals have a first coat of lemon yellow and a second coat of yellow ochre; the leaves have a first coat of yellow green and a second of blue green. In Fig. 203, the gladiolus flowers have a first coat of rust brown mixed with yellow ochre and a second coat of rust brown mixed with a touch of magenta; the stamens and anthers, yellow ochre; and the leaves, stems, and sepals, two coats of yellow green, and the tallest leaf has a third coat of blue green.

201. Composition of roses and daisies.

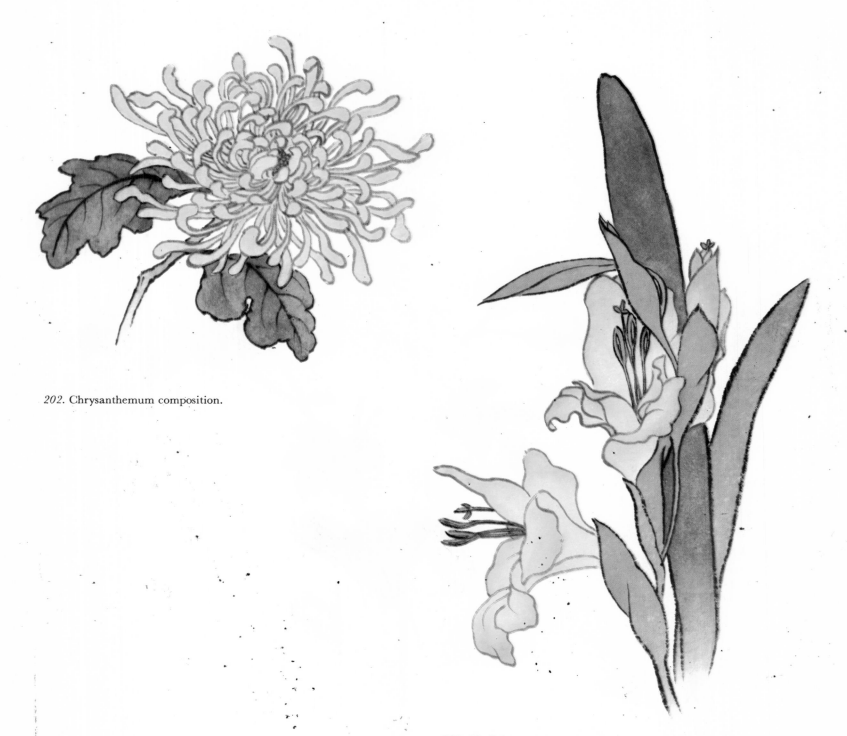

202. Chrysanthemum composition.

203. Gladiolus composition.

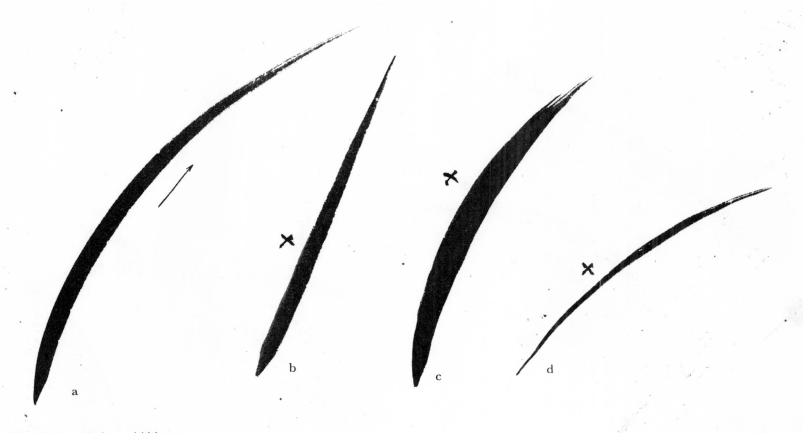

204. Strokes for orchid leaves.

Mō KU. We shall take the Chinese orchid as our example of this style. Also called the marsh or grass orchid, it is not the glamorous blossom found in the tropics but a flower with a beauty and grace of its own. This is another of the flowers used to depict the four seasons, and many artists specialize in painting it. The orchid represents the *ch'i,* or spirit, of spring; the bamboo, that of summer; the chrysanthemum, autumn; and the plum represents winter. Although the orchid may also be painted in outline, this flower seems to lend itself more gracefully to *mo ku.* It should be painted in a lighthearted, carefree way, so that the leaves seem to be fluttering and swaying in a breeze.

The leaves are painted first, then the flowers and stems, and the "heart" of the flower is dotted in last. The front of each leaf should be dark, and the back, light. The flowers are very light; the stem, medium; and the heart, the darkest shade of all. Use brush No. 5 for the leaves, No. 4 for the flowers, and No. 1 or 2 for the stems and heart.

For leaf strokes, the arm is held up off the table, with slight tension in the muscles of the upper arm and hand. Point the tip of the brush straight toward your own chest and swoop down on the paper. (Here is that airplane landing and taking off again.) Begin with the carp's-head stroke, brush away from you, and end with a rattail (Fig. 204*a*). These leaves are soft, thin, and pliable, so curve the stroke either to the right or left. It should never be stiff and straight *(b)* or too fat *(c)* or too thin *(d).* Practice this stroke on newsprint.

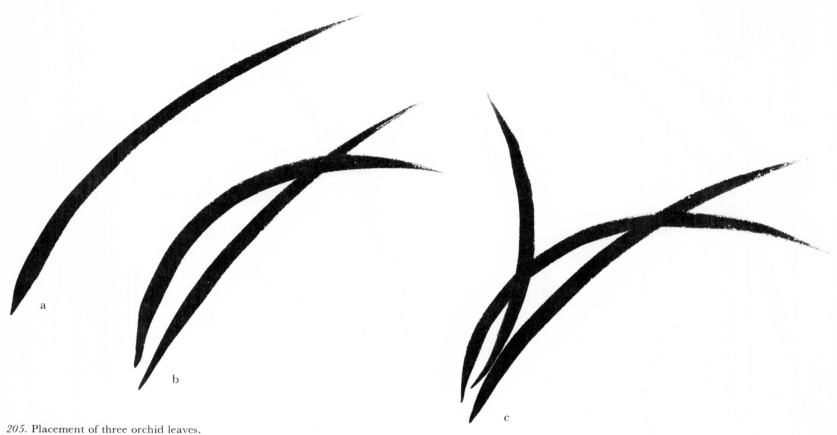

205. Placement of three orchid leaves.

The first leaf bends to the right (Fig. 205*a*). Start the second leaf so the beginning of the stroke does not quite touch the first; continue the stroke up and then over to the right, crossing over the first leaf *(b)*. The third leaf is painted upward to curve to the left and cross the second leaf near the base of the plant *(c)*, to form what the Chinese call "the eye of the phoenix." You will want to break the strokes sometimes to make turned-over leaves. Notice that the curve still continues and that the two strokes do not touch (Fig. 206*a*). In *(b)* the break is too abrupt and the strokes too heavy, and in *(c)* the strokes overlap. The ink shading must be different in each of the two strokes of a turned-over leaf, going either from dark to light or light to dark. More leaves may be added, keeping their lengths uneven, but do not let three leaves cross at the same point, as they will then form an asterisk and look unnatural (Fig. 207*a*), although one leaf may be crossed by two others at different points. Orchid plants have an elliptical base, so do not let yours look like *(b)*, which is growing from a flat base in addition to having too many leaves. In grouping many leaves, each should be distinct and separate from the others so they do not look jumbled or too densely massed. If the composition has only a few leaves, they should be placed so that they do not look sparse.

206. Turned-over orchid leaves.

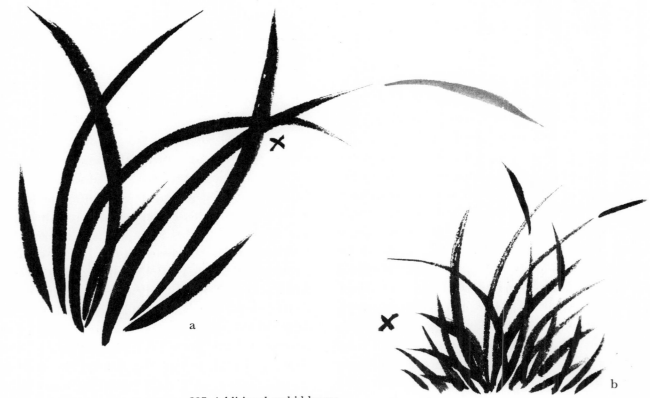

207. Additional orchid leaves.

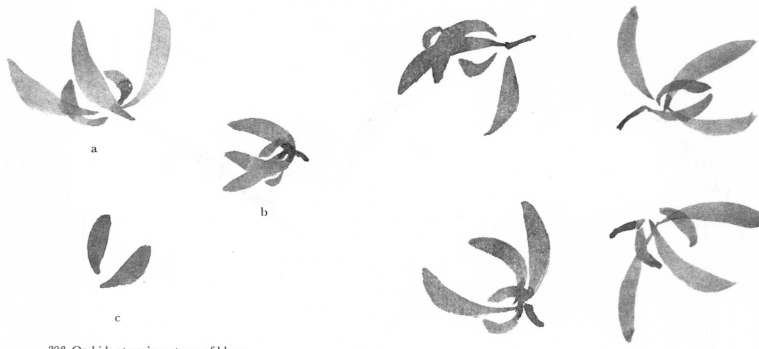

208. Orchids at various stages of bloom.

209. Orchid petals in various positions.

Flowers of the grass orchid bloom on a stem which grows out of the center of the plant. Fully opened flowers (Fig. 208 a) are at the bottom of the group, half-opened ones are in the middle (b), and unopened buds at the top (c). Orchids have five petals, three large petals and two smaller ones. Each stroke is similar to the one used for leaves but is much smaller and shorter. The petals should be painted in a variety of positions (Fig. 209); full face, bending over, looking up, and looking to the right or left. Some petals should overlap or cross the others.

After painting the leaves (Fig. 210 a), paint the blossoms (b), beginning with the buds. Start with the topmost one on the stem and proceed downward. There may be two or three buds, then two or more half-opened flowers, and then three or more in full bloom. Place the flowers on alternate sides of what will be the stem and put some directly in front of the stem as you descend. You should either have a good mental picture of the direction in which the stem is to be growing or work from a *kao tze* for the correct placement of the flowers. The stem is painted, after the flowers are finished, in a succession of short bone strokes made without lifting the brush from the paper (c). Start from the base of the top bud and bring the stroke down to a point near the base of the second bud. Hesitate here to make the joint, but do not lift the brush. Continue on down the stem this way, hesitating near the base of each flower. Smaller stems are then painted in short rattail strokes, to connect the flowers to the stem at each joint. If a flower or bud is painted in front of the stem, the stem stroke is of course broken at these places. Now the accent mark of the orchid, the heart, is dotted in (d). The series of quick hook and teardrop strokes (Fig. 211 a) used for the accent is much like the Chinese character for "heart" (b). These strokes should be practiced until they can be dotted in quickly and rather casually. The ink should be dark, however, and the stroke bold. The completed orchid should look like Fig. 212.

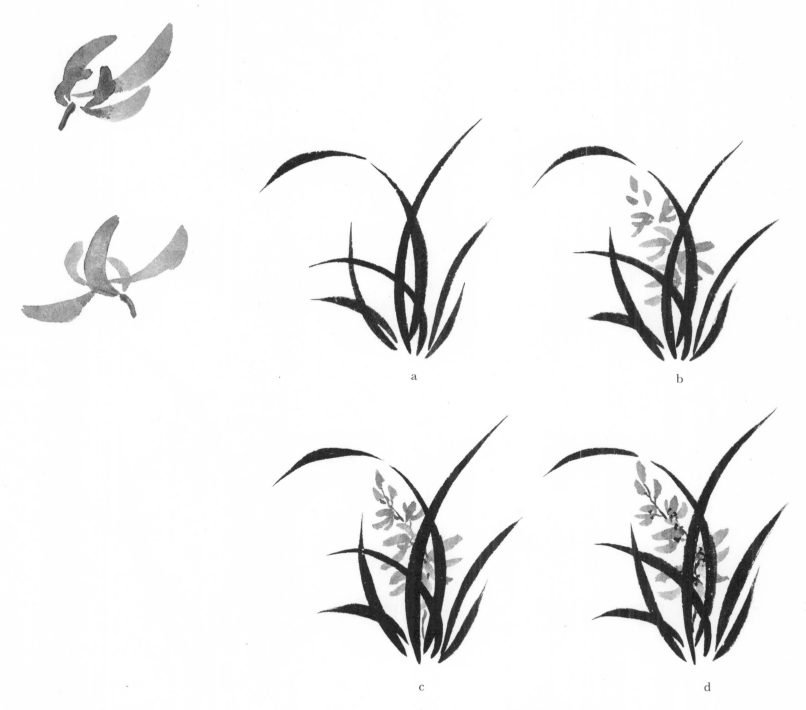

210. Painting orchids.

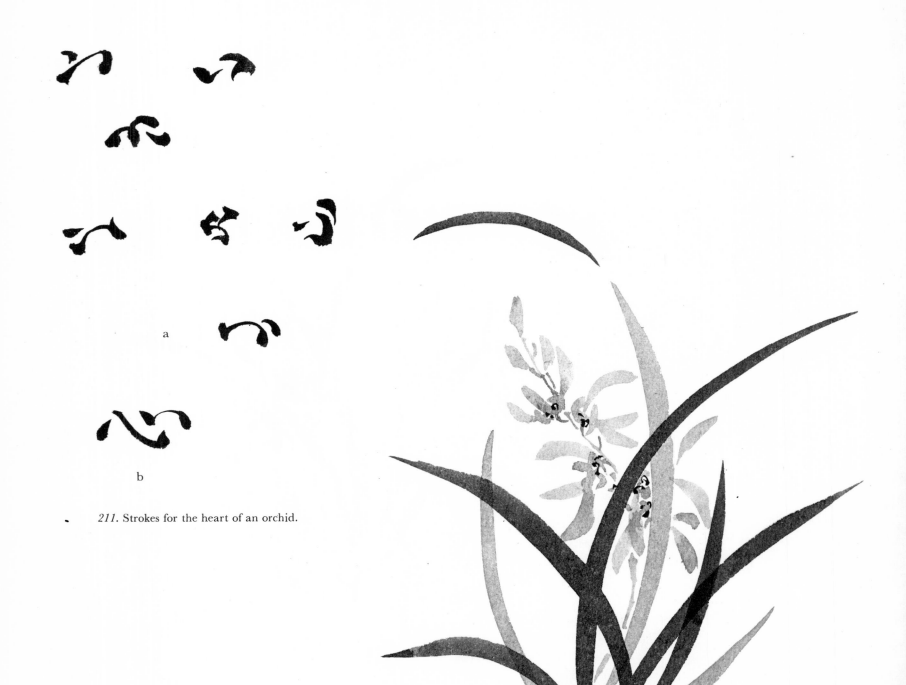

a

b

211. Strokes for the heart of an orchid.

212. Orchid composition.

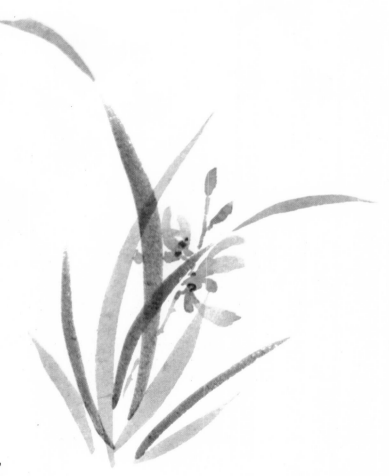

213. Coloring an orchid.

When painting orchids in color (Fig. 213), a blue green, grayed by the addition of a little black ink, is used for the inside or front surface of the leaves. Yellow green is used for the outside or back surface. The stem is the same shade as the leaf backs. Flowers are a lighter shade, almost chartreuse. The lighter shades too should be grayed by adding black ink to the mixtures, but just a drop or two of dark gray ink wash is enough. The heart is dotted in a deep shade of magenta. Use the same colors as washes when painting the orchid in outline.

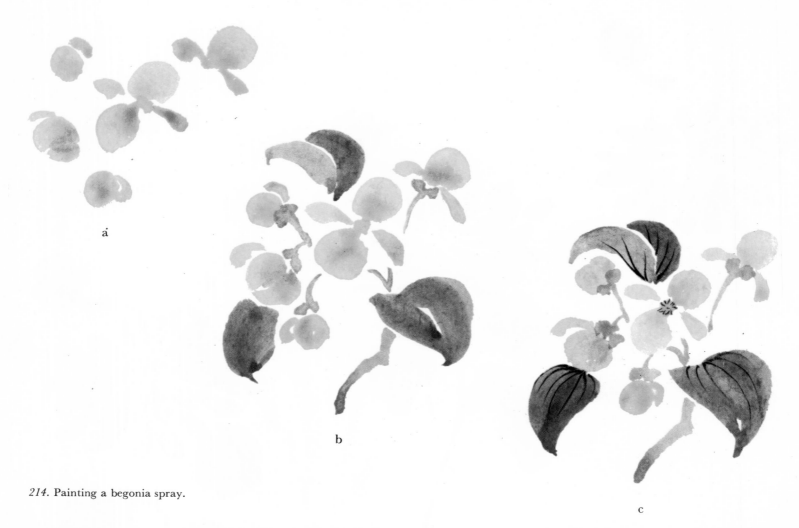

214. Painting a begonia spray.

The same techniques should be applied to the painting of other flowers in the *mo ku* style. For a flower which has short, rounded petals and leaves, the brush is held vertically rather than at a slant as it is for the orchid. Petals of the plum are a good example of this stroke. (See Chapter 4, Lesson 3.) A small spray of begonia makes another easy subject on which to try rounded strokes. First paint the begonia flowers, which have only four petals (Fig. 214a). Then add the stems and leaves, remembering to vary the color on the front and back of the leaves (b). Finally, paint the accent strokes showing veins and stamens to give the composition spirit (c). For flowers, as for any ink painting, the size of the stroke is determined by the amount of pressure applied to the brush; the shape of the stroke, by the angle of the brush. Some leaves or flower petals are so large as to require two or more strokes, which should be painted in sequence while still wet so the colors will blend without leaving obvious lines of demarcation.

Some more examples of *mo ku* flowers and leaves will be useful. In Fig. 215a is a chrysanthemum flower and bud to which stems and leaves are added (b). Notice how the accent strokes in (c) seem to wake up the composition.

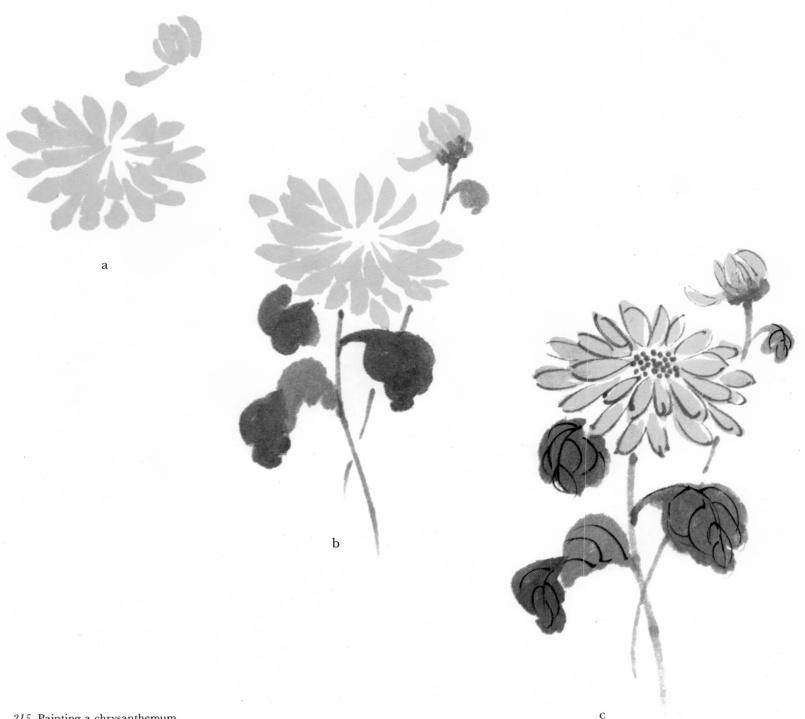

a

b

c

215. Painting a chrysanthemum.

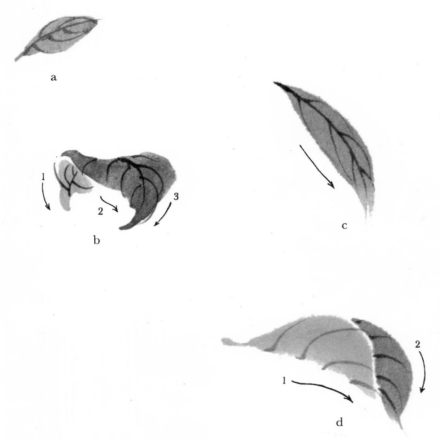

There are various types of leaves which you should try. The leaf in Fig. 216*a* was done in one stroke, with the brush slanted. On tiny new leaves like this, the veins may be wine red. In *(b)* the back of the leaf was done in one stroke and the front in two. One stroke is enough for a long slim leaf like the one in *(c)*. The veins should be stroked on quickly and casually. A turned-over leaf like that in *(d)* is molded in two strokes, each using a different color. The three strokes for *(e)* were done with the side of the brush, as if writing the letter "M." Seven quick strokes formed the ragged-edged leaf in *(f);* these strokes *must* be done quickly so the color will blend. In all cases, try to relax with *mo ku* because it should be spontaneous and free. Once you get the feel of it, you will find it both easy and fun!

216. Various types of leaves.

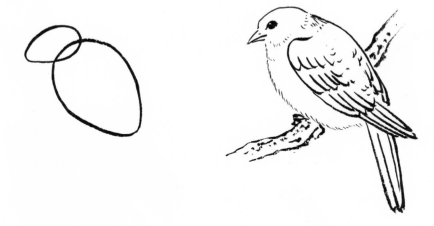

Lesson 2 : Birds

Birds should be painted in their natural habitats. They may be perched on a branch of the species of plant or tree from which they might obtain their food or which would be native to their locality. A bird may be painted with a berry or perhaps a small moth in its beak. When there are two or more birds in a single composition, the Chinese artist creates a feeling of harmony in their relationship through their positions in the painting. One bird may be looking up and the other down, or they may face each other as if in conversation.

A bird begins life in the egg, and so the body is shaped. The head is a smaller version of this same oval. By varying the placement and angles of the two egg-shaped ovals, quick sketches may be made of birds in many positions (Fig. 217). They may be shown perched on a branch, singing, eating, flying, pecking at their feathers, or sleeping. Always practice first by tracing the examples before trying them freehand, but after tracing, experiment with these shapes before making the *kao tze* to plan your own composition. One

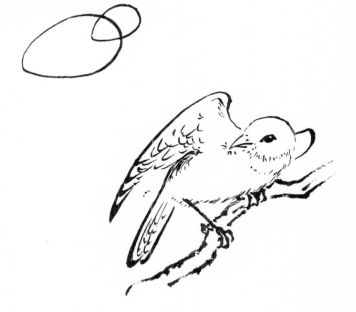

217. Drawing birds.

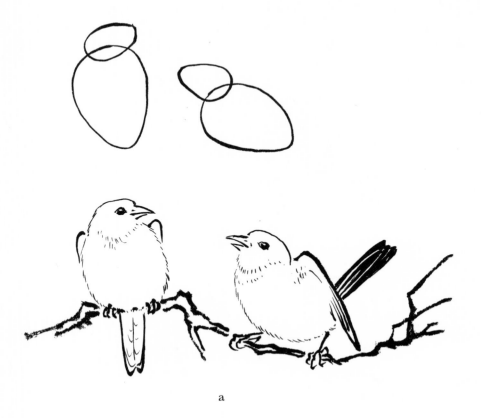

a

general rule to remember is that mountain birds have short beaks and long tails (Fig. 218a), while water birds have long beaks and short tails (b).

Always begin with the beak, painting first the upper half (Fig. 219a) and then the lower half and the nostril (b). Next, the eye is placed close to and in line with the upper half of the beak (c). The top of the head is then painted (d) and tiny strokes are made for the throat feathers (e). The line of the back is next in order (f), followed by the wing feathers (g). Then add the breast feathers, which are soft and should be treated in the same way as those on the throat (h). Add the tail (i) and then the legs and feet (j). Finish by placing your bird on a branch. Trace the completed illustration carefully several times.

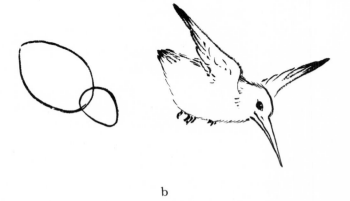

b

218. Mountain birds and water birds.

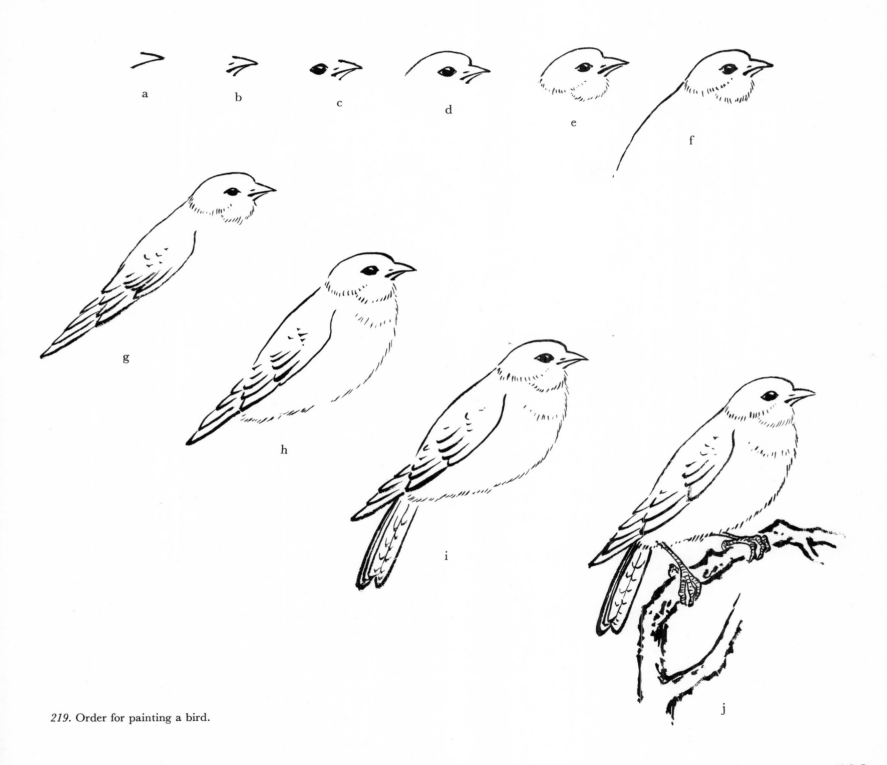

219. Order for painting a bird.

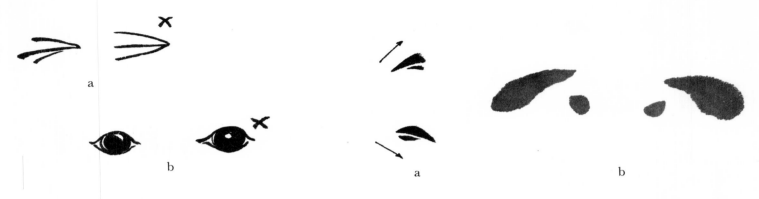

220. Strokes for beak and eyes.

221. Strokes for facing bird in different directions.

KU FA. A dark shade of ink and a wet brush should be used for outlining the beak, eyes, legs, and feet of a bird. Use brush No. 1 or No. 2. Strokes used for the beak may be nailhead, rattail, or elongated teardrop, depending on the direction the bird is facing. The line where the upper and lower halves of the beak meet must be longer than the other two lines (Fig. 220 a). The eye is formed by holding the handle of the brush vertically and rotating the tip until the desired shape is achieved. The lively spirit of a bird is communicated by the bright shine in his eye, so remember always to leave a tiny spot bare of ink; this light should be placed above or to one side of the iris (b), not in dead center.

Bone strokes are used for the legs and feet, and tiny flicking hook strokes indicate the claws. It is correct to use a wet brush for the quill feathers on the wings and tail because they are glossy, but for areas such as the downy stomach and the soft feathers of the back, a dry brush is more effective. Tiny hair-line strokes delineate the throat, breast, and abdomen, and heavier strokes make the wing feathers. Legs and feet are outlined with the bone stroke, and the scaly skin covering them may be painted in minute detail, using a curved bone stroke.

Colors in several light washes which are built up gradu-

ally are applied after the outlining is completed. Colors must of course conform to the species of the bird.

MO KU. Use brush No. 7 or No. 8. For *mo ku*, the beak, which is painted first, may either be outlined as for *ku fa* (Fig. 223) or painted in two heavy strokes, one for the upper half (Fig. 222 a) and one for the lower half (b). Use a fairly dark shade of ink. When the head faces left, pull from the tip of the beak to the head (Fig. 221 a), and when it faces right, pull from the head to the tip of the beak. After adding the eye (Fig. 222 c), with a medium shade of ink brush in the top of the head in one curving stroke, a variation of the teardrop (d). Use the same right and left method for the head (Fig. 221 b) as you did for the beak. Apply a lighter shade of ink for the cheek or throat in another stroke (Fig. 222 e). Next paint the wing feathers, pulling from the body to the wing tips (f), and then the tail, this time pulling from the tip to the body (g). Use one stroke for each quill feather. The wings, back, and tail are painted in varying shades of ink depending on the species of bird, but the wing tips and tail tip are usually darkest. The breast and abdomen are washed on in one or two broad strokes in a lighter tone (h). Legs and feet are bone strokes, one stroke for each leg and one for each section of the claws (i).

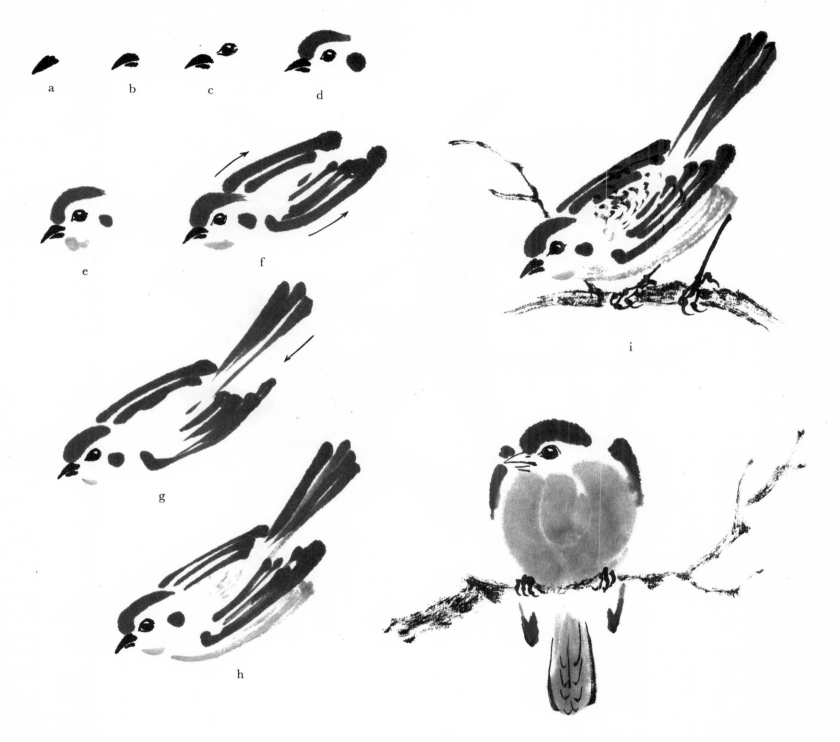

a

b

c

d

e

f

g

h

i

222. Painting a bird.

223. Bird in mo ku with ku fa beak.

a

When painting birds in color in the *mo ku* style, each of the brush strokes should be done in the color natural to the particular bird. Accent marks in black ink are added afterward for the nostrils, eyes, tips of feathers, and sometimes a few light, dry brush strokes on the breast or abdomen.

Mo ku and *ku fa* styles may be intermingled in bird and flower painting. If the bird is to be painted in *mo ku* the surrounding branches and flowers may be *ku fa* (Fig. 224 *a*), or vice versa *(b)*. Rules are lenient in this respect.

224. Combinations of mo ku and ku fa for bird and background.

b

a

Lesson 3 : Insects

Any insects which are included in paintings of birds and flowers should of course be in their own natural element. For example, bees are often found near roses (Fig. 225*a*), dragonflies hover over water and are associated with lotus flowers or water lilies *(b)*, the voracious praying mantis may be perched on a spray of half-eaten leaves lying in wait for its prey *(c)*, and a cicada might be climbing a willow branch *(d)*. Some species, such as wasps, dragonflies, bees, and butterflies, can be naturally shown in flight. The caterpillar, beetle, or ladybug *(e)* may be crawling on a stem or leaf, while others, such as the cricket *(f)* or the grasshopper, are found in grasses or moss.

b

225. Insects in their natural elements.

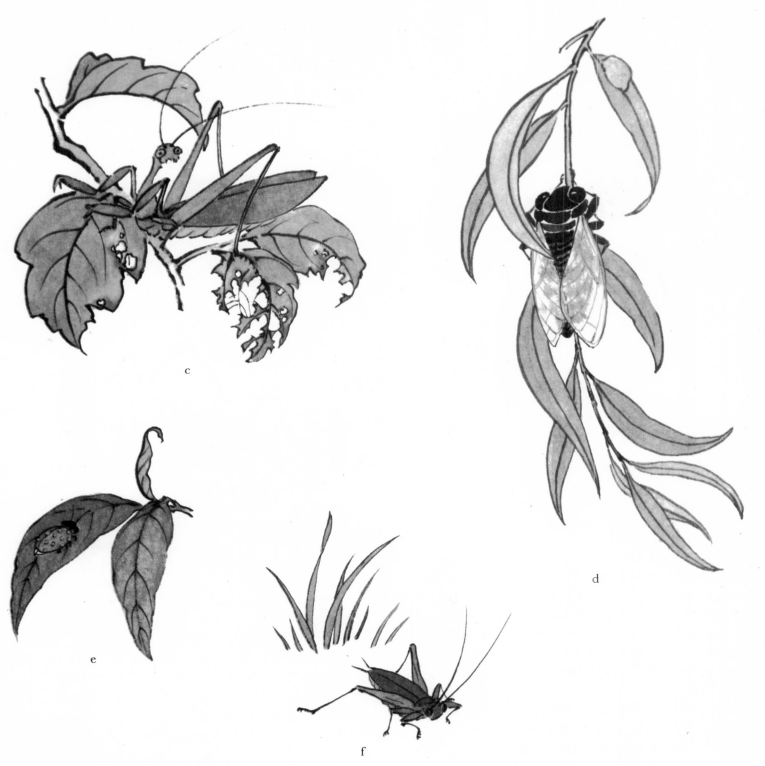

c

d

e

f

226. Insect's antennae.

227. Wings of a flying insect and use of spots of color.

228. Order of strokes for painting an insect.

The smaller the insect, the more delicate the brushwork should be, but regardless of the size of the insect, the antennae and wings must be painted with extreme care, using a hair-line stroke. It is essential that each antenna be painted in a smooth unwavering stroke, painted from left to right (Fig. 226). If the insect is shown flying, the wings may be done with a dry brush from the base of the wing, where it connects to the body, fading outward and ending short of the actual tip (Fig. 227*a*). When coloring these wings, first cover the entire wing area with a clear water wash and then add tiny dots of blue, green, and lavender and blot quickly *(b)*. This gives the illusion of iridescent, fluttering wings.

Heads and bodies of most insects are painted in solid, heavy strokes, in a dark shade of ink. Follow the order in Fig. 228, painting the eyes, head, thorax, abdomen, wings,

legs, and finally the antennae. Use a dry brush on fuzzy insects, such as the bumblebee or caterpillar (Fig. 229*a*), but on shiny ones such as wasps or beetles *(b)*, a wet brush is necessary. A butterfly usually combines wet- and dry-brush techniques as the wings are soft and velvety and the head, eyes, and legs are hard and shiny *(c)*. The antennae of any insect should be painted swiftly and surely in a long, fine, curving rattail stroke. Eyes are done in black ink, with a spot bare of ink to suggest the glossy surface. Legs are painted with a wet brush and black ink, in a series of fine bone strokes. Either the *ku fa* or the *mo ku* style may be used for insects. Fig. 230*a* shows an insect's legs painted both ways. The moth and ant in *(b)* are *mo ku,* and the wasp in *(c)* is *ku fa.* Fig. 231 is my painting of my brother's grasshopper, Gangrene, whom I mentioned in the Introduction.

229. Dry- and wet-brush techniques used for different insects.

230. Insects painted in ku fa and mo ku.

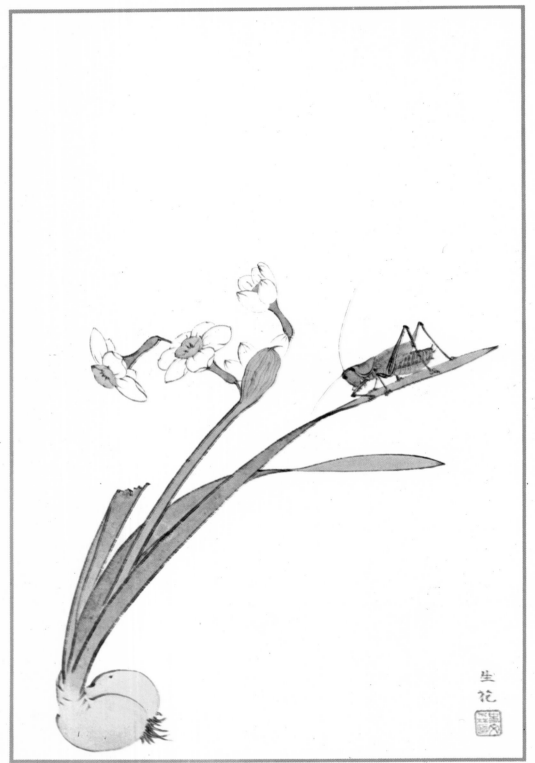

231. "Gangrene."

. . . A figure should seem to be contemplating the mountain; the mountain, in turn, should seem to be bending over and watching the figure. A lute player plucking his instrument should appear also to be listening to the moon, while the moon, calm and still, appears to be listening to the notes of the lute. Figures should, in fact, be depicted in such a way that people looking at a painting wish they could change places with them. Otherwise the mountain is just a mountain, the figures mere figures, placed by chance near each other and with no apparent connection; and the whole painting lacks vitality.

—MAI-MAI SZE, *The Tao of Painting*

JUST AS landscapes, flowers, and birds are all considered separate categories in Chinese painting, so is the representation of figures a separate category. Within this particular category, the painting of religious figures is thought by some to be on the highest plane of all. Other classifications of figures are: characters from Chinese mythology, warriors, ladies, philosophers, children, peasants, and portraits.

As a rule, high-born women are shown inside their homes, in a courtyard, or in a garden. They may be seated at a dressing table which is covered with toilet articles, looking in a mirror, painting, or writing characters at a desk. They might be playing a musical instrument, reading, or embroidering. Sometimes they are shown in a courtyard either

with children playing around them or simply gazing at the scenery.

Uniforms of military men and women are painted in bright colors and are intricately designed and patterned. (There are many stories of women who went to war, sometimes to avenge husbands killed in battle.) These martial types are generally posed in warlike stances or mounted on horseback.

Scholars or philosophers may be placed in a mountain or woodland scene, but the surrounding landscape is incidental to the figure in this case. They may be posed in any of the following ways: standing and looking at the scenery, seated, reading a book, or drinking tea or wine.

Children are often in groups, playing some kind of game, as the Chinese have always loved to indulge their children. The background in a painting of children should be a courtyard or the interior of a house.

Figures of peasants and laborers can be occupied with tasks such as cutting wood, working on a boat, fishing, tilling the soil, or planting rice.

Ancestor portraits are classified separately, as in these the artist must catch a likeness of his subject. (This is also true, to a lesser extent, of figures in Chinese mythology.) The

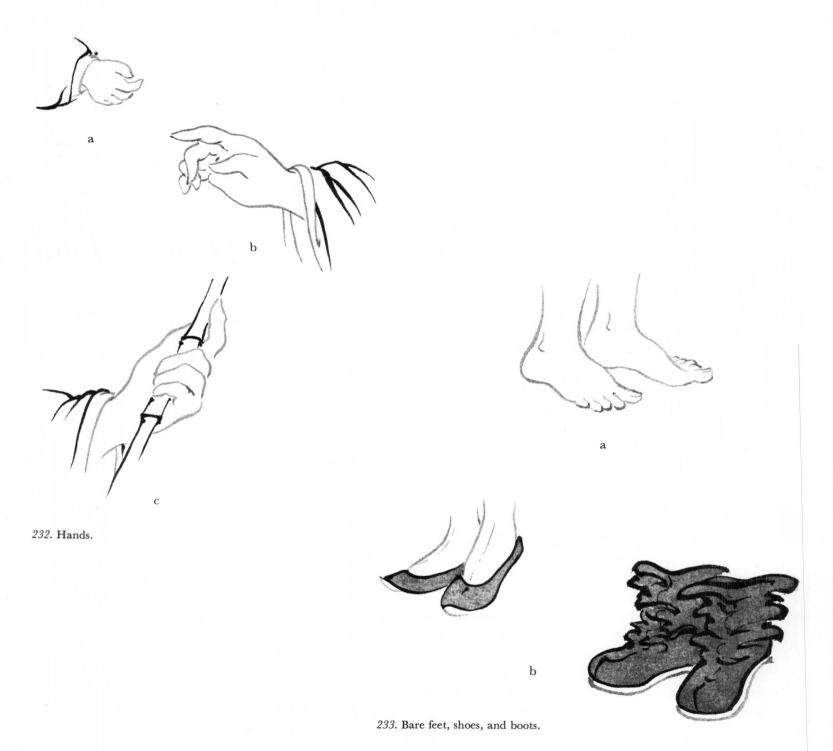

232. Hands.

233. Bare feet, shoes, and boots.

234. Proportions of the face.

235. Strokes for painting Chinese eyes.

subjects of these portraits were posed solemnly and in elaborate formal dress, seated with dignity on thronelike chairs.

To review the general rules for painting figures, turn back to Chapter 5, Lesson 4. Remember to use the proper shades of ink and smooth strokes. Use a very fine line and a pale gray ink mixture for the folds of undergarments which may show at the neck and wrists. Leave spaces for the hands which, if they are visible, are outlined in light gray. Notice that Chinese hands, whether those of a child (Fig. 232 a), a woman (b), or a man (c), always look smooth and supple. Feet are outlined in light ink (flesh shade) if they are bare; if the feet are covered, the shoes or boots should be dark and outlined in a still darker ink mixture (Fig. 233). The more detailed features are left until the general outline and garment are completed.

Features are not too difficult if you follow these rules. The area between the hairline and the chin is divided into thirds, as Fig. 234 indicates. The hair, eyes, and eyebrows are painted at first in as light a shade of ink as the flesh. The Chinese eye should not be round (Fig. 235 a), and contrary to some Western thinking, it does not slant down to the nose (b) but is set straight across. The so-called almond look is achieved by painting the upper lid in a very shallow "S" curve (c). Painting the pupil of the eye in a round circle results in a staring effect (and looks Caucasian as well) so allow only one half or two thirds of it to show. The lower lid may be painted in a much finer stroke than that of the upper lid (d). This is especially desirable when painting a figure of such proportions that all details of the features are distinct.

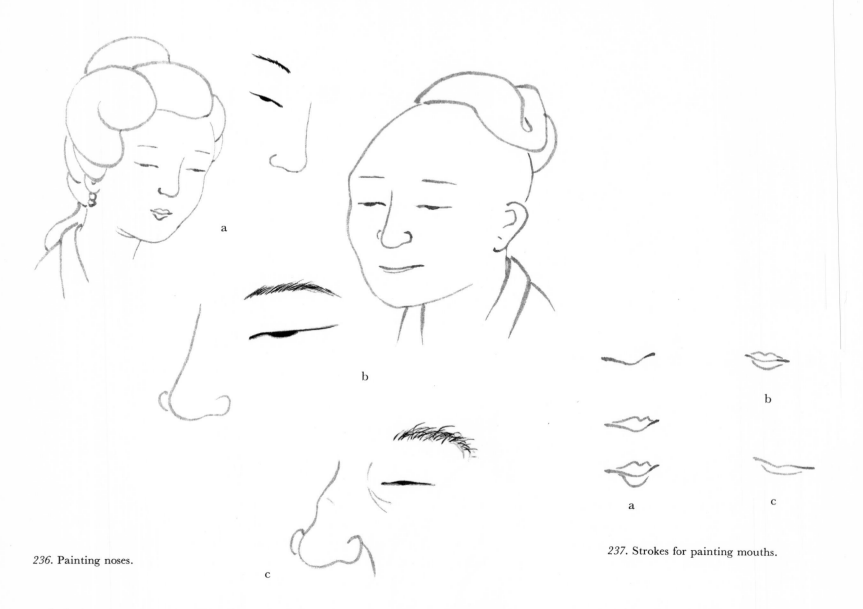

236. Painting noses.

237. Strokes for painting mouths.

A lady's nose should be straight and fairly long (Fig. 236 a); a man's nose is larger but also straight (b); while that of an old man may have become arched and crooked (c). Women's and children's mouths are tiny rosebud shapes, although a woman's mouth is fuller (Fig. 237 a) and that of a child, rounder (b). A man's mouth is almost a straight line, and usually only the lower lip is outlined (c). To paint mouths, first place the line where the lips meet and then paint the upper lip followed by the lower. In a child's face, all the features are rounder than those of an adult (Fig. 238).

After the outlining of the entire figure is finished (Fig. 239a), colors are washed on, using many layers of pale shading (b) and (c). For robes, the color is placed along the folds and edges and then blended toward the center with the clear water brush. If the color is applied too hastily or carelessly, the result will be too bright and blotchy (d). For women and young girls, pastel shades of all colors

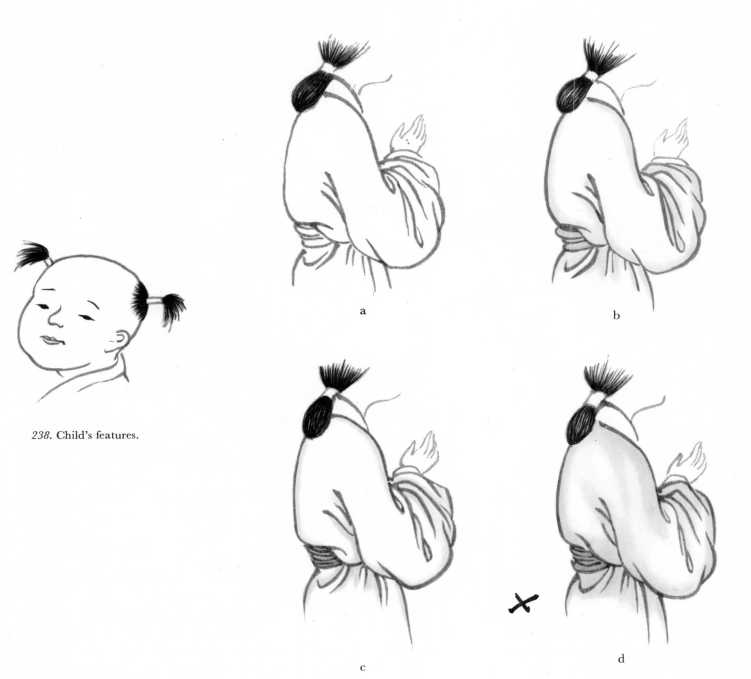

238. Child's features.

a

b

c

d

239. Coloring the robes.

240. Colors for women's and children's clothing.

241. Colors for men's garments.

may be used on the garments, while children's clothing, on the other hand, is usually very bright and gay (Fig. 240). Shoes for women and children generally match or harmonize with their robe's colors. Gowns of older women and garments of all men are subdued into gray, blue, brown, and plum (Fig. 241); their shoes are shaded with black ink. Undergarments which show at the neck and wrist are white, which is applied after all other coloring is completed.

Ladies' hair ornaments made of precious jewels or feathers are given strong mineral colors; use green for jade, white for pearls, red for rubies, and blue for lapis or kingfisher feathers. A lady may be shown carrying a fan which, if made of silk, should be treated in such a way that it looks transparent (Fig. 242). When seen through the mistiness of the silk fan, colors are dimmed and the outline is less defined. Bright colors may be used on the frame of the fan if it is made of lacquer; and if there is a design on the silk, it may have brighter colors than are used on the robes.

Women's complexions should be a pale pink or apricot. Deep pink is used high on the cheekbones and over the eyelids where Chinese beauties of those times applied rouge. The color is shaded off into the pale flesh tone by blending with clear water. Lips may be painted a bright rosy red. For men the skin tones should be light brown—never, never use yellow. The hair area is covered with a soft blue-gray wash, blended with water at the hairline.

242. Lady with a silk fan.

a

b

c

d

243. Painting an elaborate hair-do.

244. Young man's hair.

245. Old man's eyebrows.

After the coloring is completed, the last step is to go over the hair, eyes, and eyebrows once more. Use black ink and brush No. 1. Hair on the head is painted in extremely fine rattail strokes, with each hair in a line with its neighbor. If a woman's coiffure is an elaborate one with many coils and rolls, each section must be done separately and the brush strokes must follow the line of the wave or roll. The technique for painting hair is complicated, but the result is worth all the effort. After a pale outline of the hair is painted (Fig. 243*a*), pale hairlines are filled in to show the direction of the coils *(b)*. A gray wash is applied next *(c)*, and lastly, fine black strokes are added for the final punctuation *(d)*.

On a man's head the hairs lie in a line from the crown toward the face and ears. Keep the hair well back from the features, because a low forehead would give the figure a moronic appearance while a high forehead is indicative of wisdom and serenity. Men's hair is simple and fairly

straight. In Fig. 244 it is drawn back from the face and tied in a cloth at the crown. On a young man the mustache and beard would be small.

Eyebrows are painted in a fairly straight line, using short fine strokes. Eyebrows of older men may be bushier than those of young men, and the hairs at the outer end sometimes droop down as far as the lid line of the eye. Fine strokes of white paint may mingle with the black to emphasize the appearance of venerable age, or the hair may be completely white. For an older man, bushy eyebrows, and mustache and a full beard are appropriate, and his scalp may well be shaved (Fig. 245).

A mustache or beard is painted in the same way as the hair on the head. When painting long whiskers or a full beard, start the stroke at the cheek or chin line and pull away in fine rattail strokes. A few hairs may cross each other and some may be wavy, but all must be fine as silk threads.

Little boys' hair is dressed in what seems a strange fashion to us. The reasoning behind some of the imaginative coiffures is that any devils that might be lurking about will be tricked into thinking that the boys are little girls. Since everyone wants boys, and girls are not worth much (to devils, at any rate), the children will remain unharmed. Part of the scalp is shaved, with a little lock left on each side of the head (Fig. 246a), a lock left on the crown (b), or one left on the back of the head (c). These locks of hair are tied with bright silk or yarn. The shaved portions of the scalp are colored gray blue and blended at the hairline into the flesh tones of the face.

Kuan Yin (pronounced gwahn yin) is an example of religious painting (Fig. 247). Originally a Buddhist male, she was transformed by the Chinese into a goddess—their Goddess of Mercy. Her cloak may be colored gray blue; the pearls, white; and the line of the halo, gold.

Lines and strokes can convey a specific mood. In the painting of Kuan Yin, notice that the strokes are smooth, flowing, and softly rounded, while in the spontaneous sketch in Fig. 248 portraying a laboring man forgetting the hardships of the day, the strokes are deliberately quick, rough, and staccato. Here you can reap the rewards of your patience in learning the classical rules and traditions. They should by now be so instinctive and automatic that the "bone structure" always comes through, even when you try a spontaneous and unhampered style.

246. Children's hair.

247. Kuan Yin.

248. Laborer at rest.

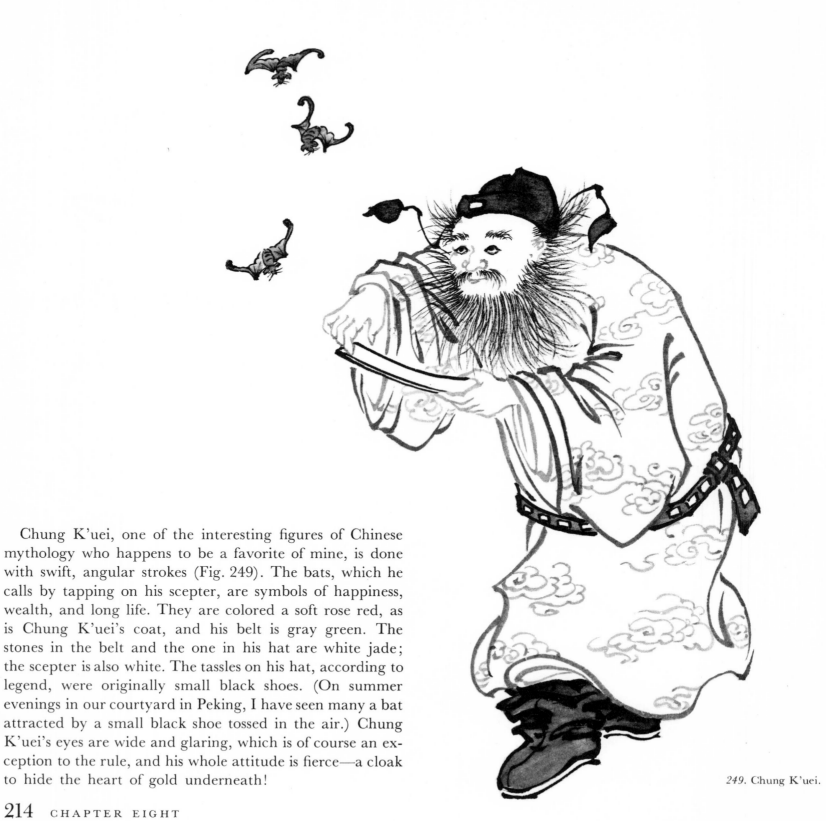

Chung K'uei, one of the interesting figures of Chinese mythology who happens to be a favorite of mine, is done with swift, angular strokes (Fig. 249). The bats, which he calls by tapping on his scepter, are symbols of happiness, wealth, and long life. They are colored a soft rose red, as is Chung K'uei's coat, and his belt is gray green. The stones in the belt and the one in his hat are white jade; the scepter is also white. The tassles on his hat, according to legend, were originally small black shoes. (On summer evenings in our courtyard in Peking, I have seen many a bat attracted by a small black shoe tossed in the air.) Chung K'uei's eyes are wide and glaring, which is of course an exception to the rule, and his whole attitude is fierce—a cloak to hide the heart of gold underneath!

249. Chung K'uei.

9

Mounting Process

WHILE WE WERE still in Peking, it was a simple matter to have a painting mounted. All we had to do was take it to a mounting shop, specify the style of mounting and the colors desired, and in a few days it was ready. But Prince P'u felt I should learn the craft of mounting pictures as part of my artistic education, so for several weeks I went to " school " at the shop where all our work was done. A tremendous table with a top made of a thick slab of wood lacquered cinnabar red took up most of the space in the little shop. On this, all the pasting, a major part of the process, was done. Hanging from the ceiling in rows were frames on which the paintings and matting silk were dried. There were great wide brushes and various other tools, bolts of thin silk, and reams of paper. I took notes on everything, and the following instructions are taken from that notebook, with some modifications to suit our present situation.

The Chinese artisans made their own paste from rice flour; I now find wallpaper paste to be an excellent substitute. Instead of that beautiful lacquered table, I have used as proxy a white enamel kitchen table, a formica-topped surface, or a large sheet of heavy glass. For lack of drying frames, I have utilized picture windows or the same surface that I used for the pasting.

The tools consist of two wide flat brushes (one soft and one stiff), a wide shallow bowl for the paste, a ruler, cutting board, knife, and spatula. The soft brush (Fig. 250*a*) is made of many small brushes attached to each other, and the stiff brush *(b)* is constructed in such a way that, as the bristles wear down, more twine can be cut to release more bristles. Since paper for backing should be white and not too heavy, your painting paper will serve the purpose. A substitute for the Chinese *ling tze* (very thin soft silk woven with a brocade pattern) which is only available in the Orient, is regular matting board. This can be either plain or covered with Shantung silk or grass cloth, but wallpaper and wallcoverings also make good matting material. To be truly Chinese, be sure you use subdued colors, and the pattern, if there is one, should be small and tranquil.

Methods for mounting paintings done on paper and on silk are different. First we will take a painting on paper and explain how it is mounted.

From a package of wallpaper paste, take enough of the dry wheat powder to make a thick paste according to directions. Pour it slowly into the water in a bowl and stir constantly until it is smooth, as it is essential that there be no lumps. Have your working surface scrupulously clean be-

215

250. Mounting brushes: (a) soft, (b) stiff.

251. Pasting the backing on a painting.

cause even a speck of dust or dirt will show up glaringly on the finished product. For the backing, cut a piece of paper which measures one inch larger all around than the painting, and place it to one side. Now lay the painting face down on the clean dry surface. Dip the soft wide brush into the paste mixture and wipe off the excess paste on the side of the bowl. Then completely cover the back of the painting plus a one-inch border around it on the working surface with paste, using a side to side motion (Fig. 251 a) and a very light touch, as wet paper tears easily. Keep brushing lightly until all the ripples flatten out. When the painting is completely flat, lay the backing paper over it and brush it down gently with a fairly stiff brush. Start at one corner, holding the rest of the backing up off the table, and brush back and forth diagonally, gradually letting the rest of the backing paper come down onto the back of the painting as you brush. Follow the direction and sequence of numbered arrows in (b). Any paste lumps or air bubbles should be brushed out to the edge. Now carefully lift one corner of the two pasted layers of paper (c) and blow gently

under them until the painting, the bottom layer of paper, is lifted off the surface on a cushion of air. The one-inch border of the backing should still be pasted to the working surface, except for the corner you have lifted. When you are sure the entire painting is off the working surface, quickly repaste the lifted corner, trapping a layer of air inside. Leave everything in this position and let the paste dry thoroughly. When it is bone dry, loosen a corner with a straight pin, slide a spatula under, and carefully tear the painting away from the edge, which remains pasted to the table.

This process takes a lot of skill, and it would be wise to practice on plain paper until you are sure of your capability. A painting can so easily be torn or smeared, and it would be very discouraging to spoil one on which you have spent a good deal of time and effort.

For a painting on silk, the same procedure is followed but in reverse. The backing paper is laid on the working surface, paste is applied, and the silk is then brushed down on it face up. This must be done with extreme care as the brushing may cause the ink and color to smear.

b c

Our substitute for the Chinese mounting method is simpler. To straighten the ripples made by the color or ink washes, float the piece of silk on water, painted side up, until the material flattens out completely. Pick it up carefully by two corners, lay it face down on an absorbent towel, and blot the back of it carefully with another towel. Now take it to your ironing board and with a warm iron press it lightly on the back until it is dry. With a steam iron it is sometimes possible to skip the bath and just press the silk on the back with the heat dial set at " silk " or " low." The painting may now be fastened to a backing with paper masking or mending tape and then matted or framed as you wish.

With the mounting completed, the next step to consider is the matting. The simplest form for a finished painting is a plain square or rectangle bordered with *ling tze*. Collections of these mounted and matted paintings are sometimes pasted together to make an album; all must of course be the same size and shape. Instead of their being fastened together along the left-hand edge, the Chinese method is to paste alternate edges (back to back and front to front), so that the finished book opens up like an accordion. The method for applying the *ling tze* and another backing is described here. Other materials may be substituted, but the same procedure should be followed.

The light, flimsy silk *ling tze* must be prepared before it can be used as a mat, and this is accomplished in much the same way as the mounting of a painting on paper. The *ling tze* is laid on the working surface and brushed with clear water. Wavy places in the weave are straightened out, the water is wrung out of the brush, and the brush is again passed over the silk to absorb any excess water. Now a thick mixture of paste is made and brushed on the *ling tze,* which is backed with a sheet of paper and dried in the same manner as a painting. When dry, it will be stiff and may easily be cut into strips to make borders.

When cutting strips of this material or straightening the edges of a mounted painting, the Chinese craftsman uses a very simple but clever way of marking and measuring. The painting or silk is folded over on itself and the edges pricked

with a pin in several places (Fig. 252a). The painting is again opened out flat, a ruler is lined up along the pin holes (b), and the paper or *ling tze* is cut along the ruler with a sharp knife.

Small strips of brocade may be pasted at the top and bottom of the painting (Fig. 253a). Strips of the *ling tze* matting are pasted first to the long sides of the painting (b) and then to the top and bottom edges (c). Now that the silk matting is in place, another backing is pasted on the painting and mat, and as a finishing touch the whole thing is edged with thin strips of brown paper cut about one-sixteenth inch wide.

Two kinds of scrolls are made: vertical ones which are hung and horizontal ones meant to be held in the hands while they are studied. These are unrolled with the left hand and rolled up with the right, presenting a constantly changing scene to the viewer. Handscrolls are the most difficult to paint because the composition must be perfect wherever the scroll is opened. To make a scroll, after the *ling tze* strips are applied on all sides, a dowel split in half lengthwise or a half-round dowel is placed at the top or beginning of the scroll and a round dowel is placed at the base or end (Fig. 254a). The brocade is pasted down around these dowels, and then the backing is put on. The final step is to glue on two roller handles (at the bottom of a vertical, or at the end of a horizontal scroll) and attach the ribbon ties at the other end (b).

Contrary to our customary way, the Chinese prefer the greatest length of matting to be at the top of their pictures on a vertical scroll rather than below. The sides are equal in width, but they are kept narrow. On a horizontal scroll the measurements at the top and bottom borders are the same, but the beginning of the scroll has more length than the ending. On any horizontal painting (Fig. 255a) then, the top and bottom measurements should be equal, and the sides, wider. On any rectangular painting which is hung vertically, the side dimensions should be equal and narrow, but there should be more space above the painting than below (b). The illustrations, done on a scale of one inch to one foot, suggest some measurements. Small flat

252. Pricking painting with pin and lining ruler to pin holes.

253. Applying strips of brocade and ling tze.

254. Dowels, handles, and ties of a scroll.

255. Ratio of measurements for scroll matting.

squares of the album-leaf variety are bordered equally on all four sides with a narrow strip, usually only an inch to two inches wide, depending on the size of the painting.

If you want your painting to have an Oriental look, these dimensions should be adhered to even when you are planning to frame your work. Good framing shops will help you with this part. Ask for a simple molding in a soft brown wood stain or black lacquer finish. It is possible also to have your work mounted by a framing shop if you do not want to go to the trouble of doing it yourself.

The procedure in this country involves placing a film between the painting and the backing and then heat-sealing them together. This is effective for both paper and silk.

Other possibilities for backgrounds on which to paint are metallic papers (gold or silver) and screens which may be bought blank, ready for painting. Colored silk makes an interesting background too, particularly in an old gold or antique brown shade. You can dye the silk yourself by dipping it in a strong coffee or tea solution. Let it stay in the bath for an hour or so and then rinse it in clear running water until the color stops " bleeding." If you have made the mistake of putting color washes on a painting too quickly with the result that the color is too bright, this is a good way to tone it down.

In closing, it seems fitting to let the old Chinese artists and critics, who said so well what I would like to express, speak for me. In his book *The Chinese on the Art of Painting,* Osvald Sirén quotes from *Hun Yü Lu* (Notes on Painting) by the 17th-century master Shih-t'ao:

> In painting one should follow the heart (mind). . . . If one is going to walk far and climb high, one must start by taking a small step.
> The ancients never did it without a method.
> The works of the old masters are instruments of knowledge.
> . . . When the superior man borrows from the old masters, he does it in order to open a new road.

It is my earnest hope that you have become somewhat imbued with the Chinese spirit and are now more aware of its influence everywhere. Having come this far, you may want more advice in order to continue on your way. This book is only " a small step." If it has in any sense whetted your appetite for more, there is a world of information awaiting you; the bibliography listed here is just a start, but it includes, in my very humble opinion, some of the cream of the literature available on this subject today.

May you have much joy and satisfaction in your accomplishments as you travel along your road.

* * *

The following are among the many outlets who carry the supplies needed for Chinese brush painting; each will accept mail orders:

The House of Sung
527 Grant Avenue
San Francisco 8, California

Helen Winnemore's
150 East Kossuth
In German Village
Columbus, Ohio 43206

Takashimaya, Inc.
509 Fifth Avenue
New York, N. Y. 10017

Bibliography

Cahill, James: *Chinese Painting,* a Skira book distributed by World Publishing Co., Cleveland, 1960.

Chang Shu-chi: *Painting in the Chinese Manner,* The Viking Press, New York, 1960.

Chiang Yee: *Chinese Calligraphy,* Methuen and Co., London, 1938.

————: *The Chinese Eye,* W. W. Norton and Co., New York, 1935.

Fei Cheng-wu: *Brush Drawing in the Chinese Manner,* How To Do It Series, Studio Publications, New York, 1956.

Hawley, W. M.: *Study Charts for Chinese Characters,* W. M. Hawley, California.

Kuo Hsi: *An Essay on Landscape Painting,* Wisdom of the East Series, John Murray, New York, 1935.

MacKenzie, Finlay: *Chinese Art,* Spring Art Books, Spring House, London, 1961.

Sakanishi, Shio: *The Spirit of the Brush,* Wisdom of the East Series, John Murray, New York, 1939.

Sirén, Osvald: *The Chinese on the Art of Painting,* Henry Vetch, Peking, 1936.

Swann, Peter C.: *Chinese Painting,* Universe Books, New York, 1958.

Sze, Mai-mai: *The Tao of Painting,* Bollingen Series, Pantheon Books, New York, 1956.

Van Briessen, Fritz: *The Way of the Brush,* Charles E. Tuttle Co., Rutland, Vermont and Tokyo, Japan, 1962.

Wiese, Kurt: *You Can Write Chinese,* The Viking Press, New York, 1945.

Willetts, William: *Chinese Art,* Volumes I and II, Pelican Books, London, 1958.

Index

223